Art in Florida

1564–1945

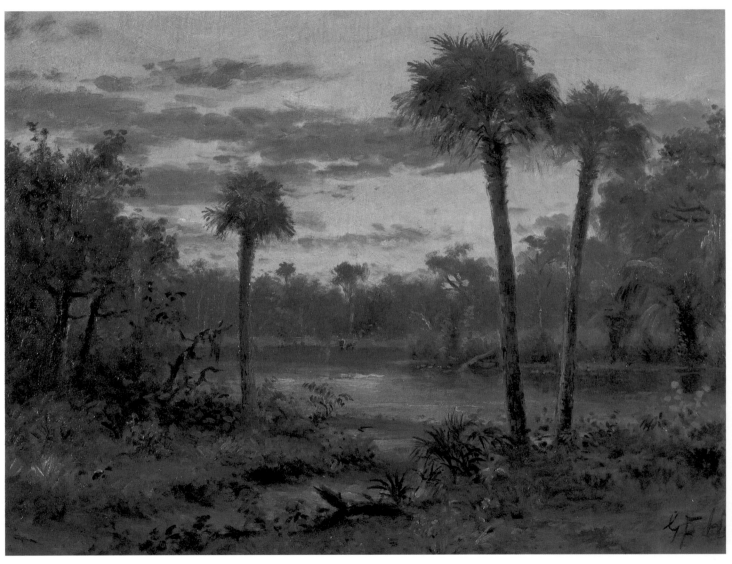

George Frank Higgins. *Palm Grove, Florida,* ca. 1875.
Oil on board, 13 1/2 x 19 1/2. Courtesy Morris Museum
of Art, Augusta, Georgia.
 Higgins' affection for Florida is reflected in this sunset
scene.

Art in Florida
1564–1945

Maybelle Mann

 Pineapple Press, Inc.
Sarasota, Florida

To Alvin Lloyd Mann,
for his love and support and for the many hours
he contributed

Inquiries should be addressed to:

Pineapple Press, Inc.
P.O. Box 3899
Sarasota, Florida 34230
www.pineapplepress.com

Library of Congress Cataloging in Publication Data

Mann, Maybelle.
 Art in Florida : 1564–1945 / by Maybelle Mann.
p. cm.
 Includes bibliographical references and index.
 ISBN 1-56164-171-5
 1. Art, American-Florida. 2. Florida-In art. I. Title.
N6530.F6M36 1999
709'.759-dc21 98-40884
 CIP

First Edition
10 9 8 7 6 5 4 3 2 1

Design by Carol Tornatore
Printed in Hong Kong

Contents

Acknowledgments

I WOULD LIKE TO THANK Robert Harper, executive director of the Lightner Museum, for all his years of encouragement; Sam and Robbie Vickers, who opened my eyes with their collection and their hospitality; Kenneth Barnes, curator of the Robert Houston Ogden Collection, for his courtesy and expert knowledge; Dan and Tracy McKenna, who literally took the paintings off the wall for photos; Sue Rainey and the American Antiquarian Society; Eric Robinson, historian of the Museum of Florida History in Tallahassee, who proved to be a fountain of knowledge; Dr. Robert Torchia, curator of the Cummer Museum of Art & Gardens in Jacksonville; Dr. Michael Gannon, professor of history at the University of Florida, Gainesville, for his help on Florida history; Dorothy Keane-White, executive director of the Florida History Center and Museum in Jupiter; Dean DeBolt, university librarian of the Special Collections Department at the John C. Pace Library at the University of West Florida; Jeffrey Barr, rare books librarian at the University of Florida, Gainesville; David C. Ward Sr., associate editor of Peale Family Papers at the National Portrait Gallery in Washington, D.C.; Kim Heitzman of the Orlando Museum of Art; Susan Lucke, registrar of the Lowe Art Museum in Coral Gables; Professor David Sokol, Department of Art History, University of Illinois at Chicago; Gloria Deák, consultant to the editor's office at the New York Public Library; Charles Tingley, librarian at the St. Augustine Historical Society; Tom Hambright, librarian at the Monroe County Public Library in Key West; Rebecca Hagen, curator of collections at the St. Petersburg Museum of History; and the many other museum personnel, private collectors who opened their homes to me, and art galleries that contributed both art and information. Librarians everywhere, I thank you. To all, your graciousness and encouragement have made this book possible.

I extend my appreciation to June Cussen, executive editor at Pineapple Press, for her keen eye, diligence, patience, and fortitude to bring this project to fruition, and to David Cussen, publisher, for his courage and foresight.

Though a number of these people have read and helped with the manuscript in its various stages, I take full responsibility for any inaccuracies which may have crept in. As for the beautiful art reproduced here, it is but a minute portion of the art I have seen and considered for this book. But a line had to be drawn (my publisher kept reminding me!). The remainder—in the hands of museums, private collectors, and galleries—I must leave to your imagination or your diligence in seeking it out. ❦

NOTE

In each instance, *Oklawaha* and *St. Johns* are spelled according to local account.

The Norton Gallery of Art (see chapter 9) is now the Norton Museum of Art.

Measurement of paintings is in inches unless otherwise noted.

Preface

SINCE THE POST–CIVIL WAR ERA, Florida has played a special role in
the hearts, minds, and aspirations of the American people. During
the 1870s, the peninsula began to attract such diverse groups
as carpetbaggers, land speculators, agriculturists, sportsmen, and
convalescents in search of a salubrious climate. In our own
generation, the Sunshine State has been one of the nation's favorite
vacation places, and many have chosen to retire here. For the
average American, the name Florida stirs up images of the
flamingo, the alligator, the hurricane, and idyllic sandy white
beaches strewn with palm trees. Florida also has a special historical
significance, and all schoolchildren are familiar with the story
of Ponce de León and his picturesque but futile search for the
mythical Fountain of Youth.

Given Florida's national mystique, it is surprising to observe
that until the publication of this volume there has never been
a comprehensive overview of the American art that the state
has inspired. On the following pages, Maybelle Mann provides a
survey of art in Florida from the late 1500s through the mid-1940s.
The reader will encounter such famous names as Martin Johnson
Heade, George Inness, Winslow Homer, and John Singer Sargent,
as well as numerous lesser-known figures such as William Staples
Drown, Frank Henry Shapleigh, Randall Davey, and Martha
Dewing Woodward. Familiar but unexpected artists such as John
James Audubon, George Catlin, and Louis Comfort Tiffany
make brief appearances. The concluding chapter is devoted to the
activities of the Works Progress Administration's Federal Art
Project. The fact that so many artists came to Florida and felt
compelled to represent its people, landscape, historic buildings,
and unusual flora and fauna confirms the state's special place
in our national esteem. This book thus constitutes a particularly
welcome and valuable addition to American regional art studies.

Robert Wilson Torchia

Art in Florida
1564–1945

Origins

FOR A LONG TIME, the American art establishment based in the Northeast, mainly in New York City, maintained there was no worthwhile art originating in Florida. A lack of familiarity with the Southern scene and Florida in particular, as well as the predominance of the New York market, contributed to this opinion. And, indeed, art development in Florida was slow because the population was so small for so long. The state's climate, along with events such as wars and the introduction of railroads, has always caused an uneven flow of settlers and visitors. The few artists who came, however, were intrigued by Florida's spectacular sunsets and sunrises, exotic forests hung with moss, and a myriad of unique flora and fauna. Even familiar biota took on new beauty in the semitropical climate.

Our story begins not with the first people to come to Florida at least 10,000 years ago, nor with the first Europeans who arrived in 1513, but with the first artist, who arrived in 1564. In this volume, the concentration is on Western art, specifically painting. Previous to this time, there was aboriginal art produced by the native peoples. There are a number of fine studies of this subject. Among them are *Florida's First People* by Robin C. Brown, *The Material Culture of Key Marco, Florida* by Marion S. Gilliland, and *Indian Art of Ancient Florida* by Barbara Purdy.

The first documented discovery of Florida by a European was made in 1513 by the Spaniard Juan Ponce de León, who at the same time identified the Gulf Stream. This warm stream originates in the Gulf of Mexico, passes through the Straits of Florida reaching a breadth of fifty miles, and then flows northeast parallel to the Florida coast, separated from it by a narrow strip of cold water. The Gulf Stream was a notable factor in the development of the state— it became the favored return route to Europe from the New World, making control of the area important. The legend that Ponce de

León came in search of the Fountain of Youth has attached itself to his discovery of Florida. True or not, the tale took on a life of its own, and as soon as it was feasible, in the nineteenth century, people flocked to Florida in search of health, wealth, and a new way of life. Hopes and dreams, coupled with the lure of gentle breezes and orange blossoms, offered promises that were hard to resist. Among the people coming to Florida were artists who wished to paint such tropical splendor. More and more Florida artists created more and more works, and soon the art that began as a trickle expanded into a flood.

In a country as large as the United States, discussions of art must be regional. As in other regions, the local biota strongly influenced the art produced. The first Europeans in the Southeast found every-thing a great surprise. From the beginning, the exotic landscape and its colorful residents must have captured the eyes and imaginations of the artists. Before the age of Abstraction, artists aimed, to the extent of their abilities, for true-to-life portrayals. This objective was modified by stylistic developments. But Florida was a latecomer on the art scene. The burgeoning of the state's population was finally accompanied by growth in the arts. Why did art take so long to gain a foothold? The same difficulties the state encountered in development affected the course of art history in Florida.

For the first three hundred years after Florida's discovery, very little art was produced except for the maps and scientific illustrations drawn by explorers and naturalists. Other than in the Panhandle area and along the shore in St. Augustine, there were so few people that the state had to depend on foreigners for artistic representation. The acquisition of Florida by the United States in 1821 opened the state to growth; however, during the first half of the nineteenth century development was slowed by the Seminole Indian Wars, which persisted until 1858, and it was further held in check by the Civil War. When an arts community did eventually appear in Florida, as everywhere, it developed with peculiarities specific to the state.

Art began to be produced by Northern newcomers, who in time came to be called "snowbirds" because of their tendency to "fly south" in the winter and back north in the summer. Both professional and amateur artists were motivated to capture the exotica they found, and they produced a variety of scenes according to their backgrounds and skills.

In the recent past, about one thousand new residents arrived in Florida each day. Though the percentage declined somewhat in the 1990s, the changes wrought by development have been profound. In the nineteenth century the Florida population also grew enormously. As the communities grew and spread, art proliferated.

We owe a debt of gratitude to the handful of artists who depicted early Florida since subsequent changes to the landscape were permanent. Early paintings create a sense of the past, when the wars that raged between Spain, France, and England for control of the peninsula made settlement virtually impossible. However,

St. Augustine, the first permanent settlement and oldest city in the United States, was maintained by a strong and beautiful fort, Castillo de San Marcos. The fort and the old city gate became popular subjects for artists.

The United States secured Florida from Spain in 1821 and it became a territory the following year. When Florida became a state in 1845, many more settlers began to arrive. For a very long time, because of transportation difficulties, the northern part of the peninsula remained the main haven for those who came for health reasons, better agricultural opportunities, the sea and its bounty, or simply the climate. Parts of the state became playgrounds for the rich while other areas remained undeveloped—some regions were still almost totally unreachable as late as the 1890s. The Florida Keys, however, were always accessible by boat and became a haven for sportsmen and tourists, among others.

The first known professional artist to set foot on the eastern shores, Jacques Le Moyne de Morgues, who drew the first map of the area, landed at St. Augustine in 1564. Le Moyne's forty-two paintings were invaluable records of Florida's past, as his portrayals of the Native Americans remain the only ones available to us from that period. The Native Americans fought the encroaching Europeans and continued until 1858 to rebel against being deported from their homeland. They were never totally defeated, however, as some escaped into the Everglades. Their artistic contributions have only just begun to be recognized.

Popular belief holds that Florida's development began with the huge real estate boom of the 1920s, but it actually started much earlier. In fact, real estate promotion was clearly the purpose of tracts written immediately after the United States' acquisition of Florida in 1821. There were a few hardy souls, mostly cotton merchants, who settled in the Panhandle along the gulf even before the area became a U.S. territory.

After achieving the stability of statehood, Florida received new interest from the Northern states. The diverse character of the state was formed with contributions from real estate development, tourism, and agriculture. The boom in real estate was followed by the growth of many other industries, such as cotton and citrus growing, as well as a short-lived attempt to cultivate mulberry trees for silk. Some initially attracted by speculation stayed on after each mania passed.

During the nineteenth century, many artists explored their visions of Florida in many ways. Landscapes predominated, and genre scenes appeared as the state began to be settled. Natural events and phenomena often played a large part in the way the state—and its art—grew. During some winters, harsh weather froze citrus and other crops, while hurricanes and the economic failure resulting from wildly optimistic real estate development schemes were equally devastating. Predictions about the future of Florida were uncertain: some saw it as a hopeless jungle, while others saw dollar signs on every blade of grass.

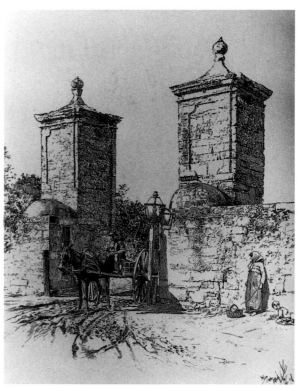

Dorothy H. Reynolds. *Ruins of the City Gateway.* (See Pl. 7.6.)

World War II changed the world, including Florida. By the war's end in 1945, art was taking an entirely new direction. In Florida, technological developments made tropical living a comfortable possibility and changed the environment for artists. This volume deals with art in Florida before World War II. (The few post–World War II artists dealt with in chapter nine formed their esthetic and creative views in the 1920s and '30s and continued their work after the war without noticeable stylistic changes.) Art developments after World War II are so tremendous, varied, and exciting that another volume will be necessary to do them justice.

One of the difficulties one faces in compiling the story of art in Florida is the paucity of published material, reflecting the popular notion that there was no art in the early years. As late as 1977, Elliot James Mackle Jr. postulated in his master's thesis:

> Images are made not by any one decision, not on a single day, not, ordinarily, by the combination of only one or two facts or circumstances. The creation of Florida's image may nevertheless be traced, the individual parts isolated for examination. Several elements grew out of details drawn from the earliest accounts of the European exploration of America. Others derive from Judeo-Christian traditions, eighteenth-century Enlightenment philosophy, and nineteenth-century American expansionist rationale. Still others have origins in such observable facts as geography, climate and native vegetation. As will be shown, however, the principal elements of the Florida image were collected, combined, promoted, and made part of the American myth in a comparatively brief period, the thirty-five years between the end of the Civil War and the beginning of this century.[1]

Certainly a great deal of cultural and artistic growth did occur in those thirty-five years, but we also want to know what happened both before and afterwards. The colorful characters who built the state were an irresistible mix of explorers, dreamers, would-be millionaires and real ones, con artists, gangsters, land developers, and people just hoping for a new life. The hopes and dreams of Florida's newcomers were reflected in the creation of a lively arts community.

Early travel literature is important to the history of Florida's art, not only because it traced the state's development but also because much of it was heavily illustrated. Jacque Le Moyne's sixteenth-century pictures were the earliest travel posters for the New World. The travel tracts of the nineteenth and early twentieth centuries were designed to lure ever more visitors to the tropical paradise. Frequently, the illustrations were boldly copied from artists, and from book to book, without so much as an acknowledgment.

Though some artists are always inspired to create no matter where they are, artists need to make a living, so they tend to

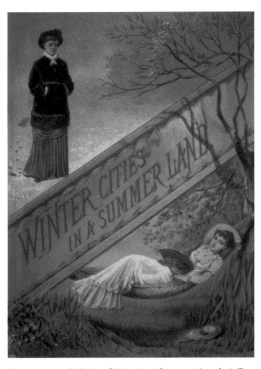

Anonymous. *Winter Cities in a Summer Land: A Tour Through Florida and the Winter Resorts of the South.* (See Pl. 7.2.)

gravitate to places where there is a market for their work. In the late nineteenth century some artists followed their patrons from the White Mountains, New Hampshire, in the summer to Florida in the winter. This combination of patronage and creativity resulted in art showing up in unexpected places. Florida scenes brought home by visitors often ended up gathering dust in Northern attics. Nevertheless, much early Florida art has remained, and as interest grows, more of it emerges. Art and artists are recorded here as they appeared—sparsely in the sixteenth, seventeenth, and eighteenth centuries, and more numerously in the nineteenth century.

Several individuals contributed greatly to both the cultural and artistic growth of Florida, although these contributions were often unintentional. Henry Morrison Flagler, Henry Plant, Addison Mizner, George Merrick, and John Ringling are some of the men who strongly affected not only the development of Florida, but also the way the state was to look. Each was also responsible for bringing some form of art to the state.

Some of the many paintings of Florida by George Inness, Martin Johnson Heade, and Winslow Homer are discussed in this book in detail. Other famous artists whose Florida art is far less familiar are Frederick C. Frieseke, Frank Benson, Doris Lee, Ernest Lawson, John Singer Sargent, Louis Comfort Tiffany, and Jane Peterson. John James Audubon is in a category all his own.

The development of Florida art in the twentieth century, both before and after World War I, reflected the extraordinary growth that had begun to occur in every other field of enterprise. The wild real estate booms of the 1920s attracted wealth, as well as artists, from all over the United States and Europe. Some of these artists were eccentric, contributing to the gossip pages while enriching the cultural life of the region. South Florida architecture, inspired in large part by Addison Mizner, took on a new Mediterranean dimension.

A phenomenon has long been present in the art market that once art is recognized in an area, previously unknown art and artists begin to emerge. Quite recently regional art has become another Florida boom. The destiny of Florida art has also been changed by collectors who concentrate on Southern art in general. All of these diverse threads are drawn together in this volume.

Despite the impressive number of artists represented here, there are still more whose work is known and even titled but remains lost. Still others left written records, such as letters and journals, of their visits but, unfortunately, nothing more. Despite these losses, art is, and has been, alive and well in Florida. As a vibrant, important record, the history of art in Florida can only continue to grow as more information is known. The explosion in development and population in Florida brought art, artists, architecture, and many other evidences of cultural expansion. The value of what we see through art cannot be overestimated in this rapidly changing world. ❧

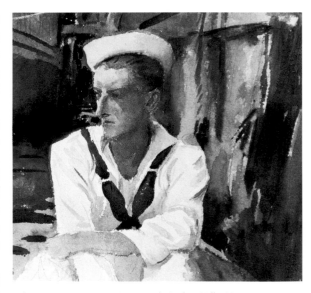

John Singer Sargent. *Basin with Sailor, Villa Vizcaya, Miami, Florida.* (See Pl. 9.6.)

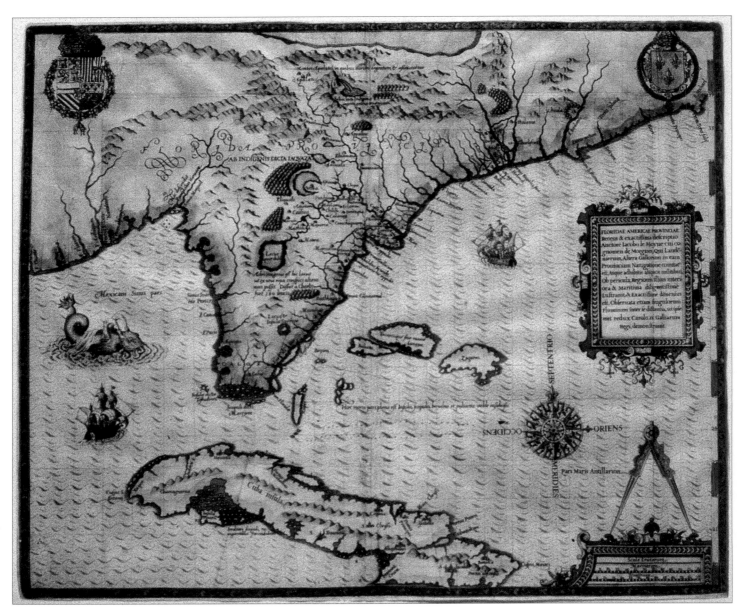

1.1 Theodore de Bry after Jacques Le Moyne. *Floridae Americae*, 1564–65. Aquatint on paper, 14 x 17 1/2 (image). Source: Theodore de Bry, centerfold in America, pt. II, Latin text, I ed., Frankfurt-am-Main, 1591. Courtesy Birmingham Public Library.

This map was the major reference for the area for 100 years.

Early Visitors

PONCE DE LEÓN LANDED IN FLORIDA in early April 1513 after a series of successful raids on islands in the Caribbean. According to legend, because he arrived at the time of the Easter feast and because of the many beautiful flowers he saw here, he named the land *La Florida* (from *Pascua florida,* meaning "flowery Easter"). In 1521 he returned to the west coast of Florida, where he was fiercely attacked by Native Americans and wounded so severely that he later died. Other adventurers followed, including Hernando de Soto, who came ashore at Tampa Bay in 1539 in search of gold and silver but died three years and many miles later near the Mississippi River. Though a few of the early Spanish explorers intended to found permanent settlements, most were interested only in fortune. In the long run, this was to work against the best interests of Spain.

The French attempted to establish a permanent European settlement in Florida with families, although it lasted only a short time. French Admiral Gaspard de Coligny, an enthusiastic Huguenot, sponsored the first expedition. On April 30, 1562, three French ships made landfall at the St. Johns River. Jean Ribaut, a fervent Calvinist, headed the group. He named the stream "River of May" and planted a stone pillar on the bank near its mouth with the French coat of arms, the date, and his name engraved on it; a replica now stands on St. Johns Bluff. Many calamities befell the colonists, and while some returned to France, those who remained were eventually driven out by the Spaniards.

Two years later René Goulaine de Laudonnière replaced Ribaut as leader and arrived at the River of May with three ships, three hundred men, and four women to establish Fort Caroline on a broad, flat knoll about five miles from the mouth of the St. Johns. This venture was also doomed to failure, for shortly more than a year later it would be destroyed by the Spaniards. Fortunately for

Detail of Plate 1.2

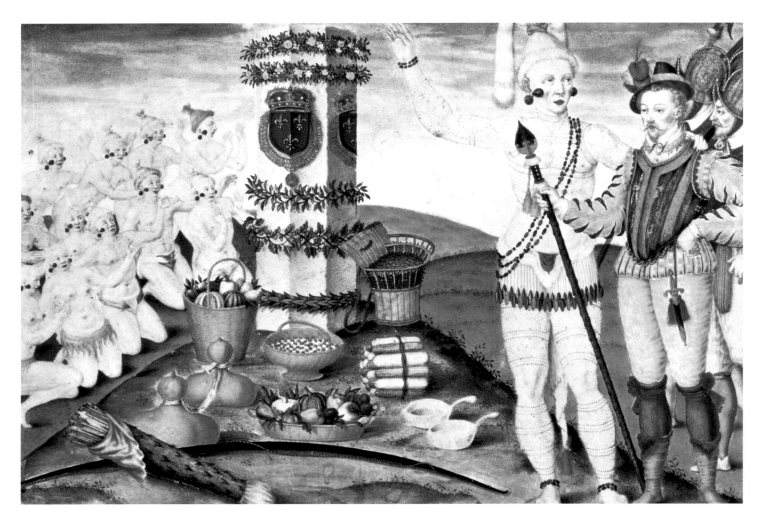

1.2 Theodore de Bry after Jacques Le Moyne. *René de Laudonnière and the Chief, Athore, at Ribaut's Column,* 1564. Gouache and metallic pigments on vellum with traces of black chalk outline, approx. 7 x 10 1/4. Print Collection, Miriam and Ira D. Wallach Division of Art, Prints and Photographs. The New York Public Library. Astor, Lenox and Tilden Foundations.

A contemporaneous glance at the bounties of Florida.

the art of Florida, **Jacques Le Moyne de Morgues,** an artist and cartographer, was with Laudonnière's group. For one hundred years, the map *Floridae Americae* [Pl. 1.1], drawn by Le Moyne, was the major reference for the area. The Spanish referred to much of what is now the Southeast as "Florida," and Le Moyne's map includes what is now Georgia and part of the Carolinas.

Le Moyne was the first European artist to come to Florida, and his images of the newly discovered continent and its people are the first in the history of Florida. Some of the French survived the Spanish attack, including Le Moyne, who returned to France with his paintings. Since Huguenots were not popular in France, he fled to England, where he remained until his death. After Le Moyne's death, his watercolors were sold to an engraver, **Theodore de Bry.** He and his sons made beautiful copper plate etchings from Le Moyne's originals, which were later lost, leaving no means to correct any errors the engravers may have made.

Le Moyne's art remains an important source of information about early Native Americans in Florida, specifically the Timucua, the tribe Le Moyne encountered. One problem with de Bry's engravings of Le Moyne's images is that de Bry had little idea how to portray Native Americans. The great art historian E. P.

Richardson described why this was so: "The discovery of America occurred when painting was in one of its greatest periods. . . . When Columbus sailed from the port of Palos into the Western ocean, the painting of the ideal world was at the height of its splendor and convincing power; the painting of the world of nature was in its infancy. . . . For all its power, Renaissance art was ill adapted, or to speak more truly, was not interested in giving us a record or a comment on the discovery of the New World."[1]

In the sixteenth century pre-Enlightenment, the noble-savage theory did not exist, so while there was curiosity about the exotic nature of the inhabitants of Florida, artists did not consider the discovery important to their work. Clues exist to show how de Bry probably changed Le Moyne's works. **John White**, who was a contemporary and friend of Le Moyne while both were in England, came to Raleigh's short-lived colony in Virginia in 1587 and 1590 and produced sixty-five watercolor drawings that are now in the British Museum. De Bry also made engravings after White's paintings. White's originals were misplaced for many years. When they came to light, it was possible to see how de Bry had embellished White's scenes. While the changes were minor, de Bry did alter some of White's original details as well as alter the works' authenticity. In de Bry's interpretation of Le Moyne's work, the forms look more like Renaissance figures than Native Americans. Despite the many details that de Bry apparently altered in his adaptations of works of Le Moyne and White, the engravings still provide much information on what White and Le Moyne witnessed. It is interesting to note that two of White's watercolors at the British Museum are titled *Warrior of Florida* and *Florida Flamingo*, indicating that White may have visited Florida in the late sixteenth century. However, some authorities believe that White's paintings were based on Le Moyne's work.

Le Moyne's *René de Laudonnière and the Chief, Athore, at Ribaut's Column* [Pl. 1.2], 1564, offers a fascinating glance at the available bounty in Florida. This may be the only original painting of Le Moyne's left, but some experts have challenged its authenticity. An article written by Christian F. Feest in 1988, which questions the reliability of the "original," concludes that ". . . the closest approximation that we can get to Jacques Le Moyne's lost original sketches of the New World is contained in the two contemporaneous copies made by John White."[2] White is known to have been associated with Le Moyne during the Frenchman's exile in London in the 1580s.

Le Moyne was a serious student of nature who had the ability to report with accuracy as well as with a charming style. However, in light of questions about the originality of this piece, difficulties with the picture arise. Here, the figures of the Timucuan tribe appear to be European in nature and Mannerist in design. The pinkish color of the Indians' skin may be another indication that the painting is not an original, rather done in the seventeenth century since the term "red men" was not used until then (to

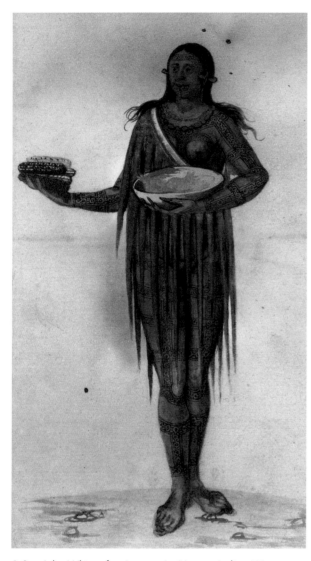

1.3 John White after Jacques Le Moyne. *Indian Woman
of Florida*, ca. 1585. Watercolor on paper, body colors
heightened with white over black lead outlines,
10 1/4 x 5 3/8. Copyright The British Museum.
 This drawing portrays an Eastern Timucuan woman of
northeast Florida.

describe the Beotheck tribe from Newfoundland, who colored their
skin with red ochre).[3]

Indian Woman of Florida [Pl. 1.3] by John White, circa 1585, also in
the British Museum, is definitely after Le Moyne and shows that Le
Moyne was not influenced by the prevailing aesthetics of his time.
A comparison with Le Moyne's *The King and Queen Take a Walk*
[Pl. 1.4], 1564, makes this clear. Since White had been to the
New World, he knew how the Native Americans looked. Obviously
he agreed with Le Moyne's view.

For two centuries, prints of de Bry's engravings of Le Moyne's
art were borrowed and imitated by other engravers to illustrate
books about America. The de Bry engravings [Pls. 1.5–1.7] are
important early records of the lives of the Timucuan tribe
because shortly thereafter the Timucua were virtually wiped out
by European diseases. While the prints depict special rituals, they
also show many aspects of daily tribal life. For example,
they demonstrate that only those in leadership positions bore
intricate tattoos [Pl. 1.6].

In a discussion of Le Moyne's work as engraved by de Bry, Gloria
Deák explains that the artistic style results from the age of
Mannerism, which flourished in Europe from approximately
1520 to 1620. Mannerism was characterized by dramatic subject
matter, elongated forms, and vivid (often harsh) color. Deák
states, " . . . Mannerism reflects a conscious preoccupation with
stylistic expression rather than with the thing expressed."[4] In
Mannerist art, the dramatic aspect of the image is emphasized
rather than the Classic Realism of the previous era. There is
definite evidence that early Florida imagery was altered or
enhanced (as was customary then) by de Bry, who interpreted
them in a Mannerist style. From both an artistic and a historic
point of view, we would like to know what was changed and how.
Deák goes on to explain:

> An extraordinary heritage had ushered in this era through the
> work of Michelangelo, Leonardo, Raphael, Titian, Correggio,
> Giorgione, Durer, Holbein and a host of others, largely Italian.
> In the hands of these Renaissance masters, painting and sculp-
> ture had reached a kind of perfection. No problem of
> draughtsmanship seemed too difficult, no subject matter too
> complicated. They turned to mathematics to study the laws of
> perspective and to anatomy to study the building of the body.
> Through their inspired efforts to achieve beauty and harmony
> in whatever they created, they elevated the status of art from
> what had been considered little more than a humble craft to a
> noble humanist pursuit.[5]

Deák's conclusions strengthen Richardson's views on the subject
of why Native Americans were portrayed as we see them in Le
Moyne's works as engraved by de Bry. Renaissance artists' pursuit
of perfection so narrowed their vision of what the rest of the world
actually looked like that they were unable to see, much less portray,

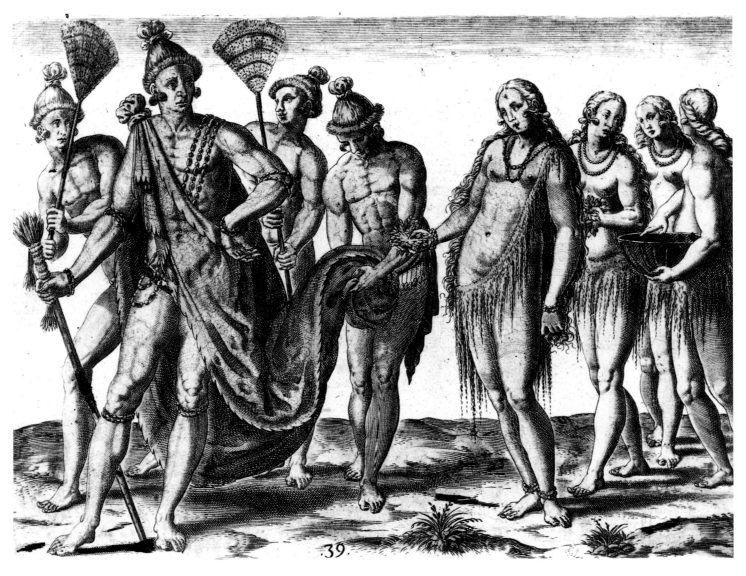

.39.

1.4 Theodore de Bry after Jacques Le Moyne. *The King and Queen Take a Walk*, 1564. Engraving, 6 x 8 1/4. Courtesy Birmingham Public Library.
 Exhibits the Mannerist penchant for exaggerating human anatomy.

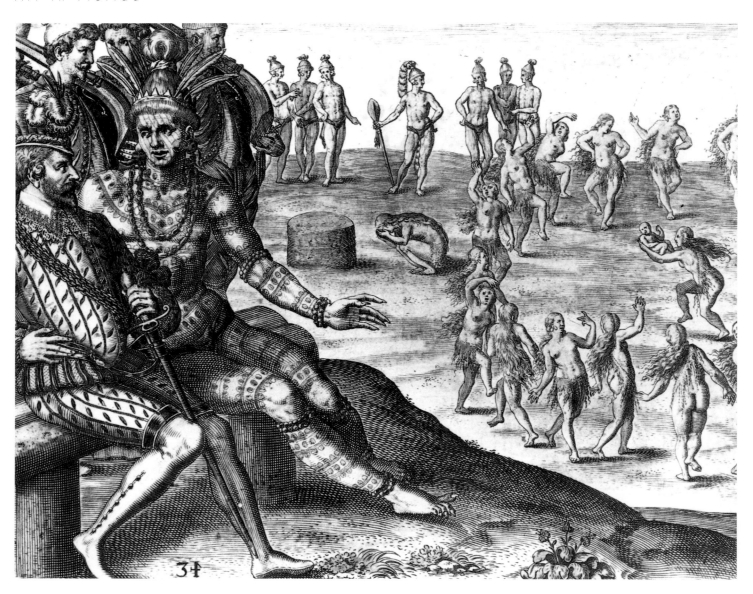

1.5 Theodore de Bry after Jacques Le Moyne. *The Sacrifice of the First-born Sons,* 1564. Engraving, 6 x 8 1/4. Courtesy Birmingham Public Library.
 Notice the weeping mother before the sacrificial altar.

the reality of a different kind of life. To repeat the essence of Richardson's criticism: ". . . Renaissance art was ill adapted, or to speak more truly, was not interested in giving us a record or a comment on the discovery of the New World."

After their victory over the French and Fort Caroline, the Spanish controlled Florida for most of the next two centuries, except for a brief interlude from 1763–83 when the British took over. Although Florida did not offer the bounty found in other areas of the New World, it was strategically important in this period since the best trade route to Europe was via the Gulf Stream, which cuts through the Florida Straits and runs along Florida's east coast. Only a few graphics and some paintings show the period from 1650–1800.

Europeans were fascinated with the discovery of Florida, as well as with the prints which appeared. However, many of these illustrations were distorted portrayals based on Le Moyne's work.

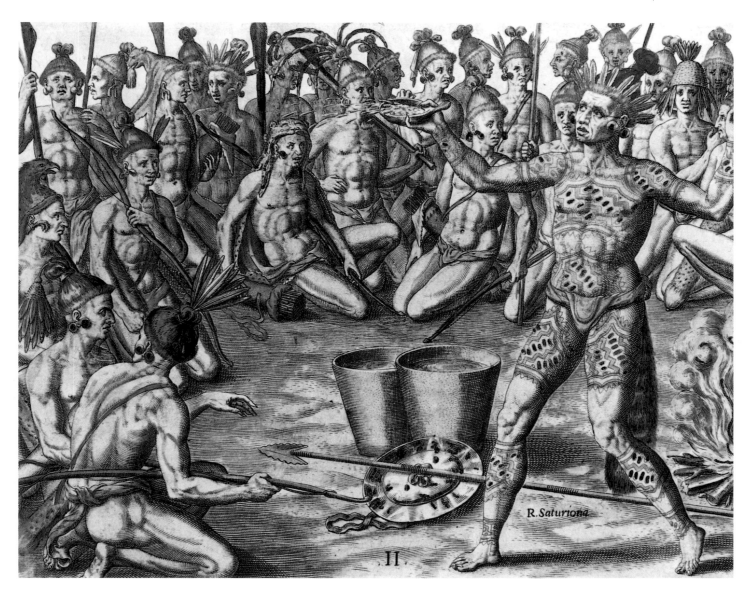

1.6 Theodore de Bry after Jacques Le Moyne. *A Timucuan Chief Prepares for War*, 1564. Engraving, 6 x 8 1/4. Courtesy Birmingham Public Library.

A tattooed chief prepares for the rituals of war.

Der König in Florida [Pl. 1.7], circa 1675, is a German print that is clearly derived from Le Moyne but offers a variation on the originals. (Compare to plate 1.4.) The text, loosely translated, locates Florida southwest of Virginia and describes the terrain as well as a fort, church, and monastery. The natives are described as tall and well-built, "colored like oil," and wearing elk skin over their genitals. The hairdo of the Timucuan males is mistakenly called a cap. The German version shows a parasol being carried over the king's head, but no such item appears in Le Moyne's prints, although palm fronds to fan the king are depicted.

A French illustration of the discovery of Florida owes nothing to Le Moyne's works, although it clearly states that the subject is the "King of Florida" [Pl. 1.8]. The accompanying text describes Florida as filled with flowers that are always green and blossoming, giving it its name. This reflects the popular theory that Ponce de León came seeking the Fountain of Youth. The

clothing worn by the king in this picture is puzzling, more suitable to a northern climate rather than a tropical one. The era of exploration stimulated many other misconceptions about the strange New World. This information was published in the mid-sixteenth century before the Le Moyne prints engraved by de Bry were circulated.

In 1565 Pedro Menéndez de Avilés was dispatched from Cadíz, Spain, with a party of fifteen hundred to found a settlement, which he named St. Augustine. The large portrait of Menéndez (undated) at the St. Augustine Historical Society is a copy of Titian's portrait, which was presented to the town by Spain in this century.

The old city gate in St. Augustine, depicted early in 1595 by an anonymous artist, was replaced in 1804, but the new gate was made of the same material—coquina. This soft, whitish limestone formed of broken shells and corals is still being quarried and is occasionally used as decoration of local buildings. The gate has been a favorite subject of artists over the years, because in this country, which lacks ancient history, it is among the oldest constructions.

The Spaniards began building a fort, named Castillo de San Marcos, in St. Augustine in 1665 to maintain a foothold in the new lands and guard the route back to Spain. It took twenty-four years to finish, and, as noted in *The New History of Florida*, edited by Michael Gannon, it was an expensive undertaking as it "cost the crown over 138,000 pesos. In the late seventeenth century . . . the

Below: 1.7 Anonymous. *Der König in Florida*, ca. 1675. Woodcut on paper, 6 3/4 x 6. Courtesy Robert W. and Alicia A. Harper.
 A German view of the Timucuan Indians.

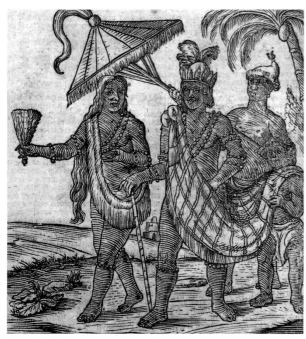

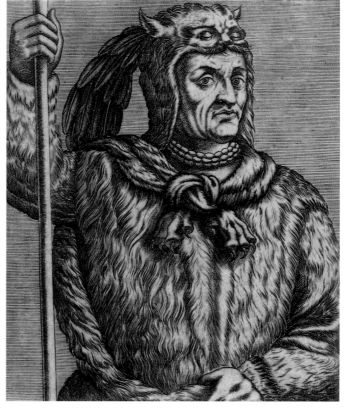

Right: 1.8 André Thevet. *Paraousti Satourina, King of Florida*. From *La France Antarctique*, Paris, 1558. Woodcut, 6 3/4 x 5 1/2. Courtesy Robert W. and Alicia A. Harper.
 A mid-sixteenth century view before Le Moyne's were circulated.

14

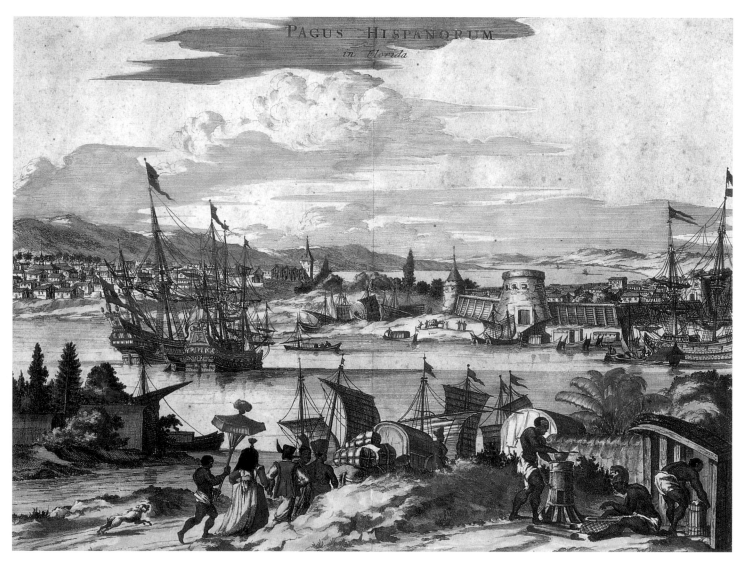

1.9 John Ogilby after Arnoldus Montanus. *Pagus Hispanorum in Florida,*1671. Woodcut on paper, hand-colored, 19 1/2 x 22 3/4. Collection of Robert W. and Alicia A. Harper.

A rare seventeenth-century woodcut of St. Augustine harbor.

new royal funds for fortifications were absorbed by the Castillo with little left to spare for the defense of the provinces."[6] Later 6000 pesos sent for other building was used to build a sea wall. Additional work was completed in 1756. The Castillo was renamed Fort Marion in 1821 when Florida became part of the United States. It was again named Castillo de San Marcos by the U.S. Park Service in the 1940s.[7]

St. Augustine's stable Spanish community had strong ties to the surrounding native people. Intermarriage between Spanish men and native women created a *mestizo* society. Because Spanish control over the years was intermittent, Spanish Florida became an economic, ecclesiastic, and military appendage of Cuba. When Spain surrendered Florida to Britain in 1763, a major part of the population relocated to Cuba. Upon the return of Florida to Spain in 1784, many of the *Floridanos* came back. With the onset of American control in 1821, contacts between Florida and the island diminished. Cuba's wars for independence from Spain began in 1868, and as they sporadically continued, thousands of

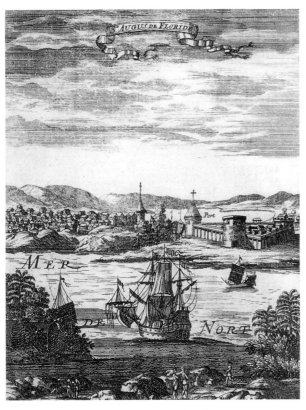

Above: 1.10 Anonymous. *Die Stadt Dels H. Augustins in Florida*, ca. 1675. Engraving on paper. Collection of Robert W. and Alicia A. Harper.

A harbor scene of St. Augustine as viewed by a German artist.

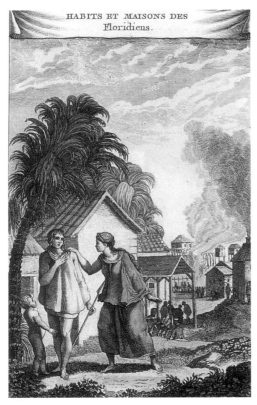

Left: 1.11 Bernard. *Habits et Maisons des Floridiens*, ca. 1700. Etching on paper, hand-colored, 10 x 12. Collection of Robert W. and Alicia A. Harper.

Old World view of New World peoples.

Cubans sought refuge in Key West and Tampa.

Maps continued to improve, but art remained sparse and inadequate. Crude "illuminations," or pen sketches, that supplemented reports from the Spanish friars were the only examples of visual history for a long time. A rare seventeenth-century woodcut of St. Augustine's harbor, *Pagus Hispanorum in Florida* [Pl. 1.9] by **Arnoldus Montanus**, was engraved by **John Ogilby**, a Scot. It documents the presence of black laborers in 1671. Interest in the city is also demonstrated in a German engraving from about 1675, *Die Stadt Dels H. Augustins in Florida* [Pl. 1.10]. *Habits et Maisons de Floridiens* [Pl. 1.11] by **Bernard** (circa 1700, France) gives us another Old World view of New World peoples, their customs, and their houses.

A 1743 engraving titled and translated from the German as *A North View of Pensacola on the Island of Santa Rosa* [Pl. 1.12] was originally published in *An Account of the First Discovery and Natural History of Florida* by William Roberts and Thomas Jeffreys in 1763. In the account, the scene is described as follows: "The town is defended by a small fort surrounded by stockades, the principal house is the governor's; the rest of the town is composed of small hutts or cabbins [*sic*], built without any order, as may be seen by the view, which was drawn by a person who resided here in 1743, and was in the service of the Havana company, and sent in a schooner laden with cargo for this place."

Other than early maps, one of the first serious accounts of the flora and fauna of the Florida region was **Mark Catesby's** *The Natural History of Carolina, Florida and the Bahama Islands*, published in London in 1731. Catesby engraved his own plates to save money, although he was not an engraver by trade. Therefore, they are crude but still strong, decorative, and beautiful [Pl. 1.13]. The colored copies were executed under his personal direction.

Catesby's main interest was plant life, for which he made two trips to the New World. He also contributed a paper, "Birds of Passage," in 1747. Catesby's excursions into Florida were minimal, however, as he spent more time in Georgia and the Carolinas.

William Bartram, a Pennsylvania Quaker who was moved by the search for the "Cosmic Truth" espoused by such Enlightenment philosophers as Jean-Jacques Rousseau, came to Florida in April 1774. In *Travels* (1791), his drawings combine unrelated plants, birds, animals, and other objects without regard to scale. He discovered and depicted enough material to fill a book that influenced scientists and poets on both sides of the Atlantic. Ralph Waldo Emerson's good friend, the English author Thomas Carlyle, reported that Bartram's work[8] ". . . has a wonderful kind of

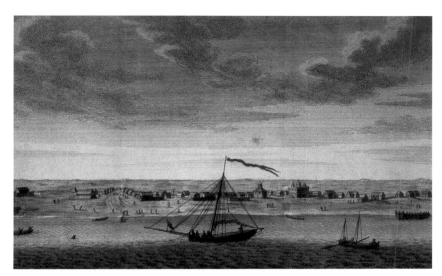

Left. 1.12 Dominic Serres. *A North View of Pensacola on the Island of Santa Rosa*, 1743. Engraving on paper, 6 11/16 x 10 13/16. Courtesy Special Collections Department, John C. Pace Library, University of South Florida.

Originally published in *An Account of the First Discovery and Natural History of Florida* by William Roberts and Thomas Jeffreys in 1763.

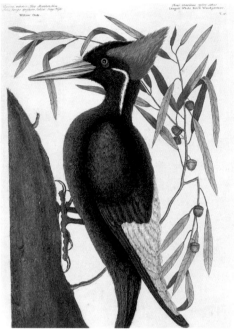

floundering eloquence. . . . He was no doubt the country's first conservationist and ecologist, for when most men were out to exploit, despoil and lay waste a virgin continent, Bartram . . . wanted to investigate, cherish, and preserve these great assets."[9]

Bartram also wrote at some length about the Seminoles, the Native Americans who had begun to migrate south into Florida after the demise of the earlier natives. Until the nineteenth century, these works were the main sources for the art of flora and fauna of Florida. His drawings consist of sixteen colored representations of snakes, birds, and flowers, as well as black-and-white sketches of birds, flowers, alligators, and marine life, sixty-four of which now hang in the British Museum. Although he was one of the best natural-history artists working before Audubon, Bartram's work has met with undeserved neglect. The drawing *Indian Shot* [Pl. 1.14] clearly demonstrates the quality of Bartram's work.

Settlement of Florida by the English was greatly accelerated when Spain supported France during the Seven Years War (also called the French and Indian War), out of fear that a British victory would upset the balance of colonial power. The British won, which cost Spain eastern and western Florida, among other major concessions. Under the British (1763–1783), Florida made considerable economic progress. The influx of British-American settlers to Florida reached a peak during the American Revolution, when Tories flocked to the region from the North. By the terms of the Treaty of Paris in 1783, Florida was returned to Spain, but her hold was extremely tenuous.

Above: 1.13 Mark Catesby. *Ivory-billed Woodpecker*, 1731. Engraving on paper, hand-colored, 13 1/2 x 10 1/2. Courtesy American Museum of Natural History, Department of Library Services, New York.

Catesby's *The Natural History of Carolina, Florida and the Bahama Islands* was published in London in 1731.

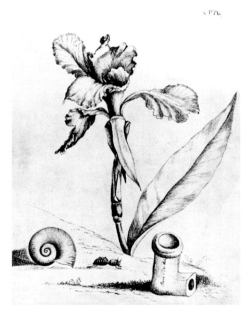

Right: 1.14 William Bartram. *Indian Shot*, ca. 1719. Drawing on paper, 6 x 4 1/2. Courtesy Special Collections Department, John C. Pace Library, University of South Florida.

William Bartram is considered to be the first conservationist and ecologist.

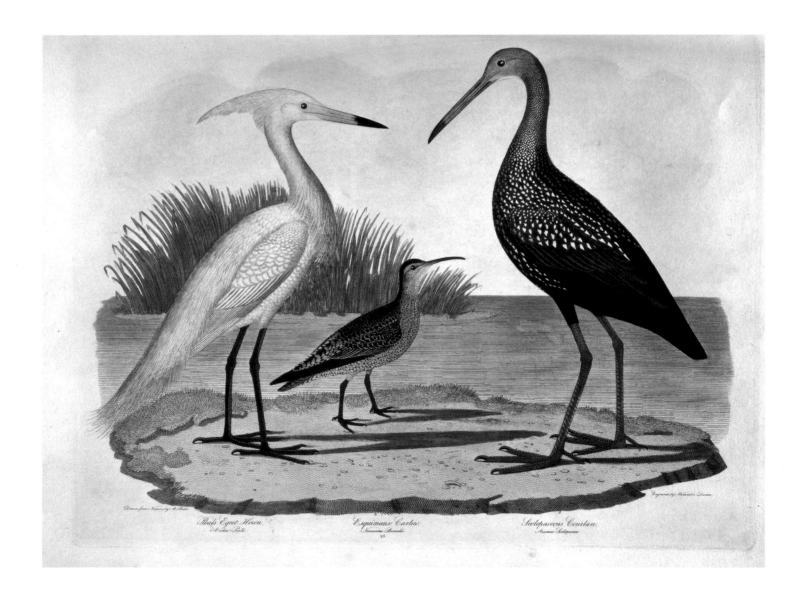

Drawn from Nature by A. Rider. Engraved by Alexander Lawson.

Peal's Egret Heron. Esquimaux Carlew. Sclopaceous Courlan.
 Ardea Peali. Numenius Borealis. Aramus Sclopaceus.
 26

The Early Nineteenth Century

IN 1819 THE UNITED STATES purchased Florida from Spain. Official occupation began in 1821 with Andrew Jackson as governor. Many European residents departed, but those who remained became great supporters of the territory. Around this time a number of volumes appeared praising the virtues of Florida. Initially, these books were not illustrated, except for the occasional map. An example is James Grant Forbes' *Sketches, Historical and Topographical, of the Floridas; More Particularly of East Florida,* published in 1821. Unfortunately, in spite of the title, the book is not illustrated. In 1823, *Observations Upon the Floridas* by Charles Vignoles was issued.[1] Vignoles was a topographical engineer, and a map of Florida [Pl. 2.2] served as a frontispiece to the book. It was billed as " . . . a reliable guide for persons traveling by water and land about East Florida."[2]

America's victory in the Revolutionary War had caused Thomas Jefferson to exclaim: "What a field we have at our door to signalize ourselves in. The Botany of America is far from being exhausted, its mineralogy untouched, and its natural history or zoology totally mistaken and misrepresented."[3] Whether or not in response to Jefferson, **Titian Ramsey Peale** made his first expedition to Florida in 1824 at the age of nineteen. Following a Bartram itinerary, he collected specimens and made drawings for Charles Lucien Bonaparte's *American Ornithology or the Natural History of Birds Inhabiting the United States* (1825–1833).

Titian Peale was the youngest of Charles Willson Peale's seventeen children. An older brother, Rembrandt, was in Europe, mainly Paris, from 1808 to 1810. When the Bonapartes were exiled after the fall of Napoleon, Charles Lucien Bonaparte moved to Philadelphia, just three blocks from the Peale family. Both the Peales and Bonapartes summered in Long Branch, New Jersey. When Charles Bonaparte needed an artist to illustrate his *American*

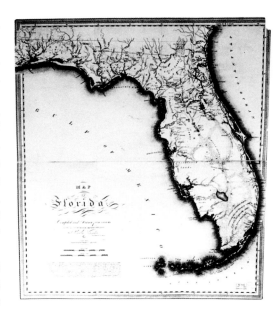

2.2 Charles Vignoles. Map of Florida, 1823. Engraving, 27 5/8 x 24. Courtesy Library of Congress Collections.
 Compiled and drawn from various actual surveys and observations.

Facing page: 2.1 Alexander Lawson after Alexander Rider. *Peal's Egret Heron,* 1823–1825. Watercolor on paper, 10 1/2 x 13 1/4. From *American Ornithology or the Natural History of Birds Inhabiting the United States* by Charles Lucien Bonaparte. Published by Carey and Lea, Philadelphia, 1823–1825, vol. 4, p. 96. Courtesy Department of Special Collections, George A. Smathers Libraries, University of Florida, Gainesville.
 A just compliment to a naturalist (Peale) to whom American zoology owes so much.

Ornithology, Titian Peale was the logical choice because of his interest in naturalism. Titian illustrated some of the birds in volumes one and four of *American Ornithology.* The illustration *Peal's* [sic] *Egret Heron* [Pl. 2.1], which includes two other birds, shows the specimen that came to be named after Peale. *Peal's Egret Heron* was painted by Alexander Rider and engraved by Alexander Lawson, both of Philadelphia, but we can surmise, since Peale accompanied Bonaparte to Key West, that Peale sketched the bird on the spot and it was copied by Rider from the original. In the volume of *American Ornithology* where this is discussed, Bonaparte wrote:

> Returning to our Egret . . . we have to state that it is dedicated to Mr. Titian Peale, by whom it was first shot for us in Florida as a just compliment to a naturalist to whom American Zoology owes so much, and from whom so much may still be expected. . . . Peale's Egret Heron is twenty-six inches long, the bill five inches, flesh colour for nearly three inches from the base, then black to the point . . . the plumage is without exception snowy white. . . .[4]

Bonaparte's prediction that Peale's career as a naturalist would flourish was proved correct. From 1838 to 1842, Peale accompanied Lt. Charles Wilkes to the South Seas as a naturalist and drew several of the plates in the report of that expedition. In 1848 Peale published *Mammalia and Ornithology.* He was also a gifted portraitist. In 1981 an exhibition of his work was shown in the Special Collections Division of the Gelman Library at George Washington University in Washington, D.C.

The history of Key West explains why and how the various artists who visited were motivated to use the island in their art. Closer to Cuba at 90 miles than to Miami at almost 150, Key West has a history encompassing a colorful array of inhabitants whose occupations were wrecking, shrimping, fishing, and smuggling. The name derives from the Spanish *Cayo Hueso,* "Island of Bones," though why it was called this has never been explained. Key West experienced a convoluted chain of ownership dating from 1815 when Spain granted the island to Juan Pablo Salas. It took several years for Congress to straighten out the true ownership of Key West after Florida was acquired from Spain in 1821. The next year, the U.S. sent Lieutenant Matthew Perry to take possession of the island. Less than a week later a group landed and claimed ownership for General John Gedden of South Carolina. Several months later, Naval Commodore David Porter arrived and, in an attempt to suppress the rampant pirates, tried to turn Key West into a military post. Finally in 1828, John Simonton, a businessman, was recognized as the legitimate owner of the island. He plotted the streets of what is now referred to as Old Town Key West.

Few people went to Key West in the early days, but one who did was **John James Audubon**. In 1832, he traveled up and down the

Facing page: 2.3 John James Audubon. *Study of Four Florida Rats,* ca. 1832. Woodcut on paper, 27 5/8 x 24. Courtesy The Cummer Museum of Art & Gardens.
A romanticized view of Florida rats.

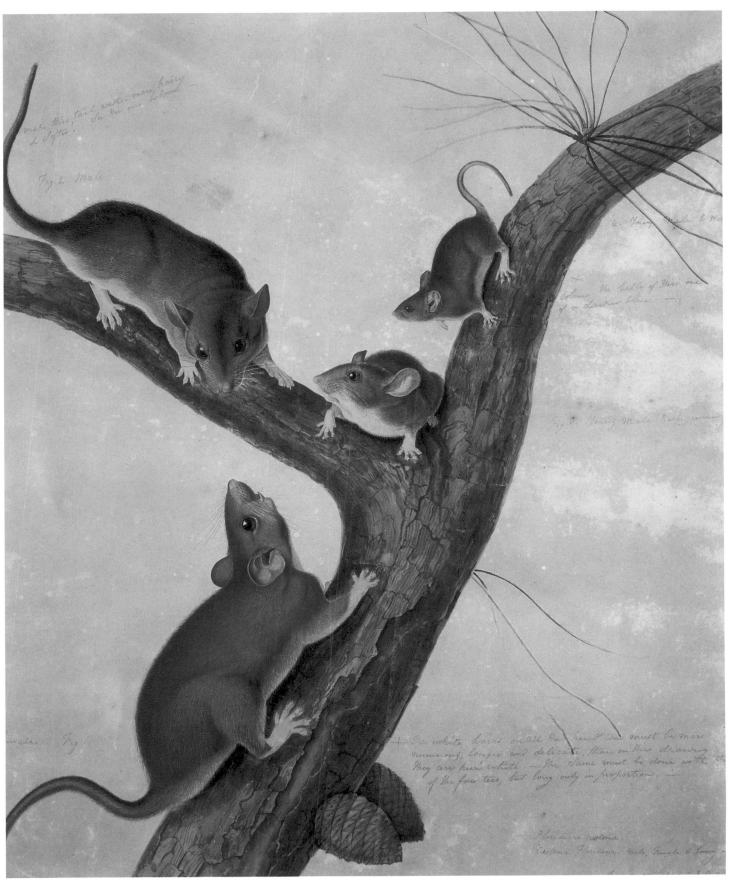

eastern coast of Florida and down into the Keys. One of our most important early visitors, Audubon used the picturesque qualities of Florida in his art. After Mark Catesby, Audubon is the most important chronicler of Florida's birds and animals. His legacy added a new dimension to the art of Florida because his drawings of birds and animals show them in their natural habitats. An understanding of Romanticism is necessary to fully appreciate Audubon's perspective. The chief characteristics of the romantic movement were an emphasis on emotion and individual expression and, according to the English poet William Wordsworth, a spontaneous overflow of powerful feeling. A romantic who led an extraordinary life, Audubon revealed his own generally anthropomorphic point of view in the birds and animals he portrayed.

After his early schooling, Audubon evaded formal education in favor of rambles in the countryside, during which he collected "curiosities." His goal in life was to produce a magnificent new work, a complete and faithful record of all the species of birds of North America. To achieve the utmost veracity in his work, he would place a freshly killed bird on a board and paint it as quickly as possible before the colors faded. He also documented

2.4 John Havell after John James Audubon. *Great White Heron,* Plate CCLXXXI, 1835. Aquatint, 25 1/2 x 38. The Roger Houston Ogden Collection, New Orleans, Louisiana.
 Note the view of Key West in the background, painted separately by George Lehman, a Swiss landscape painter who accompanied Audubon to the island.

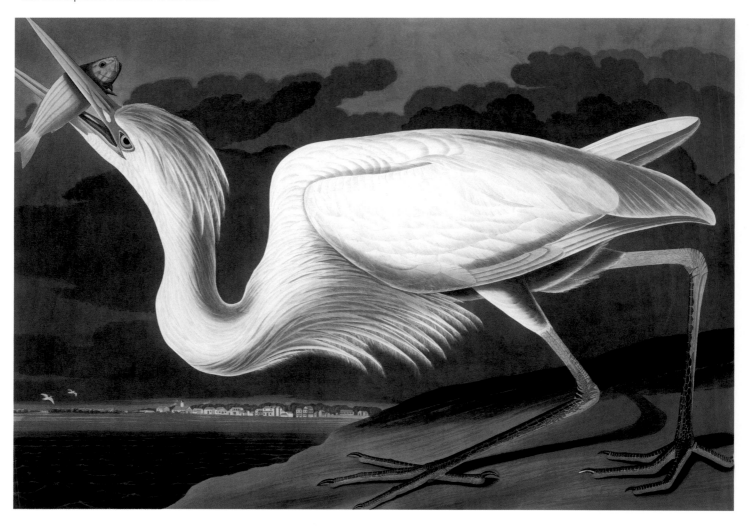

many small animals in similar fashion. A fine example of his treatment can be seen in *Study of Four Florida Rats* [Pl. 2.3], circa 1832. There is a detailed handwritten description for the engraver and colorist for the male, female, and young. It is signed and dated "Nov. 30, 1841."

Audubon visited Key West briefly in 1832. In his *Birds of America*, published sequentially between 1831 and 1838, he included what he called the Key West pigeon, though it is actually a dove. The detailed background painting of Key West in *Great White Heron* [Pl. 2.4] (Plate CCLXXXI) was done separately on May 26, 1835, by **George Lehman**, a Swiss landscape painter who accompanied Audubon and contributed many of the landscape backgrounds for the Southern paintings.

While George Lehman was in Key West, inspired by stories of pirates, he created *The Pirate's Well—Key West* [Pl. 2.5], n.d., graphically portraying an imaginary scene of pirates. Their ship can be seen offshore in the distance. Lehman went on to become an important aquatintist and designer for engravers. He later formed the print-publishing firm of Lehman and Baldwin in Philadelphia.

Audubon was deeply involved in the development of his prints. After some difficulty with his original printer, he chose Robert Havell Jr., a London engraver whose skills in finishing and elaborating Audubon's compositions made him the perfect collaborator. Apparently, Audubon had especially strong feelings about how Havell and his assistants should treat the sky and background detail during the hand-coloring process. "Amend this rascally sky," he noted on one painting; on another, "finish this ground better"; on still another, he advised them to add "an old rotten stick."

Among Audubon's more dramatic compositions of Florida birds are the *Brasilian Caracara Eagle* (Plate CLXI), *The Booby Gannet* (Plate CCVII), *The Florida Cormorant* (Plate CCLII), *The Hooping* [sic] *Crane . . . View in the Interior of the Floridas with Sand Hills in the Distance* (Plate CCLXI), and *The Frigate Pelican* (Plate CCLXXI).[5]

Although Audubon's name has become synonymous with wildlife conservation, he killed for sport and amusement as well as for his art. He considered it to be a very poor day's outing in Florida if he shot fewer than a hundred birds. From St. Augustine he wrote: " We have drawn seventeen different species since our arrival in Florida, but the species are now exhausted and therefore I will push off. . . ."[6] In Audubon's defense, it should be pointed out that during the same period in Florida's history, the supply of these species seemed limitless, and many others treated the animals similarly.

Audubon is the most famous artist known to have visited Key West until after the Civil War. (It is possible that other artists visited, especially in 1849 and just after, as there was much traffic through Key West by those en route to California during the Gold Rush, but they left no record and no art to note their passing.) In the meantime, other events changed the character of the isle. Running

2.5 George Lehman. *The Pirate's Well—Key West*, n.d.
Lithotint on paper, 5 5/8 x 9 1/2. Courtesy Monroe County
Library.
 An imaginary scene of a pirates' den.

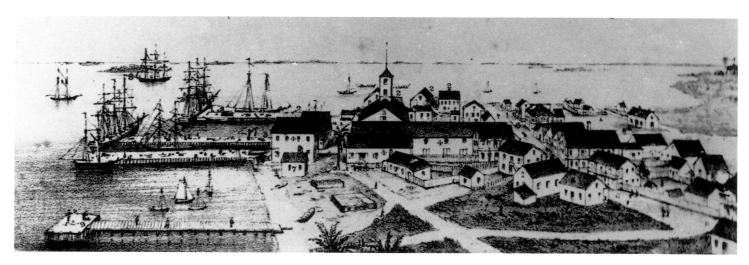

2.6 W. A. Whitehead. *The Business Part of Key West*,
1838. Woodcut on paper, 4 x 10. From *Key West, the Old
and the New* by J. Carter Brown. Courtesy Monroe County
Library.
 This print shows the growth of commerce in Key West.

2.7 Frank Hamilton Taylor. *A Night in Key West,* 1880. Black-and-white brush drawing, 7 x 9 3/4, university gallery purchase DR-83-29. Courtesy The Harn Museum of Art, University of Florida.

Another triumphant entrance for President Grant.

aground on the reefs was one of the greatest dangers facing newcomers to the area. Key West profited by making the salvage of wrecked ships a regulated industry. Between 1832 and 1855, the town's population grew from five hundred to twenty-seven hundred. In **W. A. Whitehead's** illustration, *The Business Part of Key West* [Pl. 2.6], 1838, it is clear that the town had progressed sufficiently to encompass its own area of commerce. Most of the new residents were New Englanders or English Bahamians, almost all of whom were involved in maritime salvage. It was an educated and colorful group on this tiny island far from mainland America: the men wore silk top hats, and the ladies served suppers on fine china and, on occasion, on gold plates. All of this wealth was the result of shipwrecks. By the late 1850s, the construction of the first of six reef lighthouses signaled an end to the wrecking industry's profitability.

The two great fires of 1859 and 1886 destroyed Key West. New wealth now came from sponging, followed by a new industry, cigar manufacturing, which resulted in the construction of factories employing thousands. This period of prosperity ended when the cigar makers moved to Tampa. Before the riches of Key West were relocated, the area had also attracted an American president, Ulysses S. Grant, whose visit was documented with drawings and articles by **Frank Hamilton Taylor**, an artist and writer who

traveled with the president. *A Night in Key West* [Pl. 2.7] shows the pageantry that accompanied Grant's visit. (See chapter eight for more on Taylor.)

Well before Florida achieved statehood, another region of early development was north along the Gulf of Mexico. Cotton farming and trade brought settlers from the northern states. **George Washington Sully**, a nephew of Thomas Sully, the famous American portraitist, was a cotton broker by vocation and an artist by avocation. One of seven children, he was born in Norfolk, Virginia, and moved with his family into the gulf area of Florida in the early 1820s, shortly after the territory was purchased by the United States. It is not known whether Sully received art lessons from his famous uncle or whether his talent was innate, but he is the first artist known to have grown up in the state. Many sketches in watercolor and pen and ink remain to demonstrate his skill; they also present Sully's unique point of view—albeit somewhat naive—which adds to their interest.

Sully made a short visit to Bermuda in 1829, but from that time until 1834 he lived in Magnolia, a small community on the St. Marks River just south of Tallahassee. Titles or comments appear on most of his watercolors. For example, one watercolor has the notation "This is the Cottage of Content/Pensacola 1834" and is dated and signed "W. Sully" on the back [Pl. 2.8].[7]

Another of Sully's sketches is of an Indian, *Hix Chijo* [Pl. 2.9]. Painted in 1834, it has a notation by the author: "Painted these rascals in Pensacola, Florida/August 1834/GWS." It is worth noting that Sully was only eighteen at the time. The town of

2.8 George Washington Sully. *This is the Cottage of Content/Pensacola*, 1834. Watercolor on paper, 3 3/4 x 6 1/4. Courtesy Special Collections Department, John C. Pace Library, University of South Florida.

Sully is the first known Florida artist to grow up in the state.

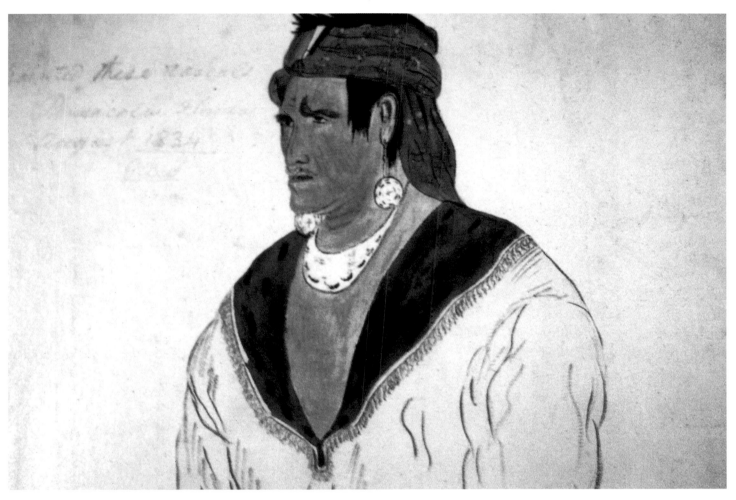

Magnolia still exists today but is accessible only by boat. When he married in 1839, Sully depicted his bride's home, where the wedding was held, and also the house they occupied afterwards (the "Cottage of Content" mentioned above). His wife, Julia Meigs Austin, died two years later in New Orleans after the birth of their daughter. Many of Sully's watercolors are in Special Collections in the John C. Pace Library at the University of West Florida. Other works are held by private collectors. ❧

2.9 George Washington Sully. *Hix Chijo,* 1834. Watercolor on paper, 6 1/4 x 9 1/16. Courtesy Special Collections Department, John C. Pace Library, University of South Florida.
 Sully was eighteen years old when he painted this Native American in Pensacola.

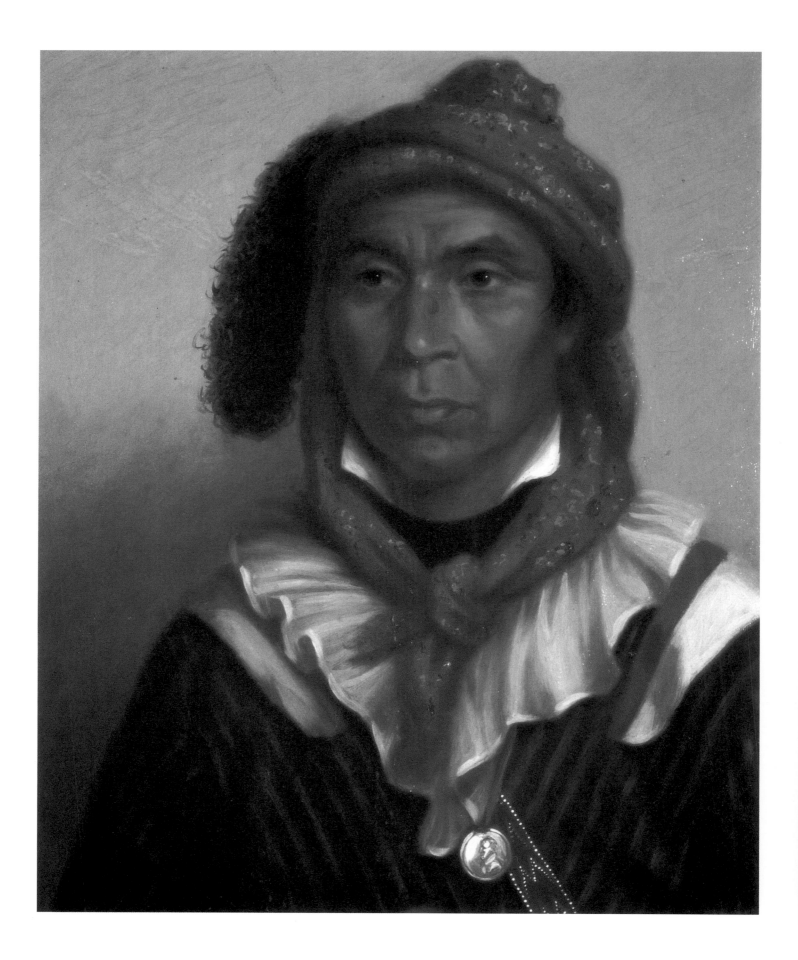

The Seminoles

THE SEMINOLES BECAME THE SUBJECTS favored by artists after the following series of events that intrigued the nation. In the 1820s and 1830s, **Charles Bird King** painted many of the Native Americans who came to Washington, D.C., to negotiate treaties with President Andrew Jackson, who pursued a broad policy of extinguishing Indian land titles in states and in removing the Indian population to the territories. Among them were eight Seminole chiefs whose portraits were reproduced in 1842 as lithographs by **J. T. Brown**. All of King's original portraits except one, *Portrait of Tulceemathla, A Seminole Chief* [Pl. 3.1], 1826, were destroyed in a fire at the Smithsonian Institution in 1865. Fortunately, Brown's lithographs after King's Seminole chiefs were made soon after the original portraits. The images remain strong and colorful.

Andrew F. Cosentino, a biographer of Charles Bird King, described the portraits of the Seminole chiefs and the lithographic reproductions in *Indian Tribes of North America*:

> [These are] handsome illustrations and informative and engaging biographies, all tinged with an underlying Romantic sense of wonder and presentiment about the nature and fate of the hapless Red Man. . . . Although King could hardly have wished for a more desirable means by which to be ushered into posterity, it is ironic to recall that his father was killed by Indians. . . . King, as is evident in the profound sympathy with which he portrayed his Indian subjects, harbored no animosity toward them.[1]

As more settlers moved into the northern part of Florida, an economy like that of the rest of the South developed, with cotton and tobacco as the chief crops. The population gradually moved

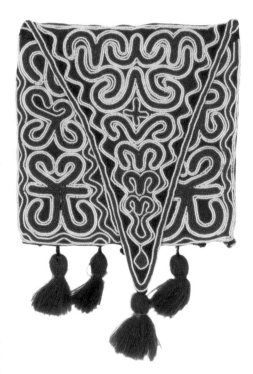

Detail of Plate 3.9

Facing page: 3.1 Charles Bird King. *Portrait of Tulceemathla, A Seminole Chief*, 1826. Oil on panel, 16 1/2 x 13 1/2. Courtesy Lowe Art Museum, University of Miami, Coral Gables, Florida.
This is the only original King painting left after the fire in 1865 at the Smithsonian Institution.

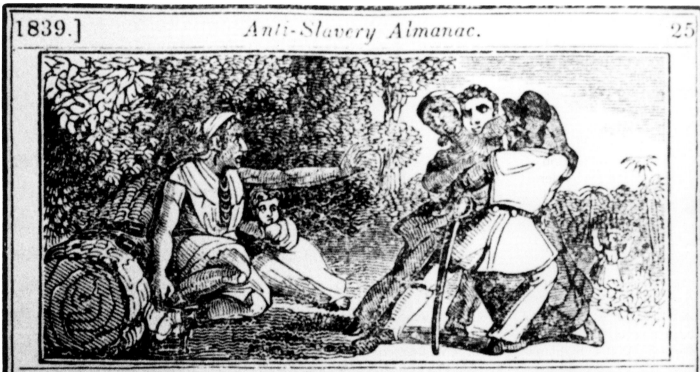

1839.] *Anti-Slavery Almanac.* 25

THE NATION ROBBING AN INDIAN CHIEF OF HIS WIFE.

When monarchical Spain governed Florida, many slaves fled thither from republican oppression, and found shelter. One of them, having married an Indian chief, their FREEBORN daughter became the wife of Oceola. She was seized as a slave, in 1835, by a person, (who had probably never seen her,) holding the claim of her mother's former master. Oceola attempted to defend his wife, but was overpowered and put in irons, by General Thompson, (our government agent,) who commanded the kidnapping party. What marvel that an Indian Chief, as he looked on his little daughter, and thought of his stolen wife, vowed rengeance on the robbers?

3.2 Anonymous. *The Nation Robbing an Indian Chief of His Wife,* 1839. Woodcut on paper, 2 1/2 x 4 5/8. From the Anti-Slavery Almanac 1839. Courtesy Library of Congress Collections.

southward, displacing many of the Seminoles, just as earlier Florida settlers had displaced the original native inhabitants.

Many of the indigenous Florida Indians were annihilated by 1706, their large tribes killed, driven into exile, or taken as slaves to Carolina by English raiders. The result was that the interior of Florida was virtually deserted by the early eighteenth century. Creek Indians from Georgia and Alabama, ancestors of the modern Seminole and Miccosukee people, moved down into Florida. Later runaway African slaves joined the Native Americans and very likely influenced their culture.[2]

The history of the Seminoles, the Native Americans who occupied most of central Florida in the eighteenth century, is complex. During the British and Spanish tenures in Florida, the number of Seminoles remained constant despite persecution, but the Americans did not tolerate their presence. In 1819, after President John Quincy Adams accused Spain of aiding and abet-

ting those hostile to the United States, Spain renounced all claims to West Florida and ceded East Florida. Afterwards, settlers poured into Florida and began to displace the Seminoles.

After Florida became a territory, efforts to remove the Seminoles increased, precipitating the Seminole Wars. When Andrew Jackson became president in 1829, proposals for general removal of the Native Americans were instituted. Jackson's history of opposition to Native Americans dated back to 1818, when he marched into Florida and seized St. Marks and Pensacola, both belonging to Spain. The attack was motivated both by the perceived Seminole threat to the Georgia border and by the Seminoles' offering refuge to slaves. In his inaugural address, Jackson proclaimed a "just and liberal policy" toward the Native Americans. Nothing could have been further from the truth. Instead, Jackson's policy was to remove the Native American population and to extinguish their land titles. Reservations were established in the West to accommodate the Seminoles, but their resistance to relocation became stronger.

Osceola was a strong leader of Seminole resistance against the whites. Born in Alabama around 1804, he denied having white blood. However, his lineage has been traced back to trader James McQueen, a Scottish highlander. Osceola's mother, Polly Copinger, a Creek of the Tallahassee group, was McQueen's granddaughter and the wife of a white trader named William Powell. Osceola was their only child. His tall, erect stature and expressive countenance showed his pride. In his dealings with whites, Osceola was proud to the point of arrogance. Although he was not a chief and, according to Native American custom, had no voice in the councils of his tribe, his natural leadership ability soon asserted itself.

The unfair treatment of Osceola's wife, Morning Dew, was one of the main reasons for his open hostility toward whites. Her mother was the daughter of a Native American chief and a slave. This gave Morning Dew the status of "free-born." Although the couple was married long enough to have four children, Morning Dew's trace of African blood gave white settlers an excuse to carry her off as a slave. She was seized as a slave by a person holding the claim of her mother's former master. Osceola never forgave the whites for what he considered an insult to both his people and himself.[3] The incident was pictured in *The Nation Robbing an Indian Chief of His Wife* [Pl. 3.2] and written about in the *Anti-Slavery Almanac*, 1839.[4]

Osceola became the most successful leader of the Seminole resistance. When the Second Seminole War broke out in November 1835, Osceola led the fight against Andrew Jackson's plan to move the tribe to the West. He was captured by the whites under a false flag of truce and was eventually moved to Fort Moultrie, an island off Charleston, South Carolina. Already in poor health from repeated bouts of malaria, he died there. His capture made Osceola famous, securing his place as the most romantic figure of the Second Seminole War.[5]

One admirer of Osceola was **George Catlin**. Although Catlin had studied law, he established himself as a miniaturist in Philadelphia

during the period 1820 to 1825. He worked in New York state from 1825 to 1829. In this era, the National Academy of Design was the recognized authority for art in the United States. Artists eagerly sought the title of academician, or even associate, of the academy because of the weight these titles carried; to have one's art accepted for an exhibition was a great honor. Although it had a small and shaky start, the organization came to dominate the art world in New York City throughout the latter part of the nineteenth century. Catlin was a founding member of the National Academy of Design, which was established in 1826. (The title "member" meant that the artist was a full academician with the highest ranking.)

Catlin saw Native Americans for the first time in Philadelphia. Fascinated, he was motivated to go west in 1832 to record the Native Americans' lives before they disappeared "to the shades of their fathers, toward the setting sun."[6] Catlin went to Fort Moultrie in 1838 to paint Osceola, who proved to be a handsome, dignified man in exotic clothing. Catlin wrote of this experience:

> Os-ce-o-la, commonly called Powell . . . is generally supposed to be a half-bred, the son (grandson) of a white man . . . and a Creek woman. I have painted him in the costume, to which he stood for his picture, even to a string and a trinket. . . . This young man, is no doubt, an extraordinary character . . . some years reputed, and doubtless looked upon as the master spirit and leader of the tribe, although he is not a chief.[7]

Catlin's painting of Osceola [Pl. 3.3] emphasizes his facial features and rich clothing. Catlin also depicted some of the other tribesmen. A number of Catlin's sketches, dated 1859,[8] are replicas from his own 1838 originals (for example, *A Seminole Woman* [Pl. 3.4]), sold to the public because of his financial needs. According to the David Ramus Gallery, the "album" that this group comes from was one of eleven albums created by Catlin in England between 1852 and 1868 to raise money.[9] Catlin was also in Florida during the winter of 1834–1835. With his ailing wife, Clara, Catlin visited his brother in Pensacola, where he painted a series of landscapes and genre paintings depicting Seminole life.

By the mid 1830s, with the threat of hostile attack fading along the East Coast, Americans had begun to accept Rousseau's theory of the noble savage and thus saw Osceola as a tragic figure. Fashionable members of Charleston society constantly visited Fort Moultrie to see Osceola in captivity until his death. Other artists also found Osceola's story interesting and either copied Catlin's piece or visited the fort. One of these artists was **Robert J. Curtis**, who had studied art in Philadelphia under John Neagle. In January 1838, at the Apollo Gallery in Charleston, South Carolina, he too exhibited a portrait of Osceola (now in a private collection).[10]

Osceola's clothing, as portrayed by Catlin and others, created great interest in Native American dress [Pl. 3.5]. Seminole and

Facing page: 3.3 George Catlin. *Osceola, The Black Drink, A Warrior of Great Distinction,* 1838. Oil on canvas, 30 7/8 x 25 7/8. Courtesy National Museum of American Art, Smithsonian Institution. Gift of Mrs. Joseph Harrison Jr.
 Catlin emphasizes the sitter's facial features and rich clothing.

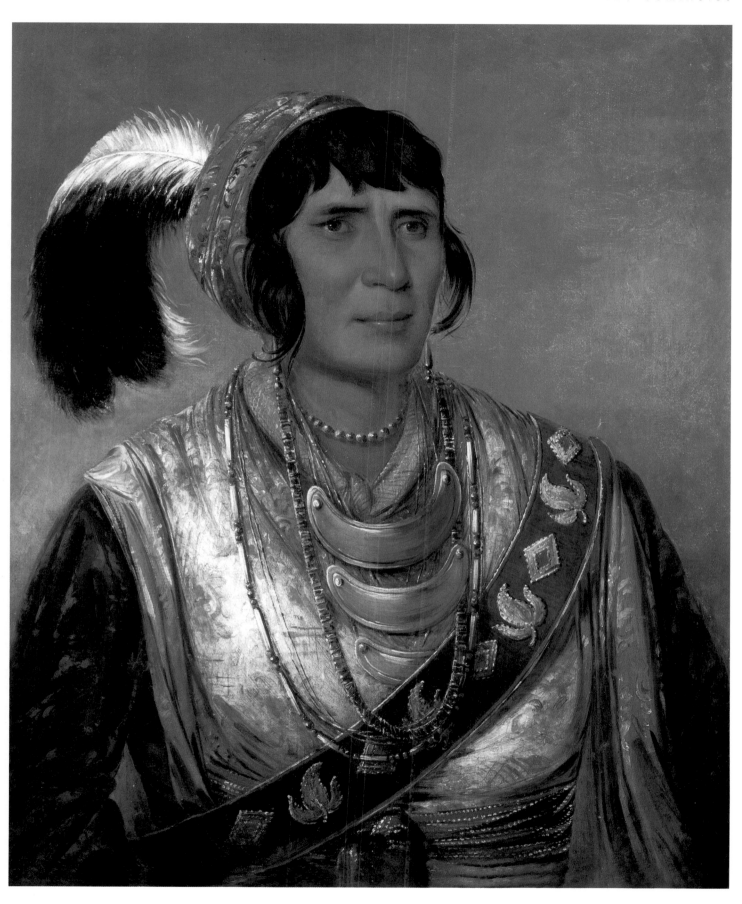

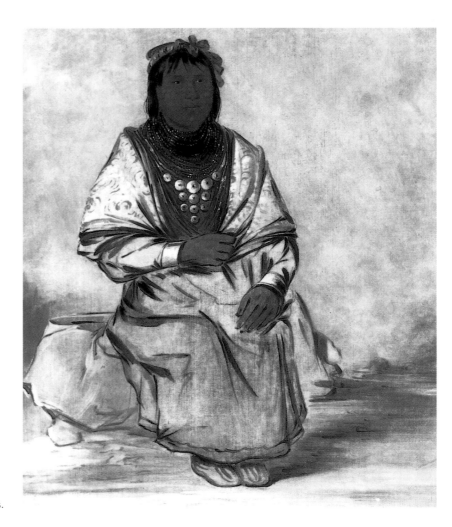

3.4 George Catlin. *A Seminole Woman*, 1838. Oil on canvas, 29 x 24. Courtesy National Museum of American Art, Smithsonian Institution. Gift of Mrs. Joseph Harrison Jr.
 One of a series of Catlin's paintings of Seminole lifestyles.

Miccosukee tribes had always made their clothes, tools, and everyday items with painstaking care. In the eighteenth century, European ready-made products such as commercially manufactured glass beads, wool and cotton cloth, tailored shirts and coats, metal cooking pots, and tools quickly began to replace traditional handmade clothes and wares. The new goods changed both the way the Native Americans dressed and their views of capitalism.[11]

Men's and women's clothing was greatly altered in the nineteenth century. A full-length portrait of Tukose Emathala [Pl. 3.6], a Seminole chief, by Charles Bird King exemplifies these changes in detail. He wears a scalloped and embossed headband of silver, as well as arm and wrist bands. A medal bearing a portrait of the president, along with his silver gorget, is suspended on his chest. The bottom of his coat is decorated with rows of sawtooth designs and straight-line appliqué. The presence of these new designs shows that Seminole women had learned the technique of patiently sewing them onto clothing.[12] These skills may have been learned from slave women of African origin, who became members of the Seminoles. The many patterns in Seminole clothing were careful and artistic.

In the introduction to *Art of the Florida Seminole and Miccosukee*

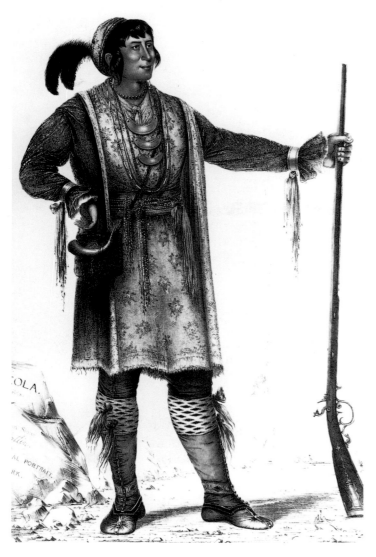

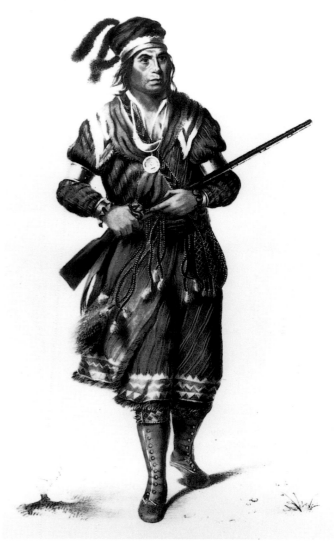

3.5 George Catlin. *Osceola*, 1838. Oil, 28 1/4 x 23 1/8.
Courtesy American Museum of Natural History, Department of
Library Services.
 Catlin's portrayal of Seminoles created a widespread
interest in Native American dress.

3.6 Charles Bird King. *Tukose-Imathla,* 1826. Lithograph
after King from the McKenney-Hall Portrait Gallery of
American Indians, 19 1/2 x 12 1/2. Courtesy National
Anthropological Archives, Smithsonian Institution.
 Note the shoulder bag with embroidered strap, the
hand-sewn designs, and the metal ornaments.

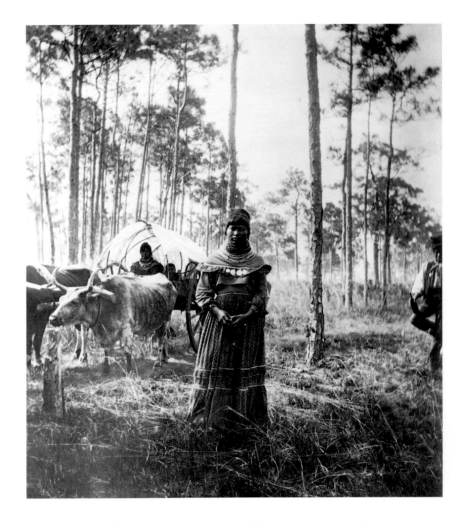

3.7 Woman with Oxcart, ca. 1890. Photograph by Dr. Charles Barney Cory Sr. Courtesy National Anthropological Archives, Smithsonian Institution.
 Note the hairstyle, massive beads around the neck, and patchwork on the skirt.

Indians, Dorothy Downs suggests: "Art is considered to be those products which man has created as a result of the application of his knowledge and skills according to the canons of taste held as artistic by his culture."[13] For the tribes we have been discussing, art was a part of daily life. Although these Native Americans are not indigenous to Florida, they have been here longer than almost any other people who claim longevity in Florida, and they have greatly contributed to the art history of Florida.

Although reduced in number by the Seminole Wars and the forced relocation policy, the Seminoles were never eliminated. Approximately two hundred Native Americans and a few blacks were left in south Florida after 1858; they sought refuge in wilderness clan camps as far removed from the whites as possible. Because of their isolation, which lasted from 1858 to around 1880, virtually nothing was known about their dress or any other aspect of their culture during that period.[14]

In 1879 Lt. Richard Henry Pratt was assigned by the acting commissioner of the U.S. Bureau of Indian Affairs to investigate the number of Seminoles in Florida and to assess how best to "provide for the relief of the Indians and educational facilities for their children,"[15] according to Downs. About three hundred Native

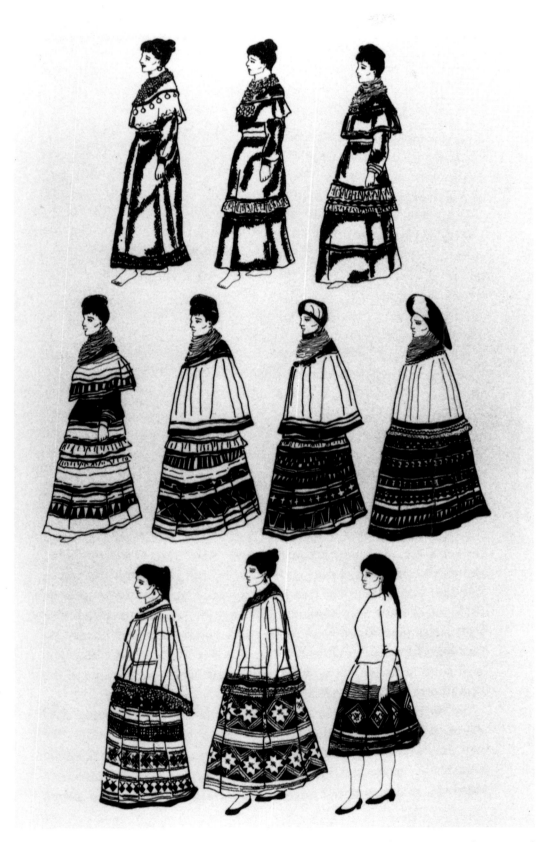

3.8 Changes in Seminole women's dress and hairstyles through the decades, 1880–1990. Courtesy Library of Congress, Prints and Photographs Division.

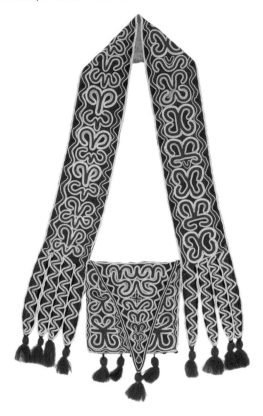

3.9 Anonymous. Bandolier Bag (Creek or Seminole), mid-nineteenth century. Red stroud, blue cotton cloth, blue/white glass beads, 30 1/2 x 19 3/4. Courtesy Lowe Art Museum. Museum purchase, 88.0052.

3.10 Bead-embroidered Sash (Seminole), nineteenth century. Wool and cotton cloth and glass beads, 25 5/8 x 4 1/2. Courtesy Lowe Art Museum. Museum purchase, 88.055.

Americans were found, but they had become very independent and did not want assistance. However, Pratt described their typical mode of dress. The men wore "the usual breech clout, a calico shirt ornamented with bright strips of ribbon, and a small shawl of bright colors wrapped around the head like a turban. The legs and feet are usually bare, but on occasion they wear . . . moccasins ornamented with strips of ribbon or cloth of bright flashy colors." The women wore short jackets and skirts of calico, and their feet were bare [Pl. 3.7]. "Cheap beads, large and small, of all colors are piled up in enormous, fagging quantities about their necks. The hair of the old women is done up in a conical shape on the back of the head. . . ."[16]

The Reverend Clay MacCauley reported to the Smithsonian Institution in 1887 that a principal Seminole wife "had six quarts [of beads] gathered around her neck, hanging down her back, down upon her breasts, filling the space under her chin and covering her neck up to her ears. It was an effort for her to move her head."[17] The changes in Florida Seminole women's dress from 1880 to 1990 are illustrated in Plate 3.8.

The economic stability of the Seminoles was endangered several times at the beginning of the twentieth century, so by 1920 their artistic traditions had seriously declined. They were rescued by the arrival of new settlers and tourists who wished to see Florida's exotic Native Americans and to acquire examples of their art. Beaded items were popular purchases (and remain so). Before the introduction of European glass beads, traditional hand-drilled beads of bone or shell were often traded across great distances. Glass beads, first presented to the Native Americans by Columbus' men, won instant approval. As late as 1970, the tradition of making beads into necklaces with a netlike design continued because of the creativity involved in color and pattern selection and because these items were inexpensive and sold well. Hand-embroidered beadwork was created beginning in the 1820s, but because it was used primarily in breechcloths and leggings, few examples have survived. The creation of loomed beadwork, however, has been an

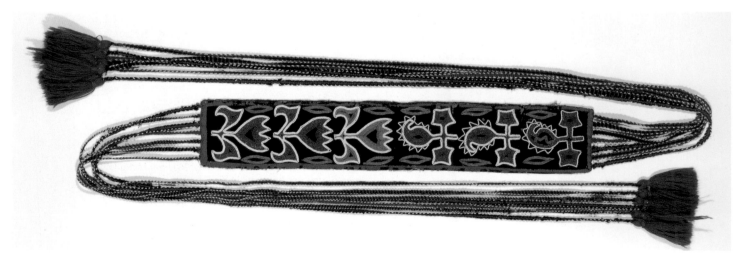

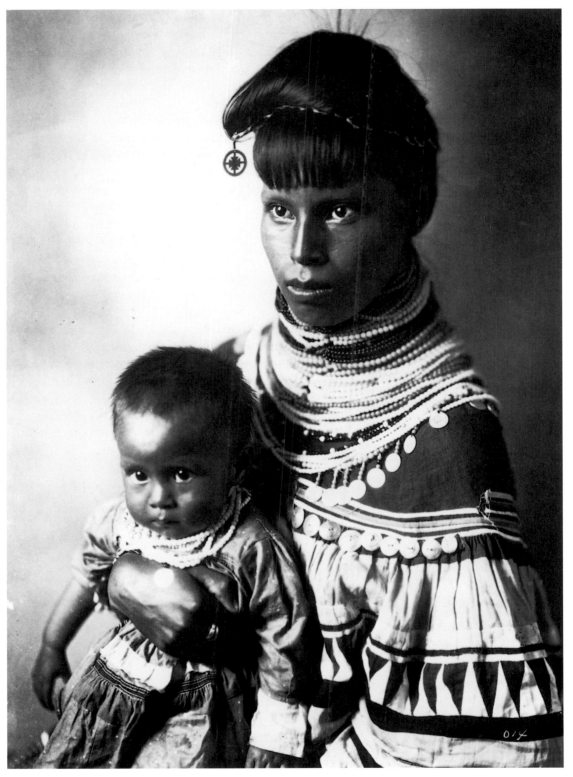

3.11 Alice (Willie) Osceola, wife of William McKinley
Osceola, and her daughter Mittie, ca. 1917–19.
Photograph by Frank A. Robinson. Courtesy National
Anthropological Archives, Smithsonian Institution.
 Alice Osceola was probably the first Seminole woman to
wear a row of patchwork on her dress.

ongoing tradition since the late nineteenth century. Museum exhibits provide numerous examples such as the bandolier bag[18] [Pl. 3.9]. These shoulder bags, worn by men only, were decorated with embroidered straps whose designs were of the owners' richly artistic cultural heritage. Another example of Seminole beadwork is the richly designed bead-embroidered sash [Pl. 3.10].

As in many native cultures, Seminole artistic traditions were most often practiced by women, since men were regarded as providers. Women made the clothing in which the beadwork decoration was the culture's primary form of artistic expression. Later, particularly after the introduction of the sewing machine, women also developed the patchwork clothing that is now recognized as a great artistic accomplishment. The photograph of Alice Willie [Pl. 3.11], who became Mrs. William McKinley Osceola, shows her wearing a row of patchwork on her dress; she may have been the first to do so. Seminole women also revived and improved traditional basketmaking, designing exquisite creations.

Seminole arts and crafts include what might be considered men's work: silverworking, chickee building, and woodworking. Seminole men continue construction and wood carving of animal or bird figures, as well as large numbers of inexpensive wooden toys, for the tourist trade. In traditional Seminole society, men also constructed the chickee, an open-sided,

3.12 Anonymous. Seminole Dolls, ca. 1937. Fabric and palm fiber, 12 inches high. Courtesy Collection of the St. Petersburg Museum of History.
Conceptual simplicity and clever integrity in depicting tribal dress. The doll on the far left in the red hat is identified as "Conopatchee Osceola, Seminole Indian."

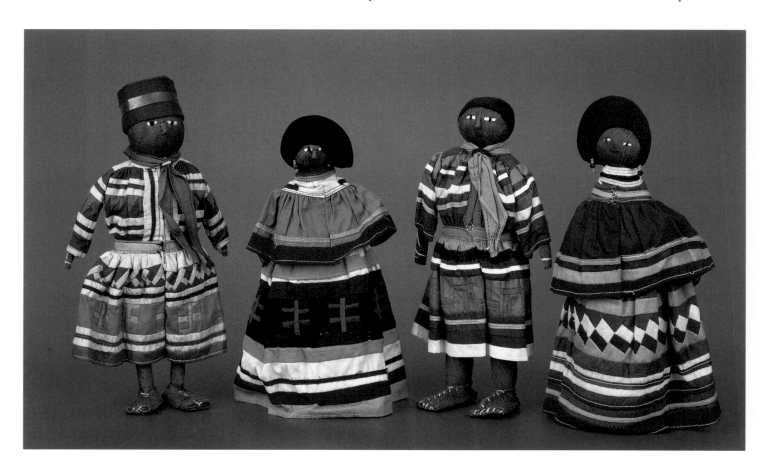

palmetto-thatched dwelling cleverly designed to accommodate life in Florida's warm climate. Many consider the chickees to be works of art; however, they are almost out of use. Like canoes, totem poles, and other Seminole traditions, they are rarely made today.

In the early twentieth century, basketmaking almost died out, but renewed interest was sparked by Episcopal deaconess Harriet Bedell, who began working with the Seminoles in 1930. The techniques she learned were passed down through her family. Today only a few Seminole artisans continue the art of basketweaving; although they win many prizes for their work, the future of this craft is uncertain because the young people have little interest in it.

Seminole palmetto fiber dolls were first marketed in the 1930s. Noted for their simplicity of design and their authentic depiction of traditional Seminole dress, they remain extremely popular. A group of the dolls from the 1930s can be seen at the St. Petersburg Museum of History [Pl. 3.12]. The bodies are made from palm fiber, and the costumes from brightly colored machine-sewn cotton. The doll on the far left in the red hat is identified as "Conopatchee Osceola Seminole Indian."

Although the Seminoles also made pottery, this tradition ended when they learned that the white man's iron pots were better for holding liquids. Ongoing studies continue to trace the history of this art.

The evidence of ceremonial objects from the Mississippi culture suggests that the Southeastern Native Americans were skilled in metalworking before the arrival of the Europeans. Silver was rarely used until the Spanish began introducing small amounts of it in the sixteenth century. European silversmiths worked among the Creeks, Seminoles, and other woodland Indian groups in the late eighteenth century. Seminole silversmiths were most productive during the nineteenth and into the early twentieth century. Silver was obtained by melting down coins of small denomination but with high silver content. As exhibited in the lithograph of Tukose Emathala [Pl. 3.6] and the paintings of Osceola [Pls. 3.3 and 3.5], Native American leaders' complete regalia included metal ornaments. In the full-length picture of Osceola by Catlin [Pl. 3.5] , we can see that he wore three silver gorgets, earrings, and thin silver bracelets tied to his wrists with ribbons or thongs. Silverworking died out in the 1930s, possibly because of the shortage of coin silver during the Great Depression, which also reduced the number of customers. However, some Native American artisans continue the tradition. The Miccosukee tribe has recently started offering jewelry-making classes, and promising work is being done by its student artists. ❧

Statehood and Development

WE KNOW LITTLE ABOUT the artists of this period before the Civil War. An oil painting titled *Public Square, St. Augustine*, circa 1845, by **Collins** (first name unknown) provides one example. Another early visitor to St. Augustine was **George Harvey**. Born in England, he came to the United States at the age of twenty. After establishing himself as an artist, he returned to England for further study before resuming his career here. He exhibited his work at New York's National Academy of Design from 1828 to 1847, winning the title of Associate Academician. Around 1833, Harvey built a home near Hastings-on-Hudson, New York, close to Washington Irving's home, Sunnyside. Here he began his notable series of "atmospheric views" of American scenery, intending to have forty engraved and published for subscription. He traveled widely to find the most desired vistas, several of which were in Florida. One untitled oil painting depicts a sunrise over the Fort Marion green. The others are *St. Augustine Plaza* [Pl. 4.1] and *Everglades, Florida.* In *Scene of the Florida Keys* [Pl. 4.2], Harvey conveys the sense of vast distance by using a fig- ure who looks at the horizon through binoculars. A painting formerly called *Rice Fields in the South* and now titled *White Pelicans in Florida* [Pl. 4.3] is signed and appears to be dated 1823, but 1873 seems more likely. Harvey's first mention of Florida was in an 1857 letter to John Eliot Howard, which began, "During my rambles in Florida . . ." A description of the painting followed: "The yellow sun, breaking through gray clouds, casts shafts of light on the blue-gray water, pale green mangrove shrubs and palm trees. White pelicans on yellow sand . . ."[1] *Scenes of the Primitive Forest of America at the Four Periods of the Year* was the only part of the series that was published. The project eventually failed because of insufficient subscriptions. The works that survive show a delicacy of touch and precision.

Detail of Plate 4.8.

4.1 George Harvey. *St. Augustine Plaza,* 1851. Oil on canvas, 17 x 28. Courtesy The National Society of the Colonial Dames of America in the State of Florida.
A contemporaneous view of the plaza in St. Augustine.

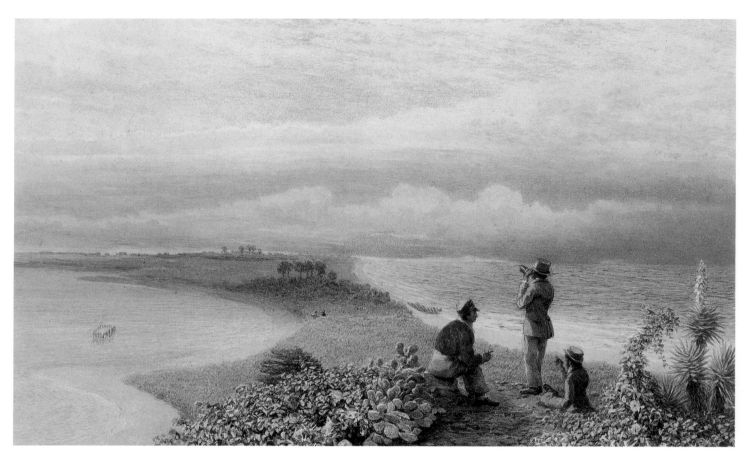

4.2 George Harvey. *Scene of the Florida Keys,* n.d. Woodcut on paper, 9 x 15. Courtesy Eckert Fine Art, Naples, Florida.

Harvey conveys the sense of vast distance.

In a letter dated April 28, 1843, William Cullen Bryant, who was visiting Florida, wrote, "The country is in profound peace from one end to the other."[2] Two years later, when Florida gained statehood, the Seminoles were evicted from Silver Springs after a landowner named James Rogers purchased eighty acres surrounding the area from the U.S. government, paying $1.25 an acre for underwater property as well as for dry land. Marion County, named in honor of General Francis Marion of Revolutionary War fame, was created about the same time. One year later, the settlement of Ocala, six miles west of Silver Springs, was selected as the county seat. By 1850, Ocala had grown to include three stores, a post office, a small hotel, and dwellings for about fifteen families. There was also a courthouse " . . . used for a church, public meeting hall and town library. The village even had its own newspaper."[3]

As the population of the United States began to grow, many people were drawn to Florida for its climate and, in particular, to Silver Springs for its healing waters. Silver Springs also began to develop a transportation and distribution center for central Florida's new settlers. At first, few made the trip by water, which was long and arduous. The stage line offered little improvement. In 1855, Lady Amelia Murray, a lady-in-waiting to Queen Victoria, visited Silver Springs by stage, or in her words, "in a bumping, bare mail carriage."[4] The journey from Jacksonville took fifteen hours. The beauties of the springs consoled her somewhat, but she found the accommodations at Ocala and

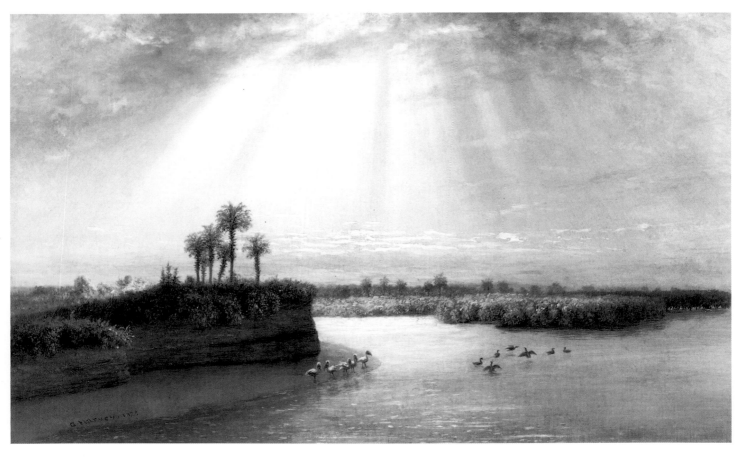

Silver Springs primitive. The Seminole uprising of 1855–1858 required that the stage line have a military escort. When the Indian attacks ceased, occasional visitors and sightseers returned.

Hubbard L. Hart, a Vermont man who had established the stage line, saw possibilities for commercial development. Steamboat traffic was prolific elsewhere in the country—why not in Florida? By 1860, the *James Burt*, a conventional steamboat with an exposed-stern paddle wheel, had completed the first commercial run from Jacksonville to Ocala, which caused a huge celebration. Business was so good that Hart built a second boat, the *Silver Springs*; however, even two boats could hardly accommodate the sightseers who wanted to make the trip. The journey from Jacksonville took two nights and a day, with no resort or fancy hotel at the end of the line, but the alluring beauty of Silver Springs more than made up for the inconvenience. However, the Civil War temporarily put an end to the tourist trade and Hart's dreams. The *James Burt* was lost in the course of the war, and the *Silver Springs* was impounded.[5]

On the Gulf Coast, Tampa's origins can be traced back to 1824, when Fort Brooke was established. The army was appointed to watch over the Seminoles on their reservation in central Florida and to prevent them from receiving arms and ammunition from Cuba or other foreign powers. The fort with the military reservation around it was synonymous with Tampa. By 1834, there were enough residents to create Hillsborough County.[6]

4.3 George Harvey. *White Pelicans in Florida*, 1873. Oil on canvas, 14 x 24 1/8. Courtesy Museum of Fine Arts, Boston, Massachusetts. Gift of Maxim Karolik for the M. and M. Karolik Collection of American Paintings, 1815–1865.

In a letter, Harvey described this painting: "The yellow sun, breaking through gray clouds, casts shafts of light on the blue-gray water, pale green mangrove shrubs and palm trees. White pelicans on yellow sand . . ."

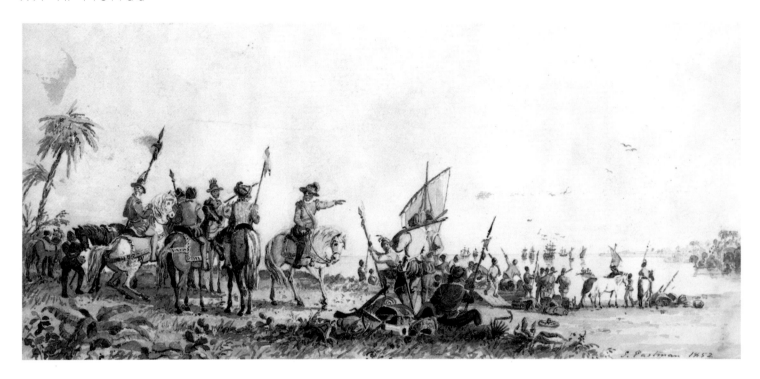

4.4 Seth Eastman. *Landing of de Soto in Tampa Bay*, 1852. Watercolor on paper, 5 3/4 x 10 3/4. Gift of Maxim Karolik. Courtesy Museum of Fine Arts, Boston, Massachusetts.

Eastman, an army officer stationed at Fort Brooke (Tampa), chose to depict a local historical event, and he approaches it from a military point of view.

4.5 Anonymous. *Landing of de Soto in Florida*, n.d. In *Ballou's Pictorial*, Boston, February 17, 1855, vol. 3, no. 7.

An 1855 view of the "noble settlers" and the war-whooping natives.

In 1840, **Seth Eastman**, an army officer and important artist, was stationed at Fort Brooke for two years. Among his paintings of the area are *Landing of de Soto in Tampa Bay* [Pl. 4.4], 1852, and *Encampment of the 1st Infantry at Sarasota, Florida*, 1841. In the former work, except for a few palm trees, all of the action centers on the hopeful conquerors. The scene depicts de Soto's landing at Tampa Bay on May 30, 1539. Under a grant to settle the entire region north of the Gulf of Mexico, de Soto and his party set off on an expedition that yielded little fortune but resulted in de Soto's death. In the Eastman painting of the de Soto landing, the point of view of a military man is paramount. The placement of men and ships is arranged for strategic defense advantage.

Eastman was born in Brunswick, Maine, and attended West Point from 1824 to 1829. Initially he served at forts in Wisconsin and Minnesota, where he was on topographical duty. From 1833 to 1840 he was an assistant teacher of drawing at West Point. He exhibited paintings at the National Academy of Design from 1836 to 1848 and was elected to full membership in 1838. He served in Florida for two years during the Second Seminole War. Although there are Native American subjects in Eastman's work from this period, Eastman showed only one painting of the West, *Indian Burial*, at the National Academy of Design. From 1850 to 1855 he worked on illustrations for Henry R. Schoolcraft's *History and Statistical Information Respecting the Indian Tribes of the United States*. When he finally retired in 1866, he was breveted the rank of brigadier general. For the rest of his career he painted Native American scenes and Western forts for the Capitol building in Washington, D.C.

It is interesting to compare Eastman's 1852 painting of the de Soto landing of 1539 with a depiction of de Soto's first Florida landing in 1513, done by an anonymous artist for an 1855 issue of *Ballou's Pictorial* [Pl. 4.5] Eastman illustrated only the explorers, while

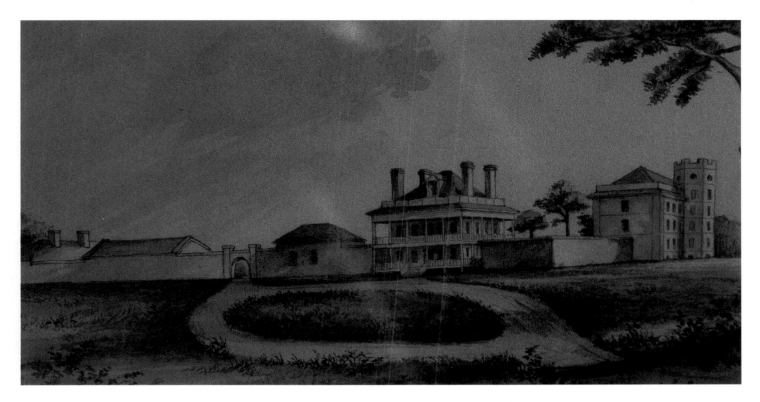

the *Ballou's* picture also shows the Native Americans de Soto encountered. It indicates the nineteenth-century misconception of the natives as war-whooping savages and the settlers as "noble" clearers of the land. Note also that the Spanish explorers look more like eighteenth-century colonists in the *Ballou's* rendition.[7]

Robert Walter Weir, who like Eastman was a drawing instructor at West Point, created a portfolio of twelve drawings of arsenals for the U.S. Army. His only known Florida subject was Chattahoochee Arsenal, located in the Panhandle, in a drawing made around 1850 [Pl. 4.6].

St. Augustine drew more than its share of artists in the 1840s. The old town's public square has been pictured many times. An intriguing, slightly primitive work is by **John Rogers Vinton**, who graduated from West Point in 1817. Vinton's rendition of *The Ruins of the Sugar House* [Pl. 4.7], 1843, depicts some of the trials pioneers faced. In the painting, Chupko surveys the devastation of the Cruger and Depeyster Plantation, also known as the New Smyrna Beach Sugar House. According to the catalog of the Vickers Collection, the painting was made on the site in 1837, during the Second Seminole War. In 1835 Seminole war parties led by Chief Philip had begun attacks on selected plantations located along Florida's east coast. An agreement was reached in 1842 acknowledging boundaries between the settlers and the Seminoles. However, mystery still surrounds the event that inspired the painting. There is a question of whether or not the mill was burned by the Native Americans. The ruins of the sugar mill are still a tourist attraction today. Vinton served in Florida in 1837 and then in Texas, where he was fatally wounded during the Mexican War in 1847.[8]

4.6 Robert Walter Weir. *Chattahoochee Arsenal,* ca. 1850. Wash drawing on paper, 5 3/4 x 9 1/4. Courtesy the McKenna Collection.
One of twelve arsenals Weir drew for the U.S. Army.

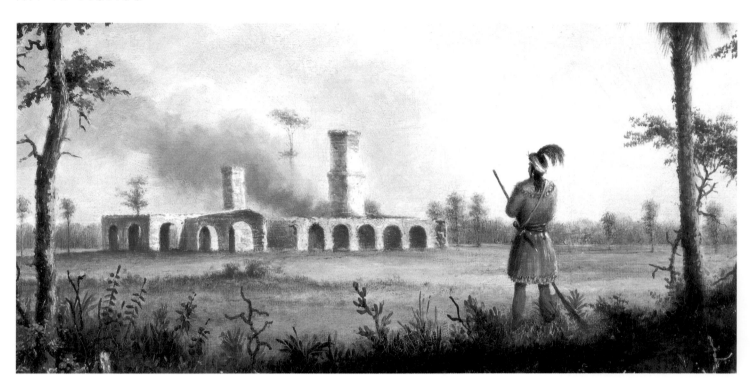

4.7 John Rogers Vinton. *The Ruins of the Sugar House*, 1843. Oil on canvas, 11 x 16. Courtesy of the Sam and Robbie Vickers Florida Collection.
The ruins are a tourist attraction even today.

A number of anonymous paintings, dated but not signed, add to the history of art in Florida. Among them, at the Cornell Museum of Fine Arts in Winter Park, is a view of Pensacola and a Florida landscape dated 1835.

John Bunyan Bristol, a self-taught artist who eventually became a full member of the National Academy of Design, made at least one visit to Florida, in 1859. A number of his paintings of Florida were exhibited at the Academy from 1861 to 1865. The visit to Florida was part of Bristol's travels along the East Coast. As a noted critic, Samuel Isham, observed, "No one constructs a landscape more firmly than he; the solidity of the earth, the level of the lake, the plane of the distant hills, the enveloping of the summer sky with sunlit clouds . . ."[9] *On the St. Johns River* [Pl. 4.8], 1866, is a good example of the sensitivity of his observations. He realistically depicts a domestic scene with parents, children, and wash on the line. Although this prolific artist continued to exhibit at the National Academy of Design until 1909, he never again presented Florida subjects.

The Civil War disrupted development and settlement. When the Civil War began in 1861, **Louis Mignot**, a South Carolinian, left the United States for London, feeling he could no longer live in this country. Mignot's *Sunset Over Florida Hammock* is dated 1863,[10] which indicates that it was painted either from memory or from sketches. In 1857, Mignot had made an important trip to Ecuador with the famous painter Frederic Edwin Church, and the two artists painted that country's dramatic scenery. Henry Theodore Tuckerman, noted New York author and art critic, in his definitive *Book of the Artists*, published in 1867, described Mignot as a master of color but also as one whose temperament and taste made him the efficient delineator of

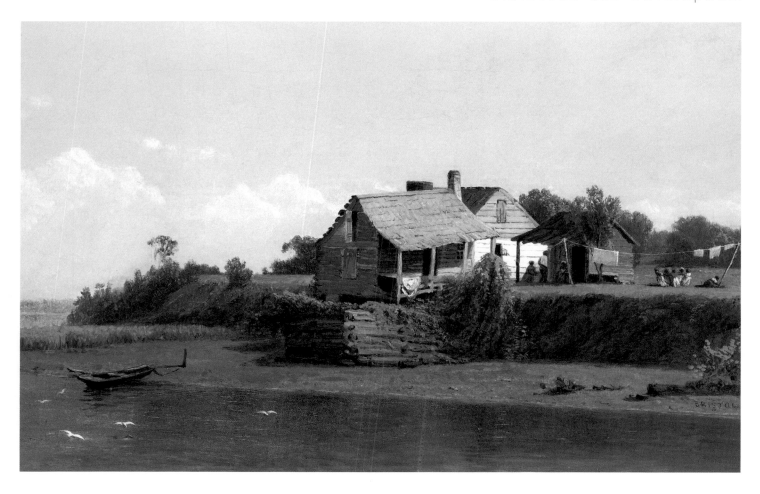

tropical atmosphere and vegetation.

Xanthus Russell Smith studied drawing at the Pennsylvania Academy of the Fine Arts from 1855 to 1858. He enlisted in the U.S. Navy at the outbreak of the Civil War, serving first as a clerk aboard the USS *Wabash* and then as personal secretary to Admiral Samuel Francis du Pont. Du Pont was dismissed for failing to take Charleston, South Carolina. Smith was reassigned to the USS *Augusta* under Captain Corvin.[11] Smith's ship docked at Pensacola after towing the Federal ironclad *Tecumseh* around Florida for the attack on the Confederate stronghold of Mobile, Alabama. One of Smith's drawings from this attack is titled *Pensacola Fl., August 25, 1864* [Pl. 4.12]. Another drawing, depicting the USS *Monongahela* [Pl. 4.10], is signed and inscribed in the lower right-hand corner: "Stem crushed in attempting/to run down Rebel Ram/'Tennessee'/Pensacola/Flor." Shortly thereafter Smith received an honorable discharge and returned to Philadelphia. Smith painted the important naval engagements of the war on a large scale. His meticulous research is demonstrated in his many detailed marine paintings, for example *Fort Pickens, Pensacola*, 1864, which shows a Federal warship, the USS *Augusta*. Smith's drawings are particularly interesting because, despite the immense amount of water surrounding Florida, marine subjects are rare.

4.8 John Bunyan Bristol. *On the St. Johns River,* 1866. Oil on canvas, 12 x 19. Courtesy of the Sam and Robbie Vickers Florida Collection.

One critic claimed of Bristol: "No one constructs a landscape more firmly than he."

49

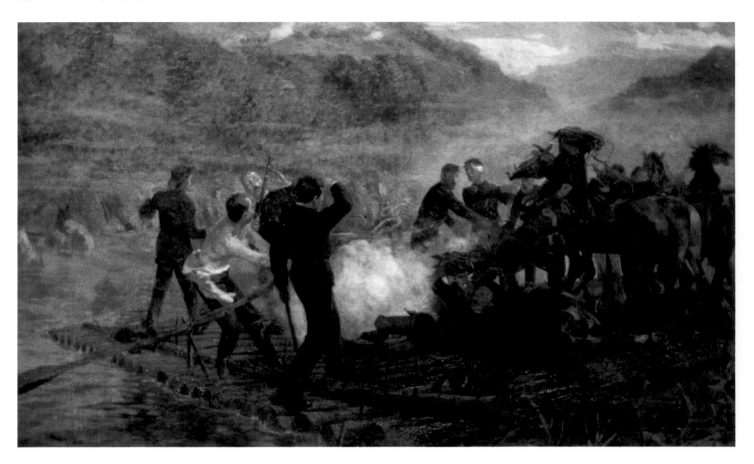

4.9 H. Dreher. *Repulse at Olustee,* n.d.
Oil on canvas, 48 x 70. Courtesy Reading Public Museum,
Reading, Pennsylvania.
 Dreher's lesser-known view of the Confederate victory at
Olustee.

4.10 Xanthus Russell Smith. *U.S.S. Monongahela, August
26, 1864.* Pencil drawing on paper, 6 1/4 x 10. Courtesy
Collection of Robert Schwarz, Philadelphia, Pennsylvania.
 In the lower right-hand corner, Smith wrote: "Stem crushed
in attempting/to run down Rebel Ram/'Tennessee'/
Pensacola/Flor."

Florida was not a major player in the Civil War. Although a number of Floridians opposed secession, most committed themselves to a war they were not prepared to fight. With a population of only 140,000, half of them slaves, Florida was left with few men to defend her. Bases at Pensacola, Key West, and Fort Jefferson never left Union hands. Hardships experienced throughout the South after the war were also suffered in Florida. Although we do not know the first name of a painter named **H. Dreher**, his *Battle of Olustee, Fla.* [Pl. 4.11], 1864, a black-and-white illustration used in many books, depicts Florida's only major Civil War battle, which took place on February 20, 1864. Interest in this battle resulted in a lithograph, issued by the art publisher Kurz and Allison in 1894, and it follows exactly all earlier representations of the battle.[12] Both the lithograph and a large oil painting, *Repulse at Olustee* [Pl. 4.9], a different view of the battle, are also signed by H. Dreher. The Battle of Olustee ended in a resounding defeat for the Union side, the Federals suffering 203 killed and 1,152 wounded, the Confederates 93 killed and 847 wounded. The battle had little military significance and probably no effect on the outcome of the war. A small museum and a memorial in the nearby town of Olustee still commemorate the event. ❦

4.11 Kurz and Allison after H. Dreher. *Battle of Olustee, Fla.,* 1864. Lithograph, 20 x 28, issued in 1894. Courtesy the McKenna Collection.
 An often-reproduced depiction of Florida's only major Civil War battle.

4.12 Xanthus Russell Smith. *Pensacola Fl. August 25, 1864.* Pencil drawing on paper, 6 1/4 x 10. Courtesy the McKenna Collection.
 This drawing was made while Smith was in the Navy during the Civil War.

Silver Springs

After the Civil War

HAD THE CIVIL WAR NOT INTERVENED, development of Florida probably would have continued at the same fast pace seen at Silver Springs. The end of the war brought the boomers back, and despite the hardships of Reconstruction, the attitudes of the pre-war white leadership remained. Advertisements sent North in the 1870s by Florida hotels and railroads were a clear invitation to visit a flower-strewn Eden for health and pleasure. The tourists, who returned in ever larger numbers, regarded Florida as one large sanitarium, though it should be noted that activity and growth were still centered in the northern part of the state. As people poured in, more money was available to support artists.

Inspired by the potential for even greater profits than before, Hubbard L. Hart, the steamboat developer, built his own hotel in Palatka and established a recruiting office in Boston for would-be tourists to Silver Springs. He widely advertised tours of his orange grove in Palatka. A painting by **W. E. B. Hayman** titled *Hart's Hotel on the Boil at Silver Springs* [Pl. 5.1], 1889, depicts Hart's hotel. As a result of Hart's promotional efforts, thousands of people visited the springs each year.[1]

On April 3, 1869, *Appleton's Journal,* a weekly publication devoted to "Literature, Science and Art," made its debut. A statement to the public announced the publisher's intentions: "Omitting ordinary news, and avoiding partisan advocacy, both political and sectarian, the JOURNAL will be devoted to general literature, to science, art and education." In its December 18, 1869, issue, *Appleton's Journal* published a full-page engraving titled *A Florida Scene* [Pl. 5.3], which was accompanied by an article about the Florida Everglades. Thus began the bimonthly publication of a series of forty-eight illustrated pieces, which later were bound into two large volumes as *Picturesque America.* Unfortunately, *A Florida*

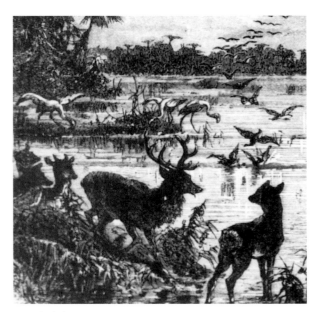

Detail of Plate 5.3

Facing page: 5.1 W. E. B. Hayman. *Hart's Hotel on the Boil at Silver Springs,* 1889. Oil on canvas, 17 x 14. Steve Hess Collection.
 The first hotel at Silver Springs.

Below: 5.2 F. W. Quarley after Harry Fenn. *Bar Light-House, Mouth of St. John's River,* ca. 1871. Engraving, 9 1/2 x 6 3/8. In *Picturesque America.* D. Appleton: New York, 1872, vol. 1, page 20.

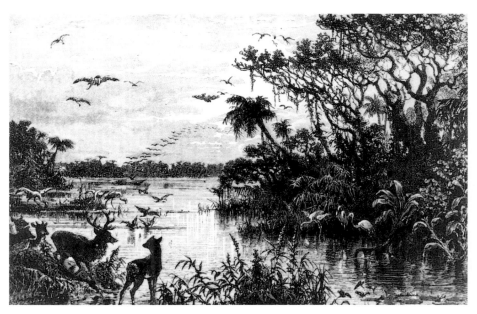

Above: 5.3 *A Florida Scene,* n.d. Engraving, 6 1/4 x 9 1/2. In *Appleton's Journal of Popular Literature of Science and Art,* December 18, 1869, vol. II, page 557.
 This Florida scene accompanied an article about the Everglades.

Below: 5.4 Robert Hinshelwood after Harry Fenn. *On the Coast of Florida,* 1871. Engraving, 5 3/8 x 9. In *Picturesque America.* D. Appleton: New York, 1872, vol. 1, page 17.

Scene was not included in those volumes. The second chapter in the first volume of *Picturesque America* was titled "St. John's and Oklawaha Rivers, Florida," indicating the intensity of the public's interest in this part of Florida at this time. The folios were fully illustrated, with many separate full-page pictures introducing each chapter. These included **Harry Fenn's** full-page engravings of the area: *On the Coast of Florida* [Pl. 5.4]; *Bar Light-House, Mouth of St. John's River* [Pl. 5.2]; and *A Florida Swamp* [Pl. 5.5]. Later in the same volume an entire chapter is devoted to St. Augustine, again illustrated by Fenn, and it includes many famous landmarks. Born in England, Fenn came to the United States in 1864 and was one of the founders of the American Water Color Society.

Not to be outdone, in 1873 Scribner's, a successful competitor of Appleton's, sent a writer, Edward King, along with an artist, **James Wells Champney**, to explore and report on the area for a series of articles later published in the book *The Great South*. Edward King wrote of Florida:

> Yet, what of fiction could exceed in romantic interest the history of this venerable State? What poet's imagination, seven times heated could paint foliage whose splendors should surpass that of the virgin forests of the Oclawaha and Indian rivers? What "fountain of youth" could be imagined more redolent of enchantment than the "Silver Spring," now annually visited by 50,000 tourists?[2]

Champney provided the illustrations that brought King's words to life. Born in Boston, Champney had studied drawing at the Lowell Institute of Drawing and was apprenticed as a wood engraver at the age of sixteen. He joined the army at the start of the Civil War but was discharged after contracting malaria. He taught drawing for two years in Lexington, Massachusetts, before leaving for Europe in 1866. In 1874, Champney married Elizabeth Williams and illustrated the books and articles she wrote. By 1877, he was named professor of art at Smith College. Around 1880 he changed his media from oils and watercolors to pastels and began to produce pastel portraits.

Many of the drawings from King and Champney's trip to Florida, including a scene of the Jacksonville waterfront, were made onboard the steamer that took them up the Oklawaha River. Other important sites on the St. Johns are depicted, along with a view of the home of Harriet Beecher Stowe in Mandarin. Profusely detailed, the drawings portray the state as a tropical paradise, in much the same way as later travel leaflets. Shown here is one of Champney's river steamer scenes richly surrounded with other Florida scenes [Pl. 5.6]. Compare it to the photograph of the steamboat *Oklawaha* at Silver Springs, taken about the same time [Pl. 5.7].[3]

King and Champney also visited St. Augustine, Champney drawing such scenes as the horse-drawn trolley on its way to town [Pl. 5.8], a picturesque street in the old town, and, of course, the

5.5 F. W. Quarley after Harry Fenn. *A Florida Swamp*, ca. 1871. Engraving, 8 1/4 x 5 1/4. In *Picturesque America*. D. Appleton: New York, 1872, vol. 1, page 22.

These three engravings by Harry Fenn served as openers for the chapter on the wonders of Florida in the collection of articles from *Picturesque America*.

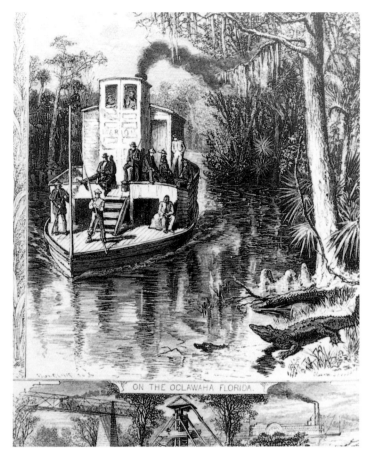

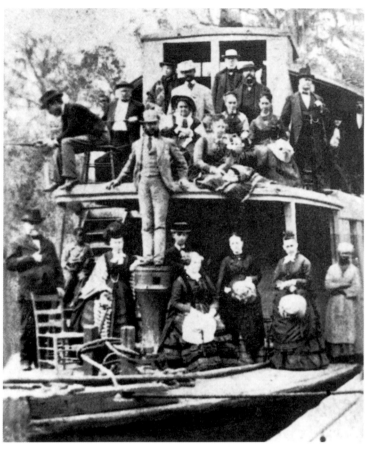

5.6 James Wells Champney. *On the Oklawaha, Florida,*
ca. 1873. Engraving, 3 1/2 x 4 1/2. In *The Great South* by
Edward King. Published by *Scribner's Monthly*, 1879.
American Publishing Co.: Hartford, Connecticut, page 410.
 An artist's view of a steamer on the river.

5.7 Anonymous. *On the Oklawaha,* 1868 or 1869.
Photograph. In *Eternal Spring,* Great Outdoors Publishing
Co.: St. Petersburg, Florida, Silver Springs, Inc., 1966,
page 115.
 An actual view of steamer transportation on the river.

historic city gate. A number of pictures of Fort Marion are also
reproduced in the book. Although his work was exhibited fairly
extensively at the National Academy of Design, Champney never
offered the academy any Florida scenes. The original version of
King and Champney's book, *The Great South*, published in 1879,
includes a drawing titled *Le Calle de la Merced, St. Augustine* [Pl. 5.9],
but this drawing was not included in the 1972 reprint. In his
drawing, Champney created a scene of old St. Augustine imagined
by King in a nostalgic paragraph:

> The romance of the place is now gradually departing. The
> merry processions of the carnival, with mask, violin and
> guitar, are no longer kept up with the old taste; the rotund
> figure of the padre, the delicate form of the Spanish lady, clad
> in mantilla and basquina, and the tall, erect, brilliantly
> uniformed cavaliers are gone; the "posy dance," with its
> arbors and garlands, is forgotten; and the romantic suburbs
> are undergoing a complete transformation.[4]

On the Road to St. Augustine, Florida.

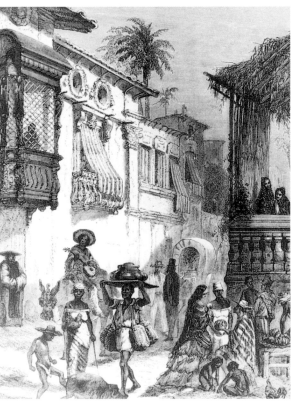

The Great South chronicles the history of St. Augustine, just as *Picturesque America* did five years earlier, but the later book covers northern Florida much more completely. After describing Jacksonville and St. Augustine in great detail, King discussed the fertility of the land around Palatka, the orange culture, and the expense of building. *Picturesque America* was exactly what the title implies: a handsome coffee-table volume focusing on scenes of Florida, with a limited text. King and Champney's *The Great South*, on the other hand, reflects a greater interest in Florida's economic development as well as in the people of the region. While there are people represented in *Picturesque America,* it is in a more detached fashion than in *The Great South.* Champney's later oil painting of a young woman, *Return from Harvesting* [Pl. 5.10], 1874, must have been developed from sketches made on the tour for the book. The painting tells us a great deal about the subject's daily life, from her bare feet, to the hoe on her shoulder, to the burden on her head, which she carries so jauntily.

The story of King and Champney's journey up the Oklawaha to Silver Springs includes scenes along the way to Lake Apopka [Pl. 5.11]. The boat passengers are shown shooting at alligators, with an account from an alligator hunter added for emphasis:

> The 'gaiter, sir, is ez quick as lightning, and ez nasty. He kin outswim deer, and he hez dun it, too; he swims more'n two-thirds out o' water, and when he ketches you, sir, he jest wabbles you right over'n over, a hundred times or mo', sir, ez quick as the wind; and you're dead in no time, sir.[5]

Champney's wash drawing from *The Great South, Colonel Hart's*

Above left: 5.8 James Wells Champney. *On the Road to St. Augustine, Florida*, 1873. Engraving, 3 1/2 x 4. In *The Great South* by Edward King. Published by *Scribner's Monthly,* 1879. American Publishing Co.: Hartford, Connecticut, page 388.
A horse-drawn trolley traveling to St. Augustine.

Above right: 5.9 James Wells Champney. *Le Calle de la Merced, St. Augustine,* 1873. Engraving, 6 x 9. In *The Great South* by Edward King. Published by *Scribner's Monthly,* 1879. Frontispiece for chapter on St. Augustine in first edition only. American Publishing Co.: Hartford, Connecticut.
A fantasy of the past.

Orange Grove [Pl. 5.12], demonstrates an important part of Florida's economy but conveys less information than **Edwin Austin Abbey's** *Sketches in an Orange Grove* [Pl. 5.14], which was published in *Harper's Weekly* in 1875. Abbey, who was self-taught, began his art career in a wood engraver's shop. He went on to become a rather notable artist and won many awards.

In 1873, the year King and Champney traveled down the Oklawaha, William Cullen Bryant, an American poet and newspaper editor, traveled in Florida. Artist Asher B. Durand pictured Bryant and painter Thomas Cole together in his famous landscape *Kindred Spirits*, emphasizing Bryant's influential presence in the world of art and letters. During his Florida travels Bryant wrote a report for the *New York Evening Post*:

> Palatka was still largely a forest, Jacksonville was thriving, with four thousand people and two new hotels, with orange trees growing everywhere. The northern invasion was under way. Invalids and idlers came by tramroad from Tocoi, south of Picolata, in carriages drawn by mules. He predicted that in time only the old fort would remain to remind one of the past. He visited Green Cove Springs and went up the Oklawaha to Silver Springs and Ocala. Two hotels at Silver Springs, one at Magnolia, and two at Palatka were full, and though the accommodations at St. Augustine had been doubled over the previous year, they were also full. He predicted a rosy future for the sunshine state.[6]

George F. Higgins depicted another part of Florida in his 1870 painting titled *The Florida Keys*. Ten years later he painted *Fishin' at Sunset*, which combines a warm and pleasant mood with a panoramic view. We know that Higgins contemplated issuing a set

Facing page: 5.10 James Wells Champney. *Return from Harvesting*, 1874. Oil on board, 17 x 13. Courtesy of the Sam and Robbie Vickers Florida Collection.
 Champney probably based this oil painting on sketches made for *The Great South*.

Below: 5.11 James Wells Champney. *Shooting Alligators*, 1373. Engraving, 4 1/2 x 5 1/2. In *The Great South* by Edward King. Published by *Scribner's Monthly*, 1879. American Publishing Co.: Hartford, Connecticut, page 415.
 King and Champney's journey up the Oklawaha shooting ct alligators.

Bottom of page: 5.12 James Wells Champney. *Colonel Hart's Orange Grove*, 1873. Pencil and watercolor, 3 1/4 x 5 5/8. M. and M. Karolik Collection. Courtesy Museum of Fine Arts, Boston, Massachusetts.
 "Jacksonville thriving . . . orange trees growin' every where." *(The Great South)*

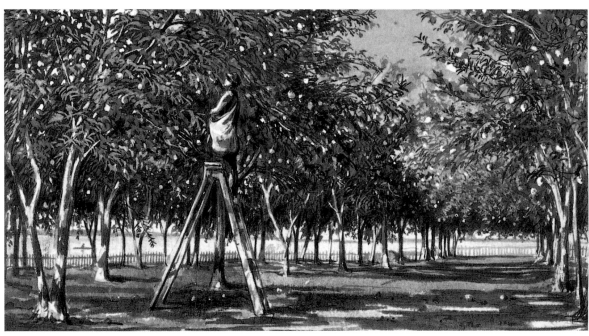

of graphics of scenes of the United States, similar to others being done at the time, but never realized his idea. A brief mention of Higgins ran in *The Tatler* in St. Augustine in 1896: "Mr. George F. Higgins . . . Boston artist . . . arrived at the Hotel Punta Gorda, Fla., on Monday Night. . . . A painting of the quaint dwelling of the oldest Punta Gorda inhabitant . . . executed during the week." Punta Gorda Harbor apparently took his fancy, as shown in his agreeable painting [Pl. 5.15]. His landscape titled *Palm Grove, Florida* (see frontispiece facing title page), circa 1875, shows a swamp with clouds at the beginning of sunset. *Florida Cabin Scene*, circa 1870s, is a fairly realistic view of the subject, unlike William Aiken Walker's cabin scenes designed for the tourist trade. Both *Palm Grove* and *Florida Cabin Scene* are at the Morris Museum of Art in Augusta, Georgia.

The work of **John Douglas Woodward** appeared in *Picturesque America, The Art Journal,* and *The Aldine,* among other publications.[7] In 1871 and 1872, while still in his twenties, Woodward completed a number of illustrations for *Hearth and Home* as part of his first major commission, a sketching tour of the South. He went to Key West, as can be seen in *Cocoa-Nut Trees at Key West, Florida* [Pl. 5.13],[8] August 12, 1871. Five drawings of Florida were included in an 1998 exhibition and catalog of Woodward's work by Sue Rainey.[9]

Landscape: Oklawahaw River, Florida [Pl. 5.16], circa 1880, by **Jules Gilmer Köerner Sr.**, exemplifies the work of the many artists who came to Florida at this time. Nothing is known of Köerner other than this painting. We know that another scenery painter, **Granville Perkins**, who was also a book illustrator, visited Florida many times because of the numerous paintings that document his visits. Shown here is *Allegator* [*sic*] *Reef, Florida* [Pl. 5.18], a watercolor dated 1874, which depicts figures in a rowboat with a lighthouse in the background. His other Florida work includes *The*

Top: 5.13 Meeder Chubb after John Douglas Woodward. *Cocoa-Nut Trees at Key West, Florida,* 1871. Engraving, 7 x 9 1/2. *Hearth and Home,* New York, August 12, 1871, vol. III, no. 32. Courtesy American Antiquarian Society.
An early view of domesticity in Key West.

Left: 5.14 Edwin Austin Abbey. *Sketches in an Orange Grove,* 1875. Woodcut, 14 1/2 x 8 3/4. *Harper's Weekly,* February 20, 1875, page 152.
Abbey carefully illustrates the orange industry from planting to packing.

Top: 5.15 George Frank Higgins. *Punta Gorda Harbor, Florida,* ca. 1900. Oil on canvas, 9 x 13 3/4. Courtesy The Cummer Museum of Art & Gardens.
Higgins' talent is evident in this painting of a small settlement on Charlotte Harbor on the Gulf Coast.

Bottom: 5.16 Jules Gilmer Köerner Sr. *Landscape: Oklawahaw River, Florida,* ca. 1880. Oil on canvas, 18 x 30. Courtesy North Carolina Museum of Art. Gift of Jules Gilmer Köerner Jr.
His work exemplifies that of a visitor who could paint.

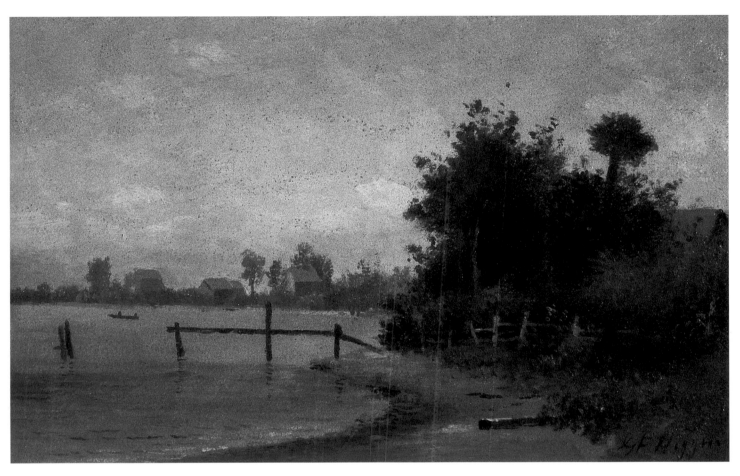

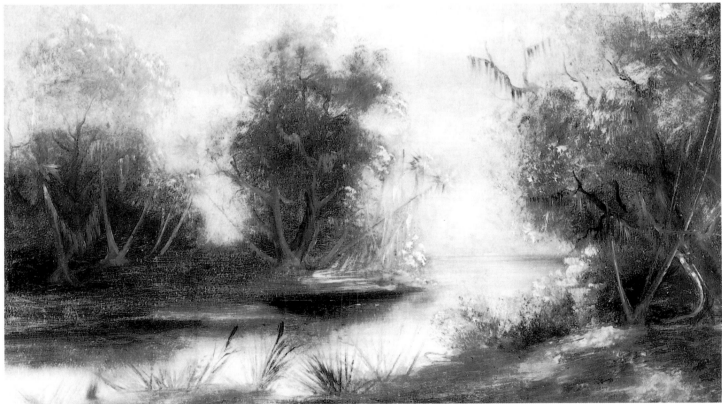

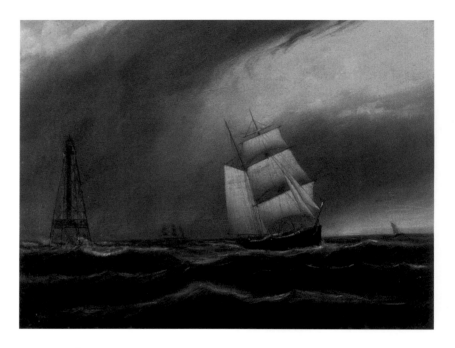

5.17 Clement Drew. *Lighthouse, Alligator Reef, Florida,* 1879. Oil on canvas, 9 x 12. Courtesy the McKenna Collection.
 Drew's view of a ship under full sail protected by the lighthouse is typical of his marine paintings.

5.18 Granville Perkins. *Allegator [sic] Reef, Florida,* 1874. Watercolor on paper, 9 1/2 x 13 1/3. Courtesy the McKenna Collection.
 Notice the skeletal iron Alligator Reef Lighthouse in the background.

Escape of Contrabands to the U.S. Bark Kingfisher, Off the Coast of Florida, 1863. *Florida Mangrove* was done in 1888, and there is an undated work titled *Florida Landscape.* In 1892 he painted *Sunset on the Oklawaha. Lighthouse, Alligator Reef, Florida* [Pl. 5.17], 1879, by **Clement Drew**, presents a ship in full sail with the lighthouse appearing as background (as it does in Perkins' painting). Born in Kingston, Massachusetts, in 1806, Drew sold art supplies before becoming an established artist. He is best known for his marine painting. The two pictures of Alligator Reef indicate that artists visited the Keys frequently.

Artists' fascination with alligators can be seen in a very large picture [Pl. 5.19] by **Clara Mitchell Carter**. The Mitchell family was one of the first to settle in Daytona Beach. Clara Mitchell married William Carter and together they published the *Halifax Journal,* the precursor of today's *Daytona Beach News Journal.* Clara's painting, done in 1887, shows her talent, though she was not a professional artist.

William Morris Hunt was Boston's leading portrait painter and teacher from 1850 to 1870. After studying at Harvard, he traveled to Europe, studying in Rome and then at the Düsseldorf Academy of Art in Germany. Unhappy with the German emphasis on mechanical style, he left for Paris, where he developed a more spontaneous technique. In the winter of 1873–1874, Hunt visited Florida and completed a number of landscapes. *Florida Landscape* [Pl. 5.20] and *St. Johns River, Florida,* demonstrate his style, which was a change from the carefully thought-out landscapes of the period. Responsible for spreading the influence of Jean Francois Millet and the loose, sketchlike mode of the Barbizon School in the United States, he influenced many others, including Winslow Homer.

Harriet Beecher Stowe, of literary fame, first came to Florida in

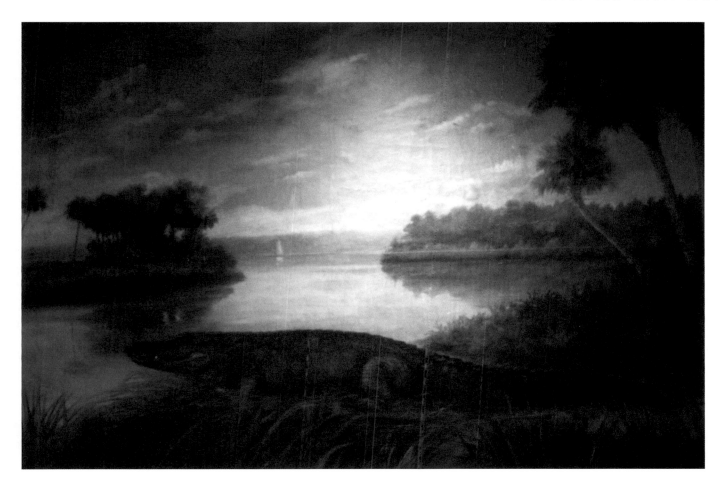

5.19 Clara Mitchell Carter. *Alligator in a Swamp*, 1887. Oil on canvas, 53 x 76. Courtesy the McKenna Collection.

Like many others, Clara Mitchell Carter was fascinated by alligators.

1866, hoping to rehabilitate her son. She leased a cotton plantation on the St. Johns River, south of Jacksonville, for the young man to operate. A year or two later she purchased a cottage and grove for herself at Mandarin. In 1873 she published the book *Palmetto Leaves*, which described the routes to the South, the St. Johns River and its landing place, St. Augustine and other towns, and the facilities and opportunities available for tourists, settlers, and invalids. Her book is not the report of a casual visitor but of an enthusiastic resident. And many visitors from the North visited her Mandarin house. Another book promoting the state was Sidney Lanier's *Florida: Its Scenery, Climate and History*, 1875, a commissioned piece that exhibited some rather distinguished travel prose.

Such writers fired the imaginations of nineteenth-century artists, who were also infected with excitement by the prevalent theory of Manifest Destiny, which called for the United States to eventually control all of North America. Similarly, *The Minorcans*, 1870, by **Edward Moran**, reflects another little-known aspect of Florida's history and is also an early indication of the interest in post–Civil War Florida. People from the Mediterranean island of Minorca were persuaded to emigrate to Florida in 1768 by Colonel Andrew Turnbull. Following their abuse and a failed attempt to establish a plantation, the Minorcans fled to St. Augustine. Today these people, originally numbering fourteen hundred, have been

assimilated into the local society. Attempts are being made to revive their culture and traditions.

Edward Moran was the eldest of three painter brothers, born in England, who emigrated to Maryland in 1844 and studied with Paul Weber and James Hamilton. By 1857 Edward and his brother Thomas had opened their own studio. Edward concentrated on marine painting; his other brother, Peter, painted figures.

Artistic interest in Florida prompted continued attention from magazine publishers, notably Scribner's. **Thomas Moran**, who already had achieved a reputation as an artist, first became involved with Florida as a result of James Wells Champney's sketches. Moran reworked a number of Champney's drawings, making woodcuts on boxwood blocks for *Scribner's* magazine. According to one study of Moran's interpretation of Champney's sketches, " . . . it is immediately clear how much Moran altered the views to conform to picturesque conventions. . . . "[10]

In early February 1877, Thomas and Mollie Moran (Thomas' wife, later a well-known artist who used the name Mary Nimmo Moran) had an opportunity to go south. *Scribner's* was planning an article about Fort George Island, at the mouth of the St. Johns River.[11] By the time of Washington's birthday, the Morans were sketching at St. Augustine, Thomas teaching Mollie. Thomas' imagination was

5.20 William Morris Hunt. *Florida Landscape,* 1875. Oil on canvas, 25 1/4 x 39. From the collection of The Harn Museum of Art, University of Florida. Museum purchase with contributed funds by Dr. and Mrs. David A. Cofrin. (Photo: Greg Cunningham.)
This painting illustrates Hunt's altered treatment of the subtropical atmosphere of Florida after his studies in Europe.

5.21 Thomas Moran. *De Soto in Florida,* n.d. Oil on canvas, 12 x 14. Courtesy Thomas Moran Biographical Art Collection, East Hampton Library, East Hampton, New York. He dramatized the dark and brooding trees.

captured by Ponce de León's association with the town. Several of the scenes for *Scribner's* appeared in an article by Julia E. Dodge.[12] The paintings, made in Moran's studio from sketches at St. Augustine, while realistic, have romantic overtones and convey the cultural isolation that still existed in Florida. A typical example is *Florida Landscape,* which may be seen at the Museum of Fine Arts in St. Petersburg.

Moran was impressed with the forests of Florida, which, when he first went to the state, were virtually impassable south of St. Augustine. An original sketch for *De Soto in Florida* [Pl. 5.21] dramatizes the dark and brooding trees which greeted the early explorers. We now call Florida the "Sunshine State," but both Moran's de Soto sketch and his 1878 painting, *Ponce de León in Florida, 1513* [Pl. 5.22] emphasize overwhelming primeval forests. In the de Soto sketch, Moran chose to dwell on the effects of Spanish moss hanging from the trees while not neglecting the massive trees themselves. Moran lightened the sky considerably and gave it more space in the Ponce de León work, in which the party are seen

5.22 Thomas Moran. *Ponce de León in Florida, 1513,* 1878. Oil on canvas, 63 1/2 x 115. Courtesy The Cummer Museum of Art & Gardens, Jacksonville, Florida. Acquired for the people of Florida by the Frederick H. Schultz Family and Barnett Banks, Inc. Additional funding provided by the Cummer Council.

A major effort based on Moran's Florida experience.

meeting with the Native Americans in a forest clearing rendered in a panoramic view.

Ponce de León in Florida, 1513, 1878, a very large canvas, was a major effort based on Moran's Florida experience. He hoped the painting would be purchased for the House of Representatives in the nation's capitol and be mounted behind the Speaker's desk. However, the theory is that it was rejected because of the claim by a Mr. Worthington of Georgetown, "an old resident of Florida," that Moran's trees were " . . . utterly unlike the timber of that State."[13] We know that these trees did exist if one was willing to explore the territory sufficiently. In the Ponce de León painting the Spanish moss can be seen in the distance, but the ponderous trees get more attention in the foreground. Politics also entered the picture. Congress chose instead Albert Bierstadt's picture, *The Discovery of California.* Robert Wilson Torchia's excellent catalog detailing the history of the Moran painting spells out the reasons for its rejection. As Torchia theorizes, the specters of the Civil War and Reconstruction hung heavily over the former secessionist states and Florida was no exception. Senator Howe of Wisconsin, who was on the art committee, judged that the Bierstadt picture was more positive because it was brighter and more clearly demonstrated the theory of Manifest Destiny.

Torchia carefully details the travels of Moran's Ponce de León painting through the years. For a long time the work actually remained in Florida but went unrecognized. Purchased by Henry Morrison Flagler, probably through the New York art dealer Knoedler & Company, for a while it was displayed in the Hotel Ponce de Leon in St. Augustine, where its presence was documented in 1892. No other painting could have been more suited to the

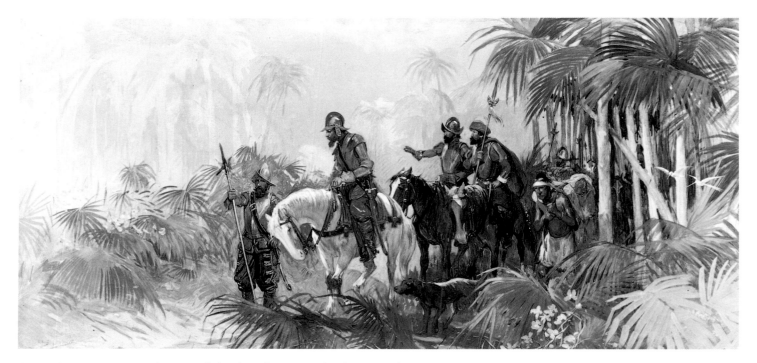

5.23 Oscar E. Berninghaus. *Florida Everglades, Ponce de León Expedition*, ca. 1914. Mixed media, 22 x 46. Courtesy The Saint Louis Art Museum. Gift of August A. Busch Jr.

Ponce de León, dispirited and discouraged—by 1914 the theory of Manifest Destiny had come to an end.

Spanish Renaissance theme of the hotel. Later Flagler transferred the picture to his home, Whitehall, in Palm Beach. After his death it resumed its travels, some of which are unknown. For a while it was out West at the Cowboy Hall of Fame. Through the actions of public-minded citizens and art collectors, the painting was brought back to Florida in 1996, where it is on permanent exhibition at the Cummer Museum of Art & Gardens in Jacksonville.

Oscar Berninghaus painted quite a different version of Ponce de León in *Florida Everglades, Ponce de León Expedition* [Pl. 5.23]. Here, Ponce de León is seen on a horse, dispirited and discouraged. This picture was made as part of a 1914 commission Berninghaus received from the Anheuser-Busch Company to show the history of America. A comparison of the two pictures indicates the waning of the influence and acceptance of Manifest Destiny. After the turn of the century, it was no longer popular.

Mary Nimmo Moran, whose formidable talent as an etcher was recognized even then, produced five prints of Florida in 1887. She signed her name "M. N. Moran" in order to avoid being recognized as a woman.[14] Sylvester Koehler explains that during the late nineteenth century, she reflected American artistic taste, attracting more attention than any other female etcher and most male etchers as well. Mary Moran was singled out and praised for the strength and experimental quality of her work. In London, she and her husband, Thomas Moran, met the distinguished critic and essayist John Ruskin, who purchased many of their etchings. Ruskin's rule that a good etching must make dramatic use of light and shade influenced Mary Moran's work.[15]

Writing of Mary Moran, Koehler said in part: "She treats her subjects with poetical disdain of detail, but with a firm grasp of

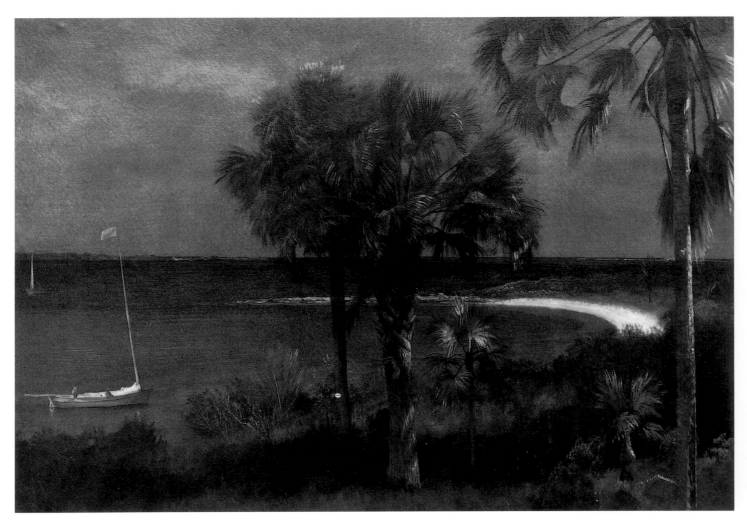

5.24 Albert Bierstadt. *Florida Landscape*, ca. 1870–75. Oil on paper, 13 3/4 x 19 1/8. Courtesy Smith College Museum of Art, Northampton, Massachusetts.
Questionable if this is Florida or the Bahamas.

the leading truths that give force and character to her work."[16] Others praised her work for its "masculine" qualities, which some printers thought would help sell her work. *Point Isabel, Coast of Florida*, 1887—which can be seen at the Parrish Art Museum, Southampton, New York—was done on the Morans' second trip to the state.

Albert Bierstadt was one of the outstanding landscape painters of the nineteenth century. Several of his paintings are titled as Florida landscapes, but there is some question about whether they represent Florida or the Bahamas. It is doubtful that this issue will ever be resolved. Regardless, Bierstadt's *Florida Landscape* [Pl. 5.24], circa 1870–1875, is included here because of his status in American art.

The growing popularity of northern Florida was also recorded by painter and printmaker **George Henry Smillie**, who visited the St. Augustine area in 1874 and 1875 to study and sketch the scenery. Smillie was the son of engraver James Smillie. He began studying with his father as a young boy and later studied with the landscape painter James McDougal Hart. By the time he was twenty-four, he was elected an associate

member of both the National Academy of Design and the American Water Color Society. *Market and Bay, St. Augustine, Florida* [Pl. 5.25], 1874, shows the artist's unusual approach to his subject, the old slave market.

Three more painters of this era should be mentioned, even though samples of their work are not shown here. **Edwin Lord Weeks'** painting, *In the Everglades of Florida*, 1873, shows the natural beauty of the area. Weeks, who was born in Boston, studied extensively in Paris and won international prizes for his art, specializing in a North African oriental genre. **Edwin D. White** was noted for his historical paintings. There is no written record of his ever coming to Florida, but he painted *The Landing of the Huguenots at the Mouth of the St. Johns River in 1564*, which may be seen at Mt. Holyoke College in South Hadley, Massachusetts. It was painted sometime before 1867 because a record of the work exists in *Book of the Artists* by Henry Tuckerman, published that year. For Protestants, the painting depicted a notable historic event comparable to the landing of the Pilgrims at Plymouth Rock.[17] Finally, **Alexander Helwig Wyant** is documented as a visitor to Florida in two landscapes, one of which, *View Down the St. John's River from Magnolia Point*, is dated 1871. Wyant began as a harnessmaker but at twenty-one decided to become a painter. On the advice of landscape painter George Inness, he solicited the patronage of Nicholas Longworth of Cincinnati, whose support enabled him to study at the National Academy of Design and in Düsseldorf.

America's painter-etcher movement began about 1878 and flourished throughout the 1880s. Many notable artists experimented with the etching medium. The Parrish Art Museum in Southampton, New York, has a collection which includes Florida scenes by **John Whetton Ehninger**, **Mary Nimmo Moran**, and **Stephen Parrish**. Etchings by Ehninger and Parrish appear in chapter six. ❧

5.25 George Henry Smillie. *Market and Bay, St. Augustine, Florida*, 1874. Watercolor on paper, 7 3/4 x 11 3/4. Courtesy the McKenna Collection.
A pleasant scene which, in fact, depicts a place where hope is abandoned—the slave market.

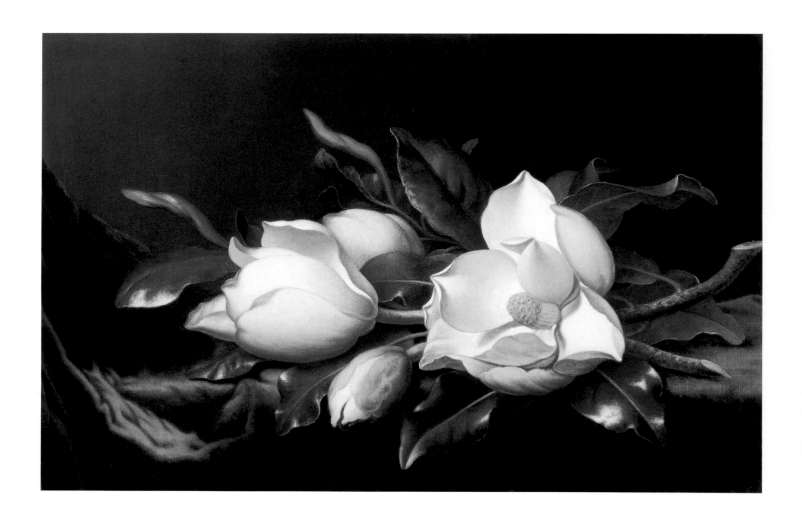

Cultural Growth
1880–1900

ARTISTS BEGAN TO DRIFT THROUGH St. Augustine early in the nineteenth century, leaving records of their visits; the old gate and Fort Marion were the chief centers of interest. Some artists were already winter visitors. Among them were **James Wells Champney**, **William Morris Hunt**, **Frank Henry Shapleigh**, and **Felix de Crano**. The transformation of the town into an art colony was sparked in 1883.

In that year, Henry Morrison Flagler, a shrewd, self-made businessman who was vice president of Standard Oil, was honeymooning with his second wife in the old town, when he met **Martin Johnson Heade**. They commiserated with each other on the lack of adequate hotels and transportation.[1] The meeting proved to be a turning point in the lives of both men. Heade, the artist, found his first true patron, and Flagler, who was in a position to do something about the problems they had discussed, began his development of Florida. Returning to New York in 1883, Flagler went to the architectural offices of McKim, Meade and White, where he engaged the services of two young men, John M. Carrere and Thomas Hastings. Construction of the Hotel Ponce de Leon was their first important commission, and they met daily with Flagler to plan the project. On December 1, 1885, construction was begun on the Spanish Renaissance Revival–style palace designed to preserve and enhance the atmosphere of the old town. No expense was spared in furnishing the 450 suites and the lobbies, and at the grand opening, glittering, newly invented electric bulbs lit the hotel's interior. The Ponce de Leon was the first hotel in the United States to be wired for electricity.

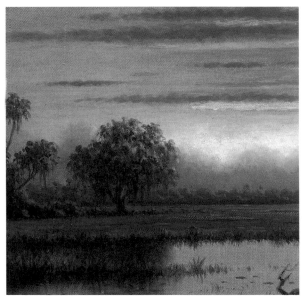

Detail of Plate 6.3

Facing page: 6.1 Martin Johnson Heade. *Magnolias*, ca. 1894–1900. Oil on canvas, 15 1/4 x 24 3/8. Courtesy The Art Institute of Chicago. Copyright The Art Institute of Chicago. Restricted gift of Gloria and Richard Manney; Harold L. Stuart Fund, 1938. Photograph © 1997 The Art Institute of Chicago. All rights reserved.
 Heade's magnolia captures the essence of the flower and its waxy, creamy petals.

6.2 Louis Comfort Tiffany. Bacchus-style stained-glass window, ca. 1888. Stained glass and lead, 7 feet x 2 feet. Courtesy Flagler College, St. Augustine, Florida. Photograph by Ken Barrett Jr.

Tiffany's stunning, intricate windows have been restored at Flagler College, formerly the Hotel Ponce de Leon.

Bernard Maybeck worked on the interior design under Carrere and Hastings, but much of the interior effect was the responsibility of **Louis Comfort Tiffany**. Tiffany had been employed by Flagler as interior decorator. He supervised the importation of rosewood, walnut, and mahogany furniture. On his own time and for his own use, using a palette of dark colors, he painted several views of St. Augustine that reflect the artistic mode of his time. His newly reorganized Tiffany Glass Company furnished the stained-glass windows for the hotel [Pl. 6.2]. Inside the oaken front doors, the light filtered through the stained glass and played upon the marble walls and columns of dark wood.

George Maynard, creator of many of the murals in government buildings in Washington, D.C., painted murals in the hotel. His themes were Spanish and classical with allegorical female figures, galleons in full sail, pirate skull and crossbones, and Florida Indian totems. Further murals by Maynard are between the stained-glass windows placed on the ceiling facing each other in pairs across the dining room space. These represented the four seasons. But the ceiling of the grand parlor was covered with angelic canvases by **Virgilio Tojetti**, painted in Paris, France, and stretched between the ceiling moldings as the hotel was completed.[2]

At the same time that Tiffany was involved in decorating the hotel, he was striving to achieve excellence and recognition as a painter. Beginning in 1867, Tiffany exhibited extensively at the National Academy of Design, but not until 1883 did he show his first Florida scene, *Old Fort at St. Augustine*. Another work, not exhibited at the Academy, was *The Castillo de San Marcos, St. Augustine*, 1885. Although Tiffany is remembered more for his famous *Favrile* glass and lamp creations than for his paintings, his works on canvas received many awards.[3]

The opening of the hotel on January 10, 1888, coincided with the first run of the Florida Special, a train that traveled from Jersey City, New Jersey, to Jacksonville, Florida, in twenty-nine hours and fifty minutes. Among the passengers was President Grover Cleveland. Later Flagler bought several local railroads and organized the Florida East Coast Railway Company. By 1896, the railroad extended as far as Miami, and by 1912 it reached Key West.[4]

Flagler made St. Augustine a winter vacation paradise. He enhanced the beauty of the old town in order to compete with less-expensive hostelries that had sprung up near the Ponce de Leon. Recognizing how improvements to the town would benefit him in the long run, he built a second hotel, the Alcazar. Another hotel was built by Boston architect Franklin Smith and named the Casa

Monica. Smith's St. Augustine home, Villa Zorayda, now called Zorayda Castle, was the nation's first poured-concrete residence. The Casa Monica opened for business in 1888, but it could not withstand the competition from Flagler's hotels. In April of that year,[5] Flagler purchased the Casa Monica, renaming it the Cordova. He also ordered the construction of two churches— one Presbyterian, one Methodist—and presented them to their respective congregations. There was already an Episcopalian church in the town, as illustrated in *The Great South,* as well as a Roman Catholic cathedral. Finally, Flagler erected a town hall and a jail, and paved the streets adjoining the plaza where the post office stood.[6]

The presence of artists on the grounds of the Hotel Ponce de Leon was essential to the Renaissance atmosphere Flagler wished to recreate. A long building designed to house seven studios was constructed on the hotel grounds. Part of this structure is still used today for art studios and classrooms by Flagler College, now housed in the former hotel. Guests from the Ponce de Leon and other hotels enjoyed the formal Friday night receptions at the studios, strolling the lushly landscaped, moonlit grounds on their way to the long building on Valencia Street.[7]

Martin Johnson Heade, who had first choice of the rooms, generally occupied number seven. Flagler's generous patronage had provided this important artist with a new life in addition to a position of social leadership and respectability. Theodore E. Stebbins Jr., a noted art historian, wrote in 1975:[8]

> The Studio of Heade, as senior member of this community, became a center of artistic and social life. Mrs. Heade served tea for the artists, their families and the local gentry two or three times a week, and Heade himself, for the first time, found himself altogether accepted by his peers.

The change in Heade's lifestyle came at the end of a long, illustrious career as a naturalist, poet, and artist. Born in Pennsylvania, he studied art early with the famous primitive painter Edward Hicks. In 1840 and 1841, he traveled extensively abroad and, on his return, exhibited *Portrait of a Little Girl* at the Pennsylvania Academy of the Fine Arts. By this time he had acquired an interest in landscape painting. In the 1850s, while based in New York City, he began a series of expeditions to Jamaica, Brazil, and other exotic places. These expeditions, which lasted for thirty years, resulted in his paintings of the native biota of orchids and hummingbirds.

Heade was certainly the most accomplished artist who worked

at the Ponce and in St. Augustine at the peak of the boom period. In the 1880s, he executed several large Florida landscapes for Flagler; in his studio, however, pictures of flowers predominated. The landscapes retain some of the aspects of Luminism that Heade had used extensively in his earlier years—including the horizontal, parallel division of space; the abstract placement of objects; and the interest in light and time of day—but not the mirrorlike images of pure Luminism. All of this can be seen in *St. Johns River* [Pl. 6.3], circa 1890–1900, and *Sunset, Tropical Marshes* [Pl. 6.4], circa 1880. While great similarities exist in their horizontal formats, the latter shows a much wider vista, while the former concentrates on the simplicity of nature.

A typical description of the flower paintings comes from an 1894 article in *The Tatler,* a local St. Augustine newspaper:

> Heade . . . had devoted his time to portraying flowers— roses—this being his especial delight, although his perfect representation of the delicate shadings of plush used for draperies and their background is unexcelled . . . work is extremely painstaking, each vein and shade faithfully delineated. A spray of daisies, Cherokee roses, apple blossoms and yellow jessamines in turn excite admiration.

Heade's range in still life at this time was narrow because he painted virtually only flowers. According to his biographer, Theodore Stebbins, ". . . a true appreciation of the symbolism of

6.3 Martin Johnson Heade. *St. Johns River,* ca. 1890–1900. Oil on canvas, 13 x 26. Courtesy The Cummer Museum of Art & Gardens.
 Heade succeeds in capturing the light and time of day.

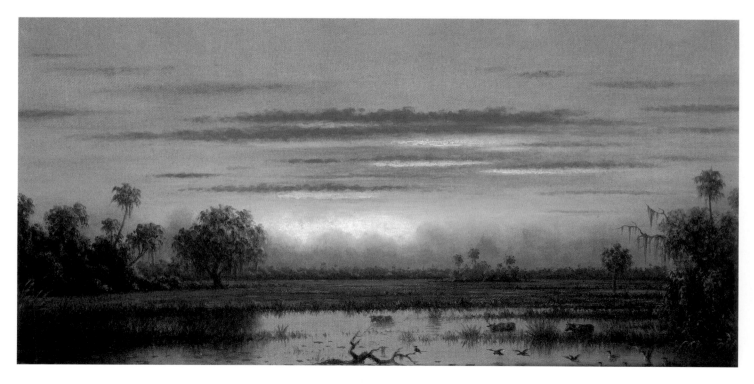

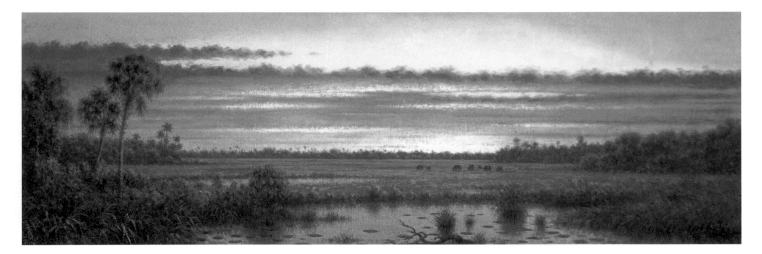

6.4 Martin Johnson Heade. *Sunset, Tropical Marshes*, ca. 1880. Oil on canvas, 12 1/4 x 36 3/4. Courtesy The Charles Hosmer Morse Museum of American Art, Winter Park, Florida. Copyright The Charles Hosmer Morse Foundation, Inc.
The abstract placement of objects and the interest in light and time of day demonstrate Heade's use of Luminism.

flowers for Victorian America is crucial to a real understanding of Heade's work . . . flowers were universally considered symbolic of the human female . . ."[9] One of Heade's magnolia paintings [Pl. 6.1] not only captures the physical essence of the flower and its waxy, creamy petals but also does this so well that the effect is unbelievably real. In the nineteenth century, the magnolia represented love of nature as well as magnificence, and Heade captured it all.

Another painter of flowers was **Ellen Robbins**, who visited St. Augustine in 1892 but stayed at the Barcelona Hotel. A picture of Cherokee roses, *Roses by the Edge of the Forest*, 1896, (which was exhibited at the Henry Morrison Flagler Museum in Palm Beach in 1998) was mentioned in an article she wrote about her visit to St. Augustine. Although she did not stay in the Flagler studios, her remembrance of a visit there was provocative:

> One had a good opportunity in these receptions of seeing people who went for the winter to St. Augustine,—some very interesting, but a large number so uninteresting that it was depressing. The artists were very eager to sell their pictures; and these Flagler studios all being in a row, with a flight of stairs at each end, when any one looking like a buyer came by a door, a head was quickly protruded to see what artist was fortunate enough to secure the sale.[10]

The Tatler, a weekly newspaper which was published through 1902, presented the artists in a much better light than did Robbins' account. It is a rich source of information about how the artists lived and what many of them looked like. Instead of starving bohemians, visitors to the Flagler studios found affluent, well-educated, and well-traveled men whose studios were furnished with fine rugs and antique accessories purchased on their travels abroad. The pages of *The Tatler* were filled with descriptions of the

art displayed in the studios, including scenes of St. Augustine as well as European street scenes and landscapes. Pictures of the Near East, flower studies, and paintings of New England flourished alongside Venetian views.

Artist **Felix de Crano** redesigned *The Tatler's* masthead in 1896. He was a longtime resident of two of the studios and had lived in the town as well. He had studied in Paris, London, and Rome and at the Pennsylvania Academy of the Fine Arts. *Skyline, St. Augustine,* which can be seen at the Lightner Museum in St. Augustine, is one of several fine paintings of the town.[11] Another from a different angle is *View of St. Augustine,* 1899 (also at the Lightner). The influence of Impressionism can be seen in de Crano's piece, *King Street Looking East* [Pl. 6.5], 1906. *Oldest House, St. Augustine* [Pl. 6.6], 1908, is the artist's rendering of a very popular subject.

Artist **Laura Woodward** also received much recognition. She was born in Middletown, New York, and by 1894 she had established a studio on Lake Worth in Palm Beach. According to documented stories, she was influential in persuading Flagler to move to the southern end of the peninsula.[12] Her constant press centered on her studies of the royal poinciana tree with its magnificent red flowers, for example, *Poinciana on Lake Worth* [Pl. 6.7]. Since the flower blooms only during the summer, her paintings were the only means by which many winter visitors were able to see the blossoms.[13] Woodward's paintings, a source of great local pride, sold nationally. She was much more than a painter of pretty blossoms, however, as shown in her oil painting titled *Tomaka Creek, Near Ormond, Fla.*

Left: 6.7 Laura Woodward. *Poinciana on Lake Worth,* n.d. Watercolor on paper, 11 x 15 1/3. Courtesy Henry Morrison Flagler Museum, Palm Beach, Florida.
 The only way winter visitors could see the summer blossoms.

Facing page top: 6.5 Felix de Crano. *King Street Looking East,* 1906. Oil on paper on a wood panel, 20 x 16 7/16. Courtesy Lightner Museum, St. Augustine, Florida.
 An example of de Crano's Impressionist style.

Facing page bottom: 6.6 Felix de Crano. *Oldest House, St. Augustine,* 1908. Watercolor on paper, 11 x 14. Courtesy the St. Augustine Historical Society.
 De Crano's version of a popular tourist attraction.

[Pl. 6.8]. She worked well in both oil and watercolor. See chapter nine for more on Laura Woodward [Pl. 9.9].

Some artists arrived in St. Augustine about the time of Flagler's first visit. **George Seavey**, whose brother Osborne would later manage the Ponce de Leon, came in 1883. In many cases, the studios themselves were more interesting than the art. Seavey's flower paintings, though decorative, were not nearly as exciting as his studio must have been. According to *The Tatler,* he was a "... man of pleasing manners and the fierceness of his mustache is neutralized by the genial good humor which lights up his face." The paper provides a detailed description of his studio, calling it a "gem of art. . . . The floor was covered with rich and costly Turkish rugs, carved chairs and an English oak cabinet."[14]

Seavey's friends **William Staples Drown** and Frank Shapleigh were also visitors to St. Augustine before Flagler's hotel was built. In the August 1966 issue of *The Magazine Antiques,* Frederic A. Sharf wrote: ". . . All three spent their winters in St. Augustine, returning north in the spring to finish their commissions, and then they migrated to some fashionable resort for the summer months." A popular subject among the town's artists, as well as a tourist attraction, was the old slave market on St. Augustine's waterfront. Northern interest in the slave market had arisen from the Civil War and its tragedies. The market still is a reminder of a terrible period in our nation's history. Drown included the market in his *St. Augustine Harbor Scene.* Another painting of the same scene, *St. Augustine Harbor From Matanzas River,* 1890, was done by **Robert German**. Little is known about the artist except that he was renowned for his miniature portraits on ivory.[15]

After the obligatory visit to Paris to study under Emile Charles Lambinet, the landscape artist and teacher, **Frank Shapleigh** made a visit to California. In 1870 he completed the first known painting of Yosemite's Hetch Hetchy Valley. He maintained a studio at the Crawford House in Crawford Notch, New Hampshire, from 1877 to 1893. His stay in St. Augustine is carefully documented, and he is described at that time in the *St. Augustine Record* as ". . . a portly and pleasant mannered gentleman."[16]

Because he carefully identified and dated every painting, Shapleigh's works are invaluable records of the period. His output—not only in Florida but wherever he worked—was prolific. Examples of his Florida work are *Fort Marion, St. Augustine,* 1888, *The Cathedral Spanish Monument St. Augustine,* 1887, and *On the Ocklawaha River,* 1887, the last an often-depicted subject. In a series of St. Augustine street scenes he conveys the atmosphere of the

6.8 Laura Woodward. *Tomaka Creek, Near Ormond, Fla.*, n.d. Oil on canvas, 18 x 27. Courtesy the McKenna Collection.
 Woodward proved she was much more than a painter of pretty blossoms.

quaint, narrow streets. *Cypress Gates Landing*, 1892, is done in his unique style. The quality of work produced by such a prolific painter necessarily varies. Two of Shapleigh's paintings that rise above the rest are *In St. George Street, St. Augustine, Florida* [Pl. 6.9], 1892, and *The Slave Market, St. Augustine, Florida* [Pl. 6.10], 1891. Plate 5.25 in chapter five by George Smillie titled *Market and Bay, St. Augustine, Florida* shows another view of the slave market.

Shapleigh and William Staples Drown painted many pictur-esque St. Augustine scenes, some small and repetitive souvenir items, but other much finer works. A watercolor by Drown of the city gate [Pl. 6.11] is untitled but nonetheless unmistakable. *Fatio House, Green Street, St. Augustine, Florida* [Pl. 6.12], painted in 1871, and *Hospital St.*, 1891, indicate Drown's sharp, clear vision.

In keeping with the character of the times, well-to-do visitors grew disinterested in domestic scenes and turned to European subject matter, but they still bought pictures of local views as souvenirs. Yet a number of artists who came to Florida seem to

F.H. Shanleigh 1892

Above: 6.10 Frank Henry Shapleigh. *The Slave Market, St. Augustine, Florida,* 1891. Oil on canvas, 10 x 16. Courtesy the Collection of Charles and Gloria Vogel.
 The view the slaves saw from the slave market.

6.11 William Staples Drown. Untitled, (city gate, St. Augustine), n.d. Watercolor on paper, 9 1/2 x 13 3/4. Courtesy the McKenna Collection.
 An unmistakable view of an often-painted subject.

Facing page: 6.9 Frank Henry Shapleigh. *In S. George Street, St. Augustine, Florida,* 1892. Oil on canvas, 20 x 14. Courtesy the Collection of Charles and Gloria Vogel.
 One of the best in Shapleigh's series of St. Augustine streets.

have ignored the scenery. For example, the important artist **Elihu Vedder** was a frequent visitor to the state because his parents were residents of St. Augustine. Many of his pictures were exhibited at the St. Augustine Historical Society, but none were of Florida and there is no record of him at the studios.

Maria Cecilia à Becket received more than her share of copy in *The Tatler*, where she was frequently referred to as that "brave little woman."[17] One of her paintings in the Flagler College Collection, *Woodland Drive, St. Augustine*, n.d., was dedicated "To my friend Mrs. Henry M. Flagler." This is one of only two known paintings by à Becket. Victor Spark, the noted American art dealer, said that as an artist she was mediocre. However, she was excellent with public relations. As one newspaper reported, ". . . in addition to her genius as an artist [she] is a brilliant conversationalist, a delightful raconteur, generous and charitable." The *News Herald,* a publication in St. Augustine, reported: "The 'Storm at Sea,' her masterpiece, was made in a fit of genuine inspiration, on the shore, out doors, exposed to all the fury of the elements she was 'called' to portray. The picture shows the genius of the artist at white heat."[18]

Alfred Wordsworth Thompson, who had a fine reputation for historical paintings with figures and horses, enjoyed a stay at Studio Row to continue the work for which he was best known.

The town became a magnet for artists, and many who came did not stay at the Ponce. Among them was Southern genre painter **William Aiken Walker**. Most of the time he stayed at the Magnolia Hotel and exhibited his work at Tugby's Gallery. However, an 1894 report on Studio Row seems to imply that Walker was occupying one of the studios.[19] *The Tatler* described some of his work:

> . . . cotton fields with bursting bolls, the picker, in his patched and faded garments singing over his work or "toting" great baskets of the sometime "king.". . . the coloring and expression faithfully reproduced—children, chickens, pigs perfectly at home with their surroundings are wonderfully suggestive of plantation life.[20]

The genre paintings described by *The Tatler* made Walker's living, but though these pictures were popular at the time, many of Walker's other Florida scenes are more descriptive of the state. Like paintings by Robert German and William Staples Drown, Walker's *St. Augustine Harbor,* circa 1890, shown in a recent exhibition at the Flagler Museum in Palm Beach, includes the slave market as part of the view.

Walker had good reason to know Florida well. He wintered here

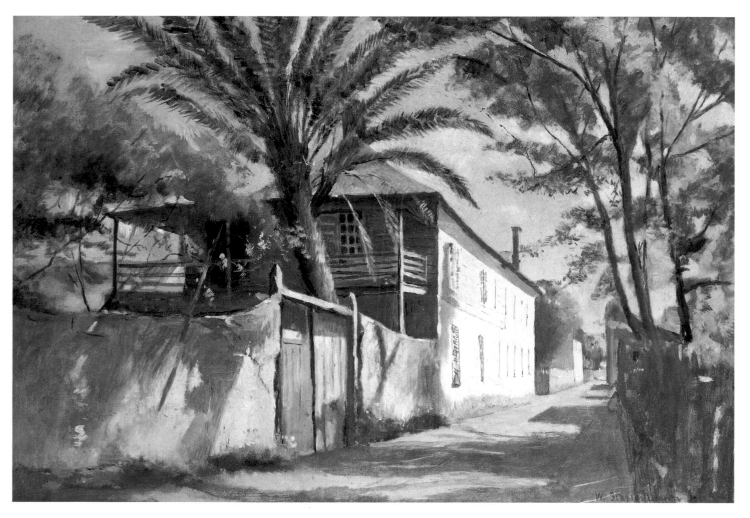

6.12 William Staples Drown. *Fatio House, Green Street, St. Augustine, Florida*, 1871. Oil on canvas, 14 x 20. Courtesy The National Society of the Colonial Dames of America in the State of Florida.

This painting indicates the sharp clear vision of the artist, even though many of his paintings were simple souvenir items.

6.13 William Aiken Walker. *Indian Key, Florida,* 1901. Oil on paper, 8 x 10. Courtesy High Museum of Art, Atlanta, Georgia. Gift of Mr. and Mrs. George E. Missbach Sr.

Though Walker praised Florida's beauty, here he shows a desolate place from which life has moved on.

6.14 William Aiken Walker. *Flagler Estate, Florida,* ca. 1890. Watercolor on paper, 3 3/4 x 2 1/2. Courtesy The Ogden Museum of Southern Art, University of New Orleans, New Orleans, Louisiana.

Although quite small and thought to have been painted for a Christmas card, this painting conveys a complete scene.

for more than thirty years. For twenty-three of those years, he helped run a boarding house in exchange for room, board, and an office he also used as a studio. In letters to friends, Walker was enthusiastic about Florida's natural beauty.[21] Yet, *Indian Key, Florida* [Pl. 6.13], 1901, depicts an abandoned fisherman's shack, a fish cage, and a sternless boat—a desolate, ravaged place from which life has moved on. In another work, a very small watercolor titled *Flagler Estate, Florida* [Pl. 6.14], circa 1890, Walker managed to convey a complex scene. Thought to have been painted for a Christmas card, this tiny scene reveals Walker's great ability to work in miniature. Small watercolors of this type by Walker are quite rare.[22]

Another notable artist, who was never mentioned in *The Tatler,* was **Otto Henry Bacher,** whose presence is documented by several etchings. Renowned not only for his etchings but also for his association in Venice with James McNeill Whistler, Bacher wrote a magazine article and a book titled *Whistler in Venice* (1908). *Ladies Entrance, Hotel Ponce de Leon,* 1887, one of Bacher's etchings, in the collection of Flagler College in St. Augustine, shows a mother and child with a doll on the steps of the hotel; several other figures can be seen through the windows.[23]

According to *The Tatler,* **C. Grafton Dana,** an American expatriate who lived in Paris for many years, came to St. Augustine in 1892 to paint. He occupied one of the Flagler studios in 1900, though one of Dana's paintings of St. Augustine's waterfront is dated 1885.[24]

Charlotte Buell Coman was a landscape painter from New York who came to St. Augustine in 1890. Her skill may be seen in *St.*

Augustine Barnyard Scene, circa 1890.[25] She exhibited extensively at the National Academy of Design but included only one work on Florida. Her painting *The Road to Town—Florida*, 1892, elicited a mixed review, throughout which she was referred to as "he." The reviewer states, ". . . it is plain that the artist has learned in suffering what he reports in his art, yet the frankness of it is amusing . . . at present these details share the tendency of everything to swim about and keep up an independent attitude, but with this exception, the picture shows a real acquisition to our open-air school."[26]

Further development of south Florida, with its warmer winter weather, eventually led to the decline of St. Augustine as a major winter resort. However, the old town is still of great interest for its history and its traditional architecture. St. Augustine remains a major art center with its active art clubs and the Lightner Museum, formerly the Alcazar Hotel.

Large numbers of artists came to Florida in the 1880s. Among them, **Stephen Parrish** began his career as an etcher rather late in life but was able to transform himself into a fine painter. Reproduced here is an etching he did in 1884, *Market Day, St. Augustine* [Pl. 6.15]. Other artists included **John Ehninger, Charles H. Osborne, Cassily Adams, Frederic Schiller Cozzens, George de Forest Brush**, and **James Brade Sword**. All left painted records of their visits to Florida.

George de Forest Brush studied at the National Academy of Design before leaving for Paris, where he continued under Jean Léon Gérome at the École des Beaux Arts. The influence of Gérome's precise academic style can be seen in *Indian Hunting Cranes in Florida* [Pl. 6.17], 1887. In discussing Gérome's students, H. Barbara Weinberg points out that in the Native American, Brush found a parallel to what he described as Gérome's "semi-barbaric" subject matter. Although Brush spent four years visiting western Native Americans, little is known about his time in Florida. However, the painting dramatically demonstrates Brush's adaptation of Gérome's ideas.

John Ehninger was best known for his paintings of familiar folklore themes and his illustrations of literary works by Washington Irving and Henry Wadsworth Longfellow. He too came to Florida, as can be seen in his etching titled *Mule Cart and Boy (St. Augustine, Fla.)* [Pl. 6.16], 1883, done in Ehninger's usual style.

Frederic Schiller Cozzens painted scenes of the America's Cup Race held off New York Harbor. He is known for those works as

6.15 Stephen J. Parrish. *Market Day, St. Augustine*, 1884. Etching on paper, 17 7/16 x 13 3/8. Courtesy The Parrish Art Museum, Southampton, New York. Dunnigan Collection, 1976. (Photo: Richard Hurley.)
 Parrish began his art career as an etcher.

6.16 John W. Ehninger. *Mule Cart and Boy (St. Augustine, Fla.)*, 1883. Etching on paper, 7 15/16 x 9 15/16. Courtesy The Parrish Art Museum, Southampton, New York. Dunnigan Collection, 1976. (Photo: Richard Hurley.)
 A genre scene in Ehninger's usual style.

6.17 George de Forest Brush. *Indian Hunting Cranes in Florida*, 1887. Oil on canvas, 21 1/2 x 26 1/2. Courtesy University of Oregon Museum of Art. Gift of Mr. and Mrs. Harold F. Wendel.

Brush's precise academic style and choice of topic reflect his training with Jean Léon Gérome.

well as for pictures of warships, fishing vessels, and, late in life, Native Americans. *Tarpon Fishing in Florida*, 1889, documents his interest in sportfishing as well.

James Brade Sword was a landscape, portrait, and genre painter who traveled widely in the United States, finally settling in Philadelphia. Before becoming a full-time painter, he was involved in canal and railroad construction. Not until 1861, later in his life, did he attend the Pennsylvania Academy of the Fine Arts. He too visited Florida, leaving *Hunting in the Everglades*, 1885, as a testament.

George Herbert McCord, who visited Florida among many other places, was born in Brooklyn. He studied for a time under several American artists before traveling to England and Italy. He painted *Florida Sunrise*, 1875, with a glowing light, reminiscent of Thomas Cole, yet retained the integrity of the Florida landscape. In another work of the same title, he moved into the realm of allusion with a nearly abstract image that suggests a dark group of trees looming in the foreground.[27] The artist continued in this style in *Sunset on St. Johns River* [Pl. 6.18], 1878, in which gradations of light and color not only add depth and perspective but also represent the sublime in nature. Although he exhibited extensively at the

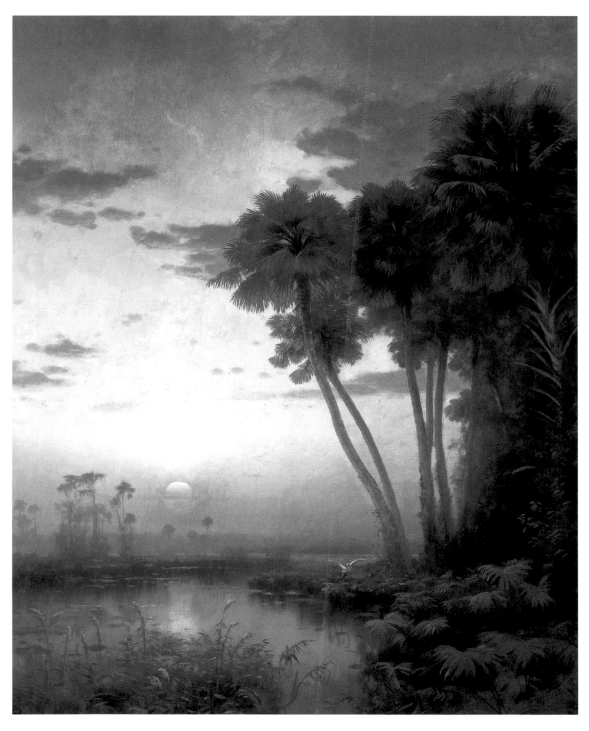

National Academy of Design, his only Florida offering there was *Evening in Florida*, painted in 1880.

Paul Frenzeny, born in France, came to America in the 1860s and soon became an illustrator for *Harper's Weekly*. The magazine sent him on a tour of the country with another French artist, Jules Tavernier. There is no record of Frenzeny's having been in Florida with the exception of his *Moonlight on the Everglades* [Pl. 6.19], 1890.

6.18 George Herbert McCord. *Sunset on St. Johns River*, 1878. Oil on canvas, 34 x 26. Courtesy The Ogden Museum of Southern Art, University of New Orleans, New Orleans, Louisiana.
McCord's gradations of light and color illustrate the notion of the sublime in nature.

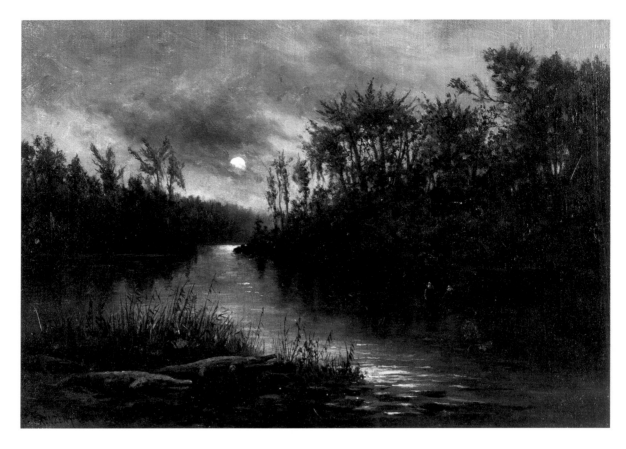

6.19 Paul Frenzeny. *Moonlight on the Everglades,* 1890. Oil on canvas, 10 x 14. Courtesy of the Sam and Robbie Vickers Florida Collection.

Frenzeny's lowering skies, evoking a night on the Everglades, are the only known record of his Florida visit.

6.20 Mary McClure. *Earliest View of Winter Park,* 1880. Oil on board, 9 7/8 x 14 1/2. Courtesy Steve Hess Collection.

Depicted are the building housing the first drugstore in Winter Park and the home of Mr. and Mrs. Knox of Osceola.

Rollins College was established in Winter Park in 1885 as a coed school, exemplifying some of the period's most liberal thinking. The college traces its origins to the Congregational Church and to Lucy Cross, a graduate of Oberlin College, who at the time was principal of an institute for young women in Daytona. Rollins College is still a major part of the town, and the Cornell Museum, part of the school, has an outstanding art collection. **Mary McClure**, probably an amateur painter, depicted *Earliest View of Winter Park* [Pl. 6.20], 1880. The picture features the first drugstore and the home of Mr. and Mrs. Knox of Osceola.[28]

Katherine Brimley Sumner Huntington, widow of Hezekiah Huntington, founder of Harper's Fire Insurance Company in Hartford, Connecticut, founded the town of Huntington as a cultural center in 1882. Located approximately thirty-five miles southwest of St. Augustine, the town could be reached by its own railroad track. Although still flourishing in 1887, the palatial home Mrs. Huntington built, as well as the thriving community and all it contained, disappeared without a trace in the 1930s, as reported in an article in *The River Flows North,* a history of Putnam County by Brian E. Michaels.[29] We know that at least one artist, **Mary White Bidwell**, was a winter resident.

Nearby another little-known artist, **Henry Koehler**, who has

been identified only as an American, left a small but very fine painting titled *Lake George, Florida* [Pl. 6.21], 1881, inspired by a large body of water southwest of St. Augustine. No further information about the artist has been found.

Canadian tourists are frequent visitors to Florida today, but there is evidence that they were visiting even by the end of the nineteenth century. **John Thrift Meldrum Burnside**, who emigrated from Scotland to Canada in 1855, was one of them. A banker and amateur painter, he left a memento of his visit with the painting *On the Beach, Daytona* [Pl. 6.22] in 1897. His windswept, lonely scene can no longer be seen because development has changed the area completely.[30]

On the west coast of Florida, development was slower. Tampa, founded in 1824 and chartered in 1834, did not escape the limitations imposed by isolation and a lack of inland transportation. As late as 1880, the community had only 720 inhabitants. In 1883, Henry Bradley Plant extended the South Florida Railroad to connect the Gulf Coast community with Jacksonville. The same

6.21 Henry Koehler. *Lake George, Florida,* 1881. Oil on canvas, 8 1/8 x 12 1/8. Courtesy Museum of Fine Arts, St. Petersburg, Florida. Gift of Spanierman Gallery.
 Koehler painted a large body of water southwest of St. Augustine.

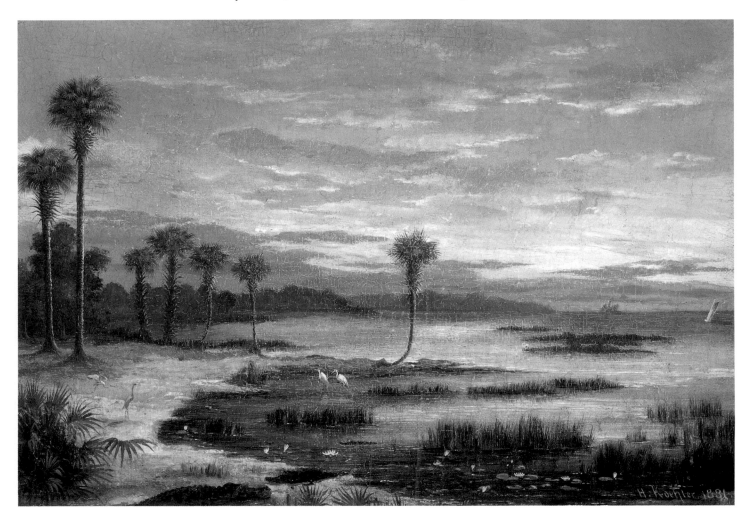

6.22 John Thrift Meldrum Burnside. *On the Beach, Daytona,* 1897. Watercolor on paper, 8 3/4 x 12 3/4. Courtesy the McKenna Collection.
An early Canadian view of the windswept, lonely beach.

year, the War Department deactivated the Fort Brooke military reservation on Tampa Bay, making the area available for private development. Two years later the cigar industry began operations. The discovery of vast deposits of phosphate generated one of the area's largest industries, and thousands of workers followed.[31]

The cornerstone for Henry Plant's Tampa Bay Hotel was laid six months after the Ponce de Leon opened in St. Augustine and began operations three years later. The hotel's grand opening took place in February 1891 with cost estimates ranging from one to four million dollars. David Nolan in his *Fifty Feet in Paradise* described the edifice:

> It was huge. It was ornate. . . . Rising like a mirage from the sandy streets of Tampa was an elongated brick building with thirteen minarets topped by silvered onion domes and gilded crescents. A walk around it on the outside covered a mile. From behind horseshoe arches of lacy gingerbread, the quarter-mile-long front porch overlooked a lush garden, which featured the words "Tampa Bay Hotel" planted in foliage. A large live-oak tree by the riverbank gave Plant a counterpart to Flagler's Ponce de León legend: he claimed, contrary to all records of longevity, that Hernando de Soto had parlayed with the Indians under its overreaching branches back in 1539.
>
> The interior was no less distinctive. Boston, New York, and Grand Rapids contributed their best, while the European shopping spree had netted items traced back to Louis Philippe and Marie Antoinette. There were bronze dwarfs, silver busts, Japanese screens, old masters . . . bric-a-brac and

more bric-a-brac. It was the age of clutter.

Plant's trains unloaded right at the porch, where rick-shaws waited to carry guests down the long hallway to the registration desk.[32]

Today the hotel serves as part of the University of Tampa and also contains a fine museum devoted to the history of the exotic structure, but its exterior still dominates the landscape [Pl. 6.23].

The calm view in a painting titled *Tampa,* 1900, by **William Henry Hilliard** (private collection), does not reflect the enormous growth and urbanization of the city already under way. An article published in the Jacksonville *Florida Times Union* in 1892 explains that Hilliard was invited to Tampa from California "for the express purpose of sketching . . . many picturesque and beautiful scenes about the Tampa Bay Hotel." We know that Hilliard visited Jacksonville for the same purpose.

On Florida's east coast, Flagler's railroad contributed to further development. In the first two decades of the twentieth century, Florida's population grew rapidly, increasing by as much as 42 percent. In contrast, during this time Tampa's population increased by up to 186 percent, reflecting its original small base.

Although great advances were occurring in photographic reproduction techniques, photography had not yet progressed sufficiently for pictures to be reproduced in newspapers. Therefore, illustrators who could attend important events were in great

6.23 Anonymous. *Tampa Bay Hotel,* n.d. Oil on canvas, 31 x 41. Courtesy Henry B. Plant Museum, Tampa, Florida.
Henry Plant's hotel (now the University of Tampa) rises like a mirage from the streets of Tampa.

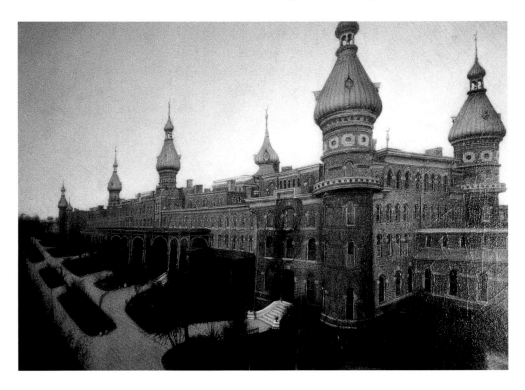

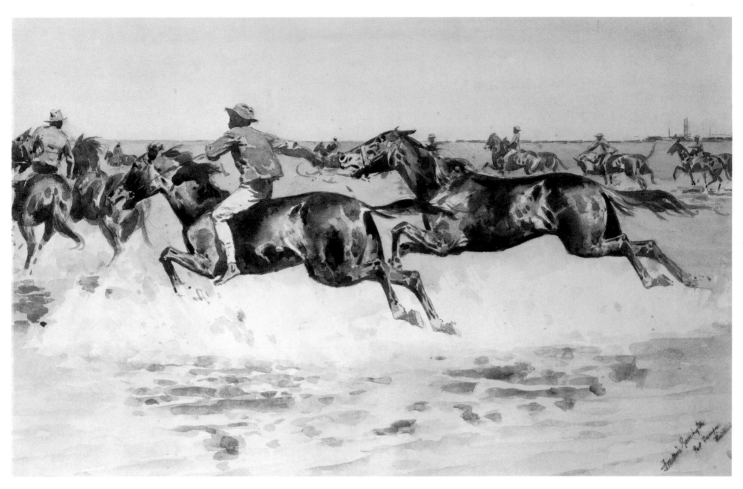

6.24 Frederic Remington. *With the Regulars at Fort Tampa,* 1898. Wash drawing, 22 x 30. Courtesy "21" Club, New York, New York.
 Remington painted this while on assignment for *Harper's New Monthly Magazine* to cover the Spanish-American War.

demand. Their drawings were transferred to wood blocks by engravers. Many of these illustrators went on to careers in the fine arts.

Frederic Remington, sent on an assignment in 1895 to write and illustrate a story about Cracker cowboys for *Harper's New Monthly Magazine*, was less than impressed with Florida. He wrote that it was a flat, sandy land ". . . truly not a country for a high-spirited race or moral giants . . ." and that the cattle were ". . . scrawny creatures not fit for a pointer-dog to mess on."[33] Two of his illustrations for the article were *Fighting Over a Stolen Herd* and *A Cracker Cowboy of Florida* [Pl. 6.25], circa 1895. The latter was modeled on Morgan Bonapart ("Bone") Mizell, a hard-drinking, hard-riding, hard-living cowboy known to light his pipe with dollar bills.

Remington is remembered mainly for his paintings of the vanishing West, which were used to illustrate magazines of the day. Largely self-taught, he spent a brief period at Yale Art School and, in 1885, some time at the Art Students League in New York City, where George de Forest Brush and Thomas Eakins were teaching. Following these periods of study, he began to submit

paintings to exhibitions, including those of the National Academy of Design, to which he sent pictures from 1887 to 1899. Remington is equally well known for his illustrations and sculptures. He knew the Native American, the cowboy, the cavalryman, and the Mexican vaquero. Because he had killed bison, grizzlies, and moose, his representations of these animals in painting and sculpture bear the stamp of authenticity and display his passion for his subjects.[34]

The Spanish-American War, or the War for Cuban Independence, brought Remington back to Florida to draw for *Harper's*, this time on assignment with the American troops. Remington went on with the army to Cuba, but several of his original sketches of Tampa and the army remain. *With the Regulars at Fort Tampa* [Pl. 6.24], 1898, demonstrates the vigor with which he infused his illustrations and sculptures.[35] The war resulted in another spurt of growth for Tampa, which the War Department selected as its main site of deployment.

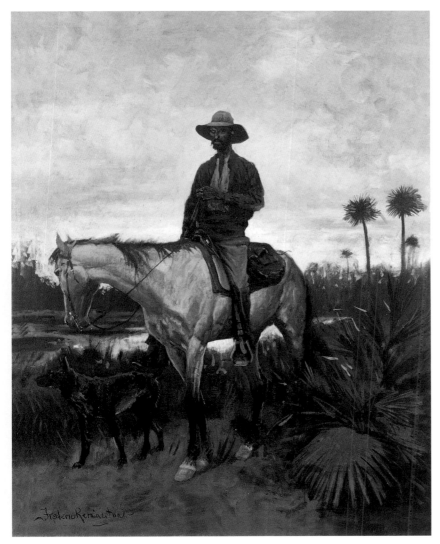

6.25 Frederic Remington. *A Cracker Cowboy of Florida,* ca. 1895. Oil en grisaille, 24 x 20. Courtesy "21" Club, New York, New York.

Not enamored of Florida, Remington wrote that it was ". . . truly not a country for a high-spirited race or moral giants."

In 1909 Remington died suddenly after an attack of appendicitis, leaving a legacy of more than 2,750 paintings and 25 sculptures.

Another artist who stayed with the troops in Tampa was **Charles Johnson Post**. His illustrations of the war included *71st Infantry, N.Y. National Guard Arrives in Ybor City, Fl.*, circa 1898; *Fifth Army Corps Prepares to Embark at Fort Tampa Fl.*, circa 1898; and *Cuban Revolutionists Leaving a Florida Cay for Cuba*, circa 1906. Following a successful life as an illustrator, Post became a career diplomat.

The important Realist **William Glackens** was also in Tampa early in his career, as an illustrator for *McClure's* magazine. Two of his 1898 works include *Scene of Embarkation at Port of Tampa* and *Loading Horses on the Transport at Port Tampa* [Pl. 6.26], 1898. Another drawing done the same year was *Street Scene at Tampa—Troops Coming.* In 1908 Glackens was one of eight artists designated as members of the "Ashcan School," which was a pejorative name coined by an art critic to describe paintings of gritty urban realism, which were against the academic trend of the day. Eventually Glackens became a part-time resident of Florida. At this writing, the only other Florida scene known to be produced by this artist is *Florida Swamp*, 1932. A photograph taken in the same year shows Glackens with Ernest Lawson,[36] another member of the Ashcan School, in Coral

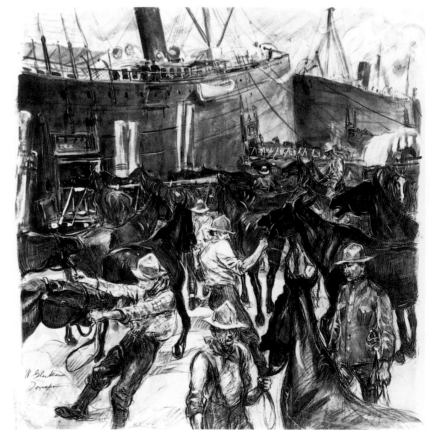

6.26 William J. Glackens. *Loading Horses on the Transport at Port Tampa*, 1898. Pen and ink with wash, white, and charcoal, 10 x 8. Courtesy Prints and Photographs Division, Library of Congress, Washington, D.C.
 Getting ready for war in Cuba.

Gables. In his long career, Glackens won many awards, including a number of gold medals.

Otto Henry Bacher sketched a scene from the Spanish-American War. His work *The Signal Tower at Jacksonville, #16 Signal Corps in Spanish-American War* [Pl. 6.27], 1903, appeared in an article about the war in *Century Magazine*.

Prior to 1900, the town of Sarasota, on Florida's west coast, established several art associations. **Adolph Robert Shulz** spent some summer months there and was active in the Sarasota Art Association and the Florida Federation of Art. Several of his landscapes in a private collection show Tonalist overtones, reflecting color in a soft, misty light. Tonalists saw objects in light and shade, representing them as they appear rather than as they are. ❧

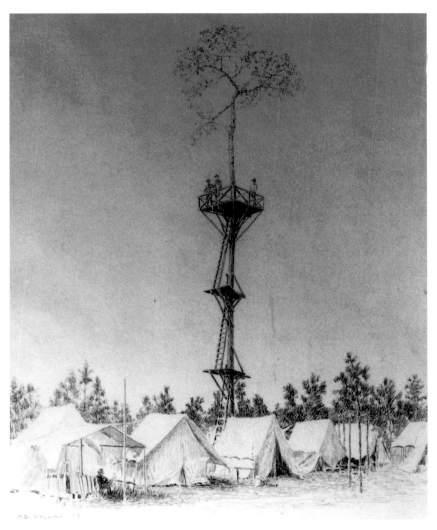

6.27 Otto Henry Bacher. *The Signal Tower at Jacksonville, #16 Signal Corps in Spanish-American War,* 1903. Pen and ink on paper, approx. 14 1/4 x 10. Courtesy the McKenna Collection.

Into

TROPICAL FLORIDA

A ROUND TRIP UPON THE St. JOHNS

ISSUED BY THE PASSENGER DEPARTMENT

De BARY-BAYA MERCHANTS' LINE.

Travel Tracts of the Late 1800s

AMONG THE STRONG EFFORTS to lure northern visitors to Florida at the end of the nineteenth century were many well-designed and illustrated travel tracts published by railroad and steamship companies. These publications provide an invaluable record of the period.

In 1881 the Cincinnati, New Orleans and Texas-Pacific Railway Company published *Winter Cities in a Summer Land: A Tour Through Florida and the Winter Resorts of the South* [Pl. 7.2]. The pamphlet is heavily illustrated, with an alluring full-color cover that shows a young woman wearing winter garb at the top left and lolling in a hammock in summer clothing at the bottom right. Through the use of art and an evocative narrative, the reader is taken on an imaginary train trip through the Southeast. As the train travels through Chattanooga, Tennessee, on its way to Jacksonville, Florida, the brochure says: " . . . It is our purpose to take the sleeper here, and say no more about it till we have arrived at Jacksonville, the Mecca of every health or pleasure seeking pilgrim." The landing of Ponce de León is depicted, as well as many other places of interest. The St. Johns River, historic St. Augustine, and other local attractions are described. Following a tour of Palatka and the state's citrus-growing region is a visit to the Oklawaha River. After that, the train travels northward through Georgia and South Carolina. Advertisements and rates for hotels, restaurants, books, and railroads are featured in the back of the brochure.

A travelogue of 1882 is titled *Into Tropical Florida: A Round Trip Upon the St. Johns* [Pl. 7.1]. A colorful cover and many illustrations also enhance this publication, but only a small portion of the text describes the area, while the remainder is devoted to advertisements. The travelogue is primarily an announcement of DeBary-Baya Merchants' Line, a steamboat [Pl. 7.3] that traversed

7.2 Anonymous. *Winter Cities in a Summer Land: A Tour Through Florida and the Winter Resorts of the South* (cover), 1881. Lithograph on paper, 7 5/8 x 5 5/8. Published by The Cincinnati, New Orleans, and Texas-Pacific Rwy. Co. Collection of the author.
 Art to lure Florida visitors.

Facing page: 7.1 Anonymous. *Into Tropical Florida: A Round Trip Upon the St. Johns.* Lithograph on paper, 7 5/8 x 5 5/8. Cover for a DeBary-Baya Merchant Line travel tract. Published by Leve & Alden, New York, 1882. Collection of the author.
 More ads than text: a taste of things to come.

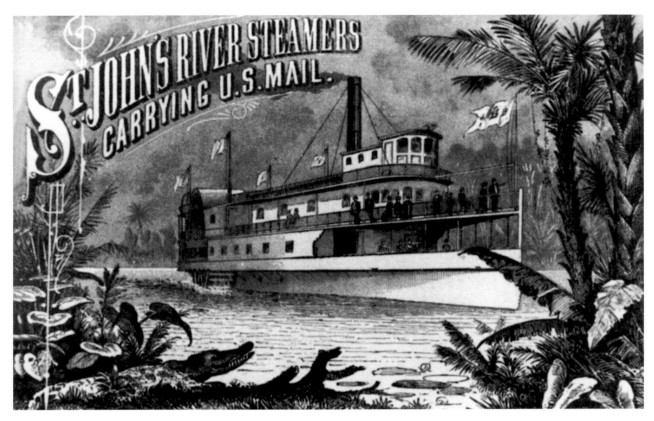

7.3 Anonymous. *Steamer DeBary*, 1882. Etching, 3 3/4 x 6 1/4. Published in the travel tract *Into Tropical Florida*, p. 27. Collection of the author.

Facing page top: 7.4 Anonymous. *Palatka, from the Larkin House*, 1882. Etching, 3 3/4 x 6 1/4. Published in the travel tract *Into Tropical Florida*, p. 15. Collection of the author.

Facing page bottom: 7.5 Anonymous. *Hotel Ponce de Leon—View from Orange Grove*. Etching on paper, 4 x 7 1/2. An illustration from *The Standard Guide to St. Augustine*, published by E. H. Reynolds, St. Augustine, Florida, 1890, p. 27. Collection of the author.

the area. As the trip down the St. Johns River is described, various locations are pictured, as in *Palatka, from the Larkin House* [Pl. 7.4], which shows a thriving community.

In 1890 *The Standard Guide to St. Augustine*, a far more elaborate directory, was published. It contains more etchings, text, maps, and advertisements and is a more attractive publication overall. All the engravings are of fine quality; most are signed with the initials "D. R." According to Charles Tingley at the St. Augustine Historical Society, the engravings were done by Dorothy Reynolds, the wife of the publisher, Erskine H. Reynolds. The handsome hotels in St. Augustine are illustrated in the foldouts; full-page views of the same scenes also appear, as in *Hotel Ponce de Leon—View from Orange Grove* [Pl. 7.5]. Another image shows the often-illustrated city gate [Pl. 7.6]. **Otto Bacher** engraved two, *Hotel Ponce de Leon—Main Entrance of Hotel* [Pl. 7.7] and *Ladies' Entrance, Hotel Ponce de Leon*. There is also a very detailed view of *Grace Church—Methodist Episcopal*. A view of the portico and gateway of the Hotel Ponce de Leon [Pl. 7.8] is signed by **Thomas Hastings** of the architectural firm Carrere and Hastings.

In 1892 another illustrated brochure for the Ocala and Silver Springs Company was published [Pl. 7.9]. Most of the views are photographs. As photography increased in popularity, the use of drawings waned, changing the character of the tracts. A subheading in the text reads, "Florida: the Land of Oranges, Tropical Scenery and Balmy Airs." Although not as attractive as the guide for St. Augustine, it is full of information for tourists and

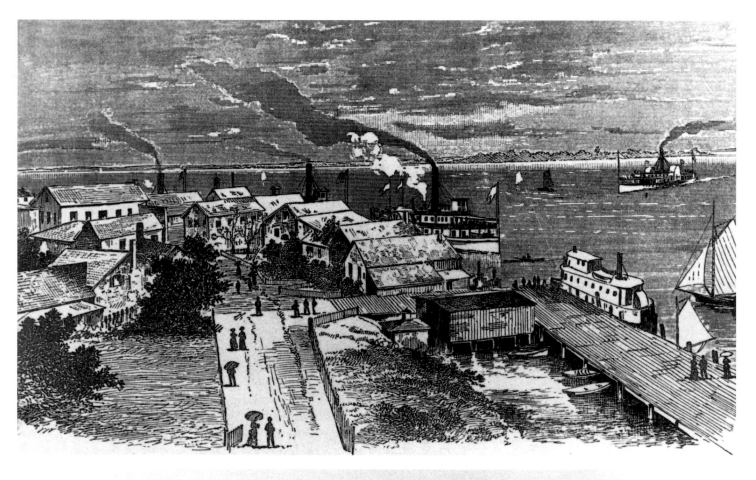

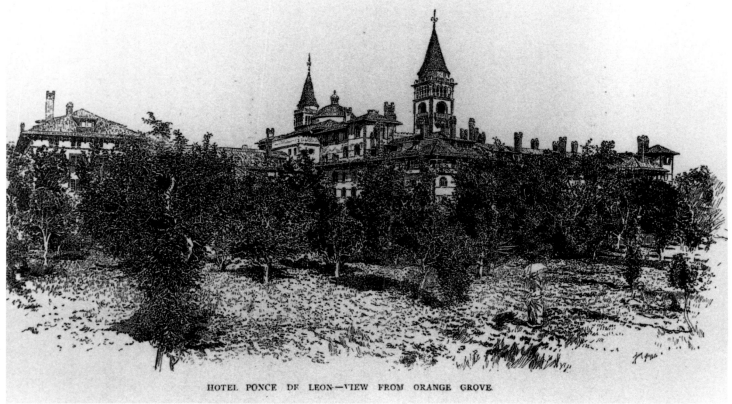

HOTEL PONCE DE LEON—VIEW FROM ORANGE GROVE.

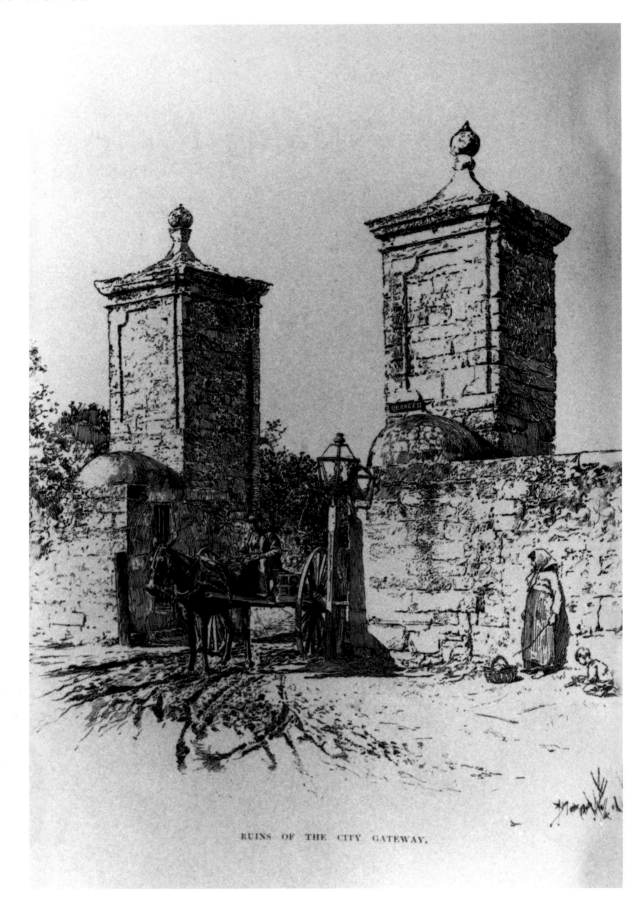

RUINS OF THE CITY GATEWAY.

Facing page: 7.6 Dorothy H. Reynolds. *Ruins of the City Gateway.* Etching on paper, 6 1/2 x 6. From *The Standard Guice to St. Augustine,* published by E. H. Reynolds, St. Augustine, Florida, 1890, p. 45. Collection of the author.
 Yet another view of those ancient gates.

Left: 7.7 Otto Bacher. *Hotel Ponce de Leon—Main Entrance of Hotel,* 1887. Etching, 5 1/2 x 7 1/2. From *The Standard Guide to St. Augustine,* published by E. H. Reynolds, St. Augustine, Florida, 1890, p. 35.

Bottom: 7.8 Thomas Hastings. *Portico and Gateway of Hotel Ponce de Leon.* Etching, 5 3/4 x 6 7/8. From *The Standard Guide to St. Augustine,* published by E. H. Reynolds, St. Augustine, Florida, 1890, p. 31. Collection of the author.
 A typical architectural rendering.

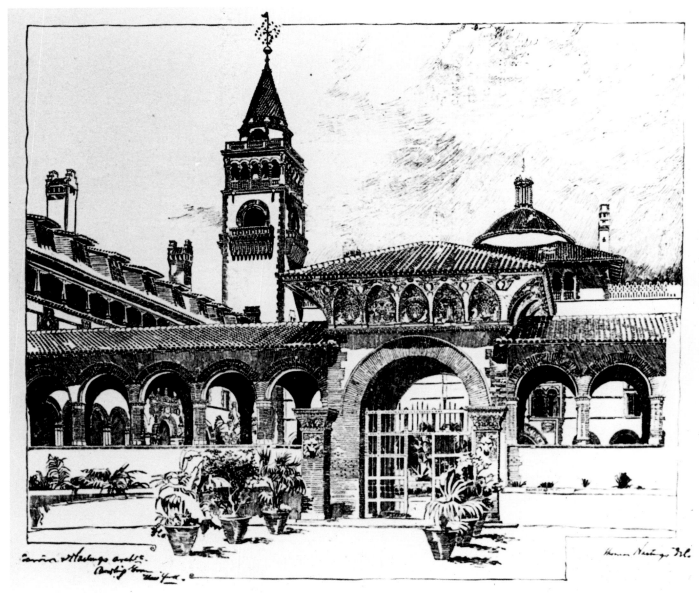

settlers, and, like the other guide, is blatantly promotional. In this piece Ocala is touted as the "coming capital" of Florida.

As late as 1935, *Shrine of the Water Gods* [Pl. 7.10], written by Carita Doggett Corse in the same spirit as the earlier brochures, was published as a historical survey of the area. The text was combined with traditional engravings of historical events and photographs of bathing beauties.

In 1889 a beautiful book titled *Florida Days* was written by Margaret Deland and illustrated by **Louis K. Harlow**. The first section is titled "St. Augustine at Daybreak, Noon and Night," and the second section is called "The Country along the St. Johns." The etchings, including *St. Augustine from the Island* [Pl. 7.11], and, in the original edition, a few tipped-in watercolor reproductions, enhance Deland's dreamy prose. Both an etcher and watercolorist, Louis K. Harlow also worked as a book illustrator.

The publications described here are only a small, representative sampling of the travel literature that was written. Though the travel brochures of the era were profusely illustrated, most of the engravings are either unsigned or the signature is illegible, and often little is known about the engraver. ❦

Above: 7.10 Anonymous. *Shrine of the Water Gods,* 1935. Lithograph on paper, 9 x 6. From a brochure written by Carita Doggett Corse. Copyright by Carita Doggett Corse. Collection of the author.
 This later travel brochure featured photographs of bathing beauties.

Left: 7.11 Louis K. Harlow. *St. Augustine from the Island.* Etching, 3 x 5. From *Florida Days* by Margaret Deland, Little Brown & Co., Boston, Massachusetts, 1889. Collection of the author.
 Harlow's art matches Deland's dreamy prose.

Facing page: 7.9 Anonymous. *Ocala and Silver Springs Company.* Lithograph on paper, 11 1/2 x 9. Published by John D. Rankin Co., New York, New York, 1892, cover illustration. Collection of the author.
 Most of the interior illustrations are photographs.

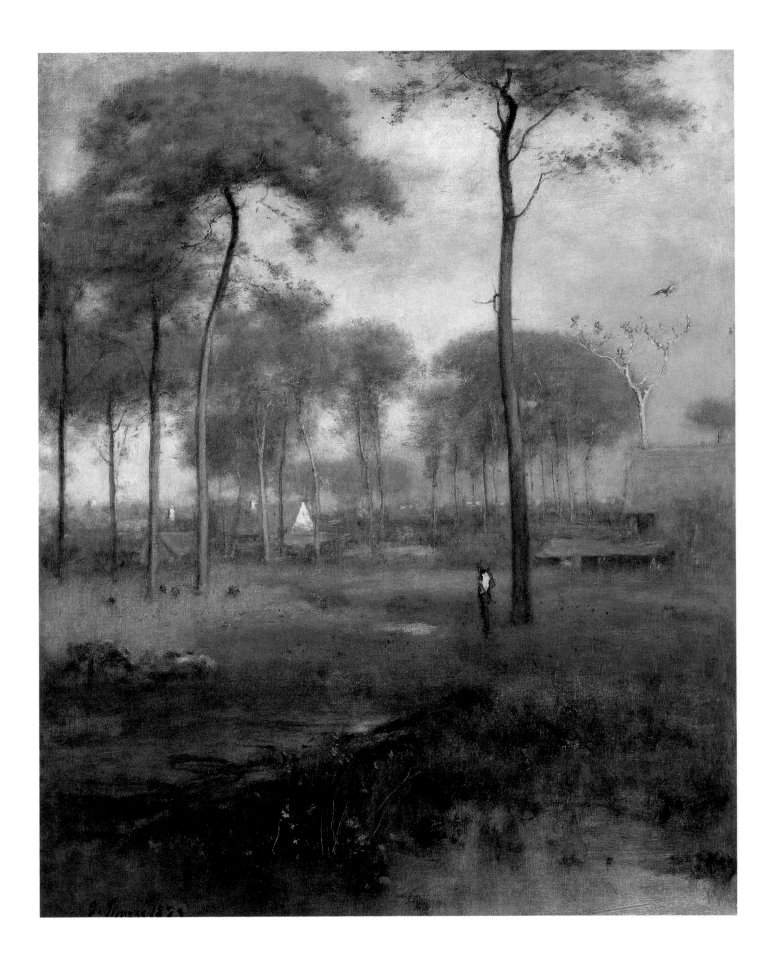

Some Notable Painters

THE PERSONAL CORRESPONDENCE of **George Inness**, the greatest innovator in the American landscape tradition, indicates that he visited Florida in the months of January and February between 1890 and 1894. Inness had an established reputation and had made a considerable purse as a landscape painter. After traveling through the state looking for new inspiration, he finally settled in a house and studio at Tarpon Springs. His early work, in the mode of the Hudson River School, emphasized the insignificance of humans before the grandeur of the landscape while concentrating on Realism in the painting's details. Later, his use of the Barbizon style of painting tends to blur some of the detail. Some critics thought that Inness' later pieces were influenced by Impressionism, but he never became a true Impressionist. Although always interested in the effects of light, Inness never allowed the palette to lose the stronger aspects of paint, nor did he choose to seize the moment in quite the same way as the Impressionists. He kept a darker palette than the Impressionists and also did not use short strokes meant to be blended by the eye.

Inness was born in Newburgh, New York, in 1825, the fifth of thirteen children. His early love of art was ignored by his father, who insisted he try the grocery business. After only one month, the fourteen-year-old walked out of the store and locked the door behind him. He studied briefly with a local painter, who soon had to confess that the boy had surpassed him. After a brief stint as an engraver, he received his only formal instruction from Regis Gignoux, a landscape painter. Later, a wealthy New Yorker named Ogden Haggerty came across Inness as he was painting in a park and became his patron. When Inness married in 1850, Haggerty sent the newlyweds to Italy for two years. Later, Inness, an ardent abolitionist, attempted to enlist in the Civil War;

Detail of Plate 8.7.

Facing page: 8.1 George Inness. *Early Morning, Tarpon Springs,* 1892. Oil on canvas, 42 3/16 x 32 3/8. Courtesy The Art Institute of Chicago. Edward B. Butler Collection. Photograph © 1977 by The Art Institute of Chicago. All rights reserved.
 Inness changed his style by accretion, adding layer upon layer of influences.

8.2 George Inness. *The Road to Tarpon Springs, Florida,*
or *Moonlight,* 1893. Oil on canvas, 25 1/4 x 30 3/8.
Gift of Mr. and Mrs. Myron Hokin. Courtesy Lowe Art
Museum, University of Miami, 55008.000. Copyright Lowe
Art Museum, University of Miami. All rights reserved.
 Inness' art shows elements of Realism, mysticism, and
Barbizon informality.

however, he was rejected because he suffered from epilepsy and had been sickly all his life.

In his early years, Inness began to use the effect of banding—that is, the contrasting of light and dark color strips—in his landscapes. One of his late pictures of Florida, *The Road to Tarpon Springs, Florida,* or *Moonlight* [Pl. 8.2], 1893, clearly demonstrates the effect of this idea. *Early Morning, Tarpon Springs* [Pl. 8.1], painted a year earlier, offers another view.

Elliot James Mackle Jr. clearly explains all the influences in Inness' work:

> Inness shaped his style by accretion, adding layer upon layer of influences, never entirely discarding that which had proved useful in the past. Elements of Realism, mysticism and Barbizon informality may thus always be present; none should be discounted in examining the meaning of the Florida pictures.[1]

The most important influence on Inness' mature style was his conversion to the doctrines of Emanuel Swedenborg. Mackle continues:

> Swedenborgianism teaches that the similarities and correspondences between the two worlds [spiritual and physical] are quite close, the differences a matter of degree and kind, the appearance of each not unlike the other. One of the chief differences is spatial: the distances between objects in the spiritual world are not absolute, as on earth; though they have the appearance of definite spaces, the "spaces" are not finite and measurable but unfixed and variable.[2]

Inness used Swedenborgianism by painting what he saw as if it were spiritual. *Tarpon Springs* could have its counterpart in the spirit world, but it is also suggested naturally in the painting by combining ideas and appearances of both.

George Inness Jr. also painted many Florida scenes. Although a better-than-average artist, he never achieved his father's fame nor developed the same facility with paint, always languishing in his father's shadow. After his father's death, his life changed dramatically. Inness went to Paris, opening a studio and exhibiting annually at the Paris Salon, where he won a gold medal. His painted figures distinguished his style from his father's, and late in life he turned to religious subjects. He kept his studio and home in Tarpon Springs and maintained another residence in Cragsmoor, New York. Eleven of his landscapes remain in the Universalist Church in Tarpon Springs. Two are triptychs: one, a series, is titled *Promise-Realization-Fulfillment*; the other illustrates the twenty-third psalm.

Hermann Herzog, less well known than Inness, was born in Bremen, Germany. He began his visits to Florida in 1869 after a highly successful career in Europe. Over the objections of his family and friends, he had enrolled in 1848 at the Düsseldorf Academy in Germany. A number of American artists also studied at the

8.3 Hermann Herzog. *Figures in a River Landscape,* n.d.
Oil on canvas, 15 3/4 x 19 3/4. Courtesy The Cummer
Museum of Art & Gardens. Gift of Mr. and Mrs. C. Herman
Terry.
 Placement of the fishermen against the landscape reflects
his European background.

school, which was noted for its severe disciplinary methods, its emphasis on firmness and accuracy of touch, and its technique for handling the freedom of an outline. Herzog's studies under the school's most famous instructors turned his interest to landscapes as he developed his own style.

Herzog's paintings were eagerly sought after by members of royalty and other collectors throughout Europe, making it possible for him to be independent and to paint whatever he wished when he came to this country. He is quoted in Donald S. Lewis' unpublished manuscript as saying, "I'd be damned if I would live and bring up my children under Prussian rule."[3] One of his sons, Hermann Jr., had moved to Gainesville, Florida, and between 1888 and 1910, Herzog visited the state often. According to his records, he did one thousand paintings in this country. Although some of his titles do not designate Florida, the estimate of Florida scenes is well beyond two hundred.

The style of landscape painting taught at the Düsseldorf Academy was similar to the sharply focused Realism of the Hudson River School. During his many visits to Florida, however, Herzog painted softer views of an unspoiled paradise. He was a sportsman, drawn to the wilds he portrayed. Although he was not an Impressionist, his handling of paint is mellow; his palette's high key may be a result of his Düsseldorf training and his studies with Hans Gude, the renowned Norwegian landscape painter. His paintings of Florida portray a wilderness very difficult to find today. In *Florida Marsh Scene*, now at the Samuel P. Harn Museum of Art at the University of Florida in Gainesville, he has not neglected the cloud formations in the sky. In *Figures in a River Landscape* [Pl. 8.3], the placement of the fishermen against the overwhelming landscape reflects—more so than in his other works—the artist's European background. Some of Herzog's other paintings can be seen at the Samuel P. Harn Museum of Art and at the Orlando Museum of Art.

The status of Key West as Florida's largest city (9,890 persons) was undoubtedly part of the reason for President Ulysses S. Grant's stop there in 1880 as part of his world tour. Illustrator and reporter **Frank Hamilton Taylor**, who accompanied the president, recorded the enthusiasm of the crowds who greeted him and documented the trip up the Oklawaha to Silver Springs, Fernandina Beach, the St. Johns River, and sites in St. Augustine.

Taylor was born in New York State in 1846. At the age of twenty-two, he moved to Philadelphia and served an apprenticeship in a lithographic firm. His career was launched when *The New York Graphic* employed him to illustrate the 1876 Centennial exhibition held in Philadelphia. Around 1879 he began his association with *Harper's Weekly*. Covering the Grant trip for *Harper's* was a prestigious assignment.[4]

Taylor's sketches and notes became the basis for the wood engravings and text in *Harper's Weekly*. At his request, his original sketches were returned; he then incorporated them into his portfolio along

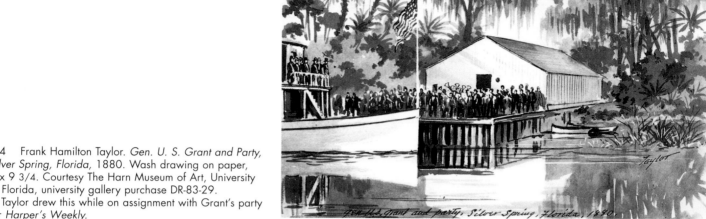

8.4 Frank Hamilton Taylor. *Gen. U. S. Grant and Party, Silver Spring, Florida*, 1880. Wash drawing on paper, 7 x 9 3/4. Courtesy The Harn Museum of Art, University of Florida, university gallery purchase DR-83-29.
 Taylor drew this while on assignment with Grant's party for *Harper's Weekly*.

with other material. Most of these items are now at the Samuel P. Harn Museum of Art at the University of Florida in Gainesville. A sketch showing an enthusiastic crowd is identified as *Gen. U. S. Grant and Party, Silver Spring, Florida* [Pl. 8.4], 1880. One sketch, titled *An Orange Grower's Home* [Pl. 8.5], is not included in this collection, suggesting that there may be others not included as well.

Winslow Homer came to Key West in 1886 to fish and paint. Homer began his career as a graphic artist. He was self-taught with training in lithography, a practice he began at the age of nineteen while apprenticed to the firm of John H. Bufford in Boston. After two years of treadmill existence, his apprenticeship ended and he began his career as a freelance illustrator. For the next seventeen years, he continued in that mode, working mostly for *Harper's Weekly*. He began painting in oils during the Civil War; his masterpiece from that period is *Prisoners from the Front*.

Homer began to use watercolors in 1873, finding the medium congenial to his talents. He was always interested in depicting human figures in outdoor settings—under the sky and in the sunlight. All of these elements came into play when he began traveling to Florida, visiting at least six times between 1886 and 1909. Sportfishing drew him, and he painted many sporting views of Florida; however, after his first visit the focus of his work changed markedly. His first five pictures of Key West were concerned with men's activities and included figures. Thereafter, most of his paintings portrayed wild and untouched areas. A practical man, Homer wanted to sell his work. He knew there was a market for art revealing natural areas where men could escape city life and live off the bounty of nature. Records show he produced forty-two watercolors of Florida scenes and subjects.

Homer was an original with an independent nature, and much has been written about his personality. He was blunt

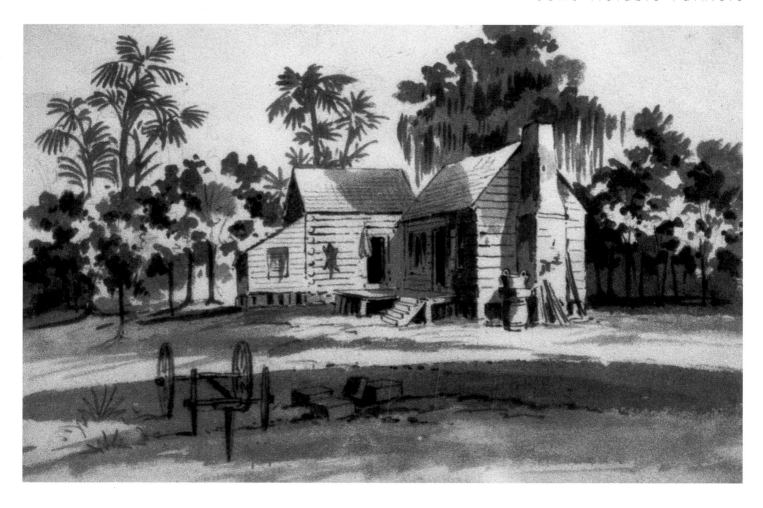

in response to inquiries. Oliver Larkin quoted from one of Homer's letters:

> I can offer you only water colors. I have them from Canada, Bermuda, Bahamas, Florida and the coast of Maine. They always net me $175 each, no frames, no matter the size: they are mostly about 14 x 21. Do you think you would like any sent to you on immediate approval for cash . . . If so what country would (you) like represented? Hurry up—as it's very cold here![5]

Larkin went on to say that Homer's gift was his use of white paper behind a transparent wash of color.

> There was no trick he could not perform with a broad brush to establish main forms, a wiry-thin one for accents, a thumb or a piece of blotting paper to suggest a texture, or the scratch of a knife blade to make water glisten or raise a highlight on a Negro's forehead. He could lead a blue wash down around white paper until that paper was cumulus cloud in the sky or foam on a reef, and he could twist his loaded brush once and for all across the water to make it here under the tropical sun.[6]

8.5 Frank Hamilton Taylor. *An Orange Grower's Home,* ca. 1880. Wash drawing on paper, 6 3/4 x 9 3/4. Courtesy the McKenna Collection.
 This is an exception to the drawings included in his personal portfolio.

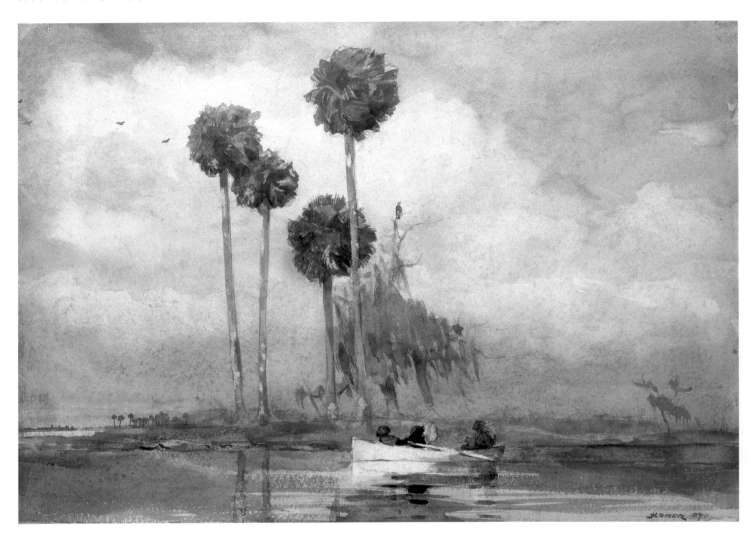

8.6 Winslow Homer. *White Rowboat: St. Johns River,*
1890. Watercolor on paper, 13 1/2 x 19 1/2. Courtesy
The Cummer Museum of Art & Gardens.
 Sophisticated, controlled image of the essence of
untouched Florida.

Facing page: 8.7 Winslow Homer. *The Shell Heap,* 1904.
Watercolor on paper, 19 5/8 x 13 7/8. Private collection.
 Realist composition joined to a crisp style made Homer's
watercolors unique among pictorial images of Florida.

Mackle points out that Homer's first visit to Key West in 1886
altered his perception of Florida. After that, his human subjects are
seen as subordinate to the setting and transient within it. Evidence
of civilization, although not entirely incidental, is limited to mov-
able tools: fishing rods and rifles, sails, steam, and rowboats. In
Florida, Homer had found an ideal place to indulge his favorite
sport while getting reasonable returns on the watercolor pictures
resulting from his trips.[7]

Two of Homer's paintings from the period 1886–1909 illustrate
his technique. *Homosassa River* demonstrates his clarity, while *In the
Jungle, Fla.* is a romantic vision of the still uncleared wilderness.
Both, at the Brooklyn Museum of Art, are examples of his skill in
watercolor. Homer was a modern painter who painted by his own
rules. He was influenced by Japanese art as early as the 1860s. His
scenes of Florida from 1890 are sophisticated, controlled images of
untouched Florida. *White Rowboat: St. Johns River* [Pl. 8.6], 1890,
exemplifies this approach. Mackle continues:

> . . . composition joined to style are what make Homer's watercol-
> ors unique in the pictorial imagery of Florida. The artist has

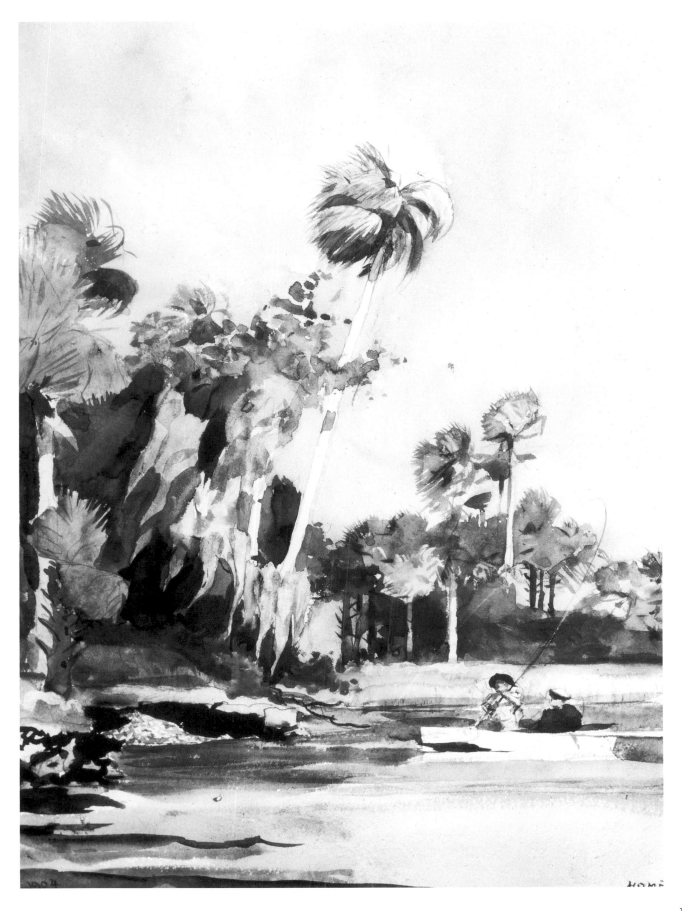

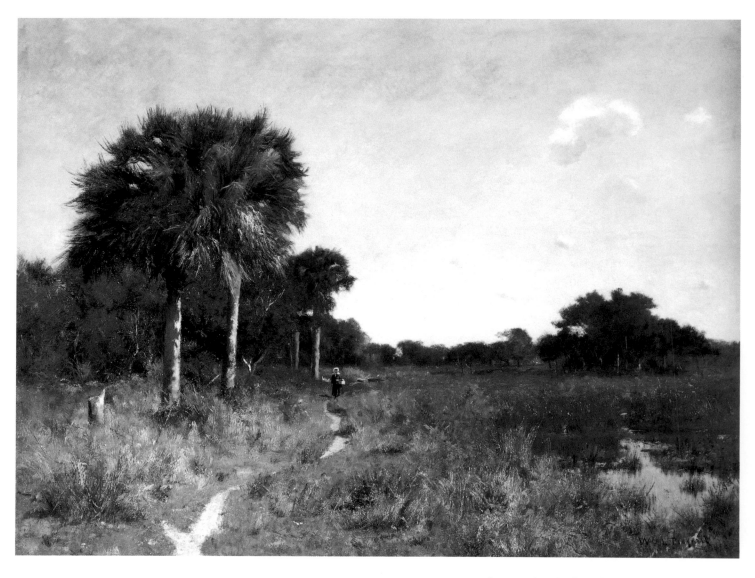

8.8 William Lamb Picknell. *Midwinter Florida*, 1894. Oil on canvas, 26 x 36. Courtesy of the Sam and Robbie Vickers Florida Collection.
A highly detailed foreground accented by two groups of sabal palms.

stripped away much of the message-loaded detail found in a picture by Moran or Bierstadt. Underbrush, individual palm fronds, clouds are drawn without the intricacy of nineteenth century Realism . . . dissolved into shapes, brushstrokes of pure color.[8]

Homer returned to Key West in the winter of 1903–1904. This visit produced *The Shell Heap* [Pl. 8.7], 1904, which shows how Homer's composition and style made his watercolors unique among images of Florida. Paintings from Homer's last years demonstrate his tendency to abandon nineteenth-century Realism. In this painting, details such as palm fronds and underbrush do indeed dissolve into dashes of pure color. Homer simplified even more than in his earlier works, although he still depicted

figures. Consciously or unconsciously, he continued the fantasy by portraying men as nearly faceless transients. Homer carried on the same idea in his inland pictures of Florida, notably the Homosassa series.

Many other artists visited Florida during the same period, leaving records of their work. Among the better known were **William Picknell** and **Robert Swain Gifford**. Picknell's short life was marked by both success and tragedy. George Inness' story inspired him, so when an uncle financed his first trip abroad, he studied for a time in the Paris studio of Jean Léon Gérome. He won acclaim at the Paris Salon and was sufficiently encouraged to return to Boston and open a studio. He traveled the United States from California to Florida. However, ill health and the grief caused by the loss of his only child resulted in his death at the age of forty-three. His painting *Midwinter Florida* [Pl. 8.8], 1894, is especially notable, given his long residence abroad and his brief career.

Gifford, a native of Massachusetts, became successful as an artist early in life. He became an associate of the National Academy of Design and by 1866 had begun a series of far-ranging travels, which resulted in many fine works. In the course of his wanderings, he visited Florida, as evident in *The Coast of Florida*, exhibited at the National Academy of Design in 1884, and *In the Everglades*, recently sold at auction.

Another visitor to the state was **James Madison Alden**, who came to Orlando in 1892. We can identify him by the paintings in a private collection. His expertise in watercolor is illustrated in *Pine Loch, Orange County, Florida, March 26, 1899, Sibley Cottage in Distance* [Pl. 8.9].

Like his father and grandfather before him, **Joseph Jefferson IV** was an actor and painter. For most of his life, he was one of America's most popular actors, known mainly for his portrayal of the character Rip van Winkle. Several paintings of Florida remain to testify to his artistic ability. He died in Palm Beach in 1905.

Another little-known artist, **Theodore Weber**, left designs for Mardi Gras floats for the annual event held in Pensacola. These flights of fancy can be seen at the John C. Pace Library at the University of West Florida, Pensacola. ❧

8.9 James Madison Alden. *Pine Loch, Orange County, Florida, March 26, 1899, Sibley Cottage in Distance*, 1899. Watercolor on paper, approx. 6 x 19. Courtesy the McKenna Collection.

The Twentieth Century until 1945

SILVER SPRINGS, SO FAMOUS in the nineteenth century, began to sink into oblivion by the late 1880s. The steamboat ride was gone, and even the unusual beauty of the springs did not seem to attract anyone until Philip Morrell invented the glass-bottom boat. By 1903 the boat rides had become a thriving business. But not until the late 1920s, when entrepreneurs again used advertising to bring in tourists, did Silver Springs once more become a popular attraction.

Motion picture companies began to use Silver Springs as a location for movie scenes as early as 1916. In 1929 a short talkie featuring Johnny Weismuller brought new attention to the springs. By the end of 1931, many movie companies were sending production crews, and scenes from several of the six Johnny Weismuller *Tarzan* films were made there.[1] Ever since, Florida has tried to lure back movie producers.

After World War I, many of the artists who came even briefly to visit Florida had already achieved recognition. **John Ottis Adams**, primarily a landscape painter, was impressed by the beauty of the moss-laden trees. *Hanging Moss, St. Petersburg* [Pl. 9.1], circa 1914–1915, reflects his earlier study of painting in Munich, where the style was realistic and atmospheric in vision, dark and warm in tonality, and daring in displays of bold brushstrokes.

Edward Lamson Henry, transcended the classification of genre painter to reach great artistic heights in his lifetime. Born in Charleston, South Carolina, in 1841, he spent most of his life in New York. His work depicted scenes of his everyday life as well as those from the past. During the Civil War he sketched with the Union army in Virginia. He won acclaim for his railroad views filled with authentic and anecdotal detail. Henry worked directly from nature when possible for landscapes and portraits and also chose architectural subjects and interiors. He came to Florida in 1919, the year he died. Although ill, he left a sketch and a more

9.2 Edward Lamson Henry. *Florida Landscape*, ca. 1919. Oil on board, 10 x 14. Courtesy New York State Museum, Albany, New York.
 This was one of Henry's last paintings before his death.

Facing page: 9.1 John Ottis Adams. *Hanging Moss, St. Petersburg*, ca. 1914–15. Oil on canvas, 18 x 14. Gift of the sons of J. Ottis Adams. Indianapolis Museum of Art. Photograph © 1991–1998, Indianapolis Museum of Art.
 Adams' work is realistic and atmospheric in vision, dark and warm in tonality.

9.3　Anthony Thieme. *Old Aviles Street, St. Augustine,* ca. 1938. Oil on board, 16 x 20. Courtesy Guarisco Gallery, Washington, D.C.
　A different view of St. Augustine than those painted earlier: sunnier, more prosperous.

9.4　Ben Austrian. *Jungle, Clark Estate, Palm Beach, Fla.,* 1916. Oil on canvas, 14 x 11. Courtesy the McKenna Collection.
　One of a series of local landscapes painted after Austrian had acquired fame and retired to Florida.

Facing page: 9.5　Eliot O'Hara. *Street in Palm Beach,* 1942. Watercolor on paper, 22 x 15. Eliot O'Hara Picture Trust. Courtesy Harmon-Meek Gallery, Naples, Florida.
　O'Hara published two books on watercolor techniques.

finished picture titled *Florida Landscape* [Pl. 9.2]. The prints produced after his paintings are much desired today.

Eliot Candee Clark grew up in New York, the son and student of landscape painter Walter Clark. He won an exhibition at the National Academy of Design when he was only thirteen. Greatly influenced by the American painter John Henry Twachtman, he also studied in Europe. Clark traveled widely, painting the American Southwest before coming to Florida. Clark published articles, biographies, and monographs on a variety of art-related subjects and also taught and lectured on art. In 1915 Clark visited Florida, where he painted *Indian River.*

Painter, etcher, and writer **Eliot O'Hara** studied abroad, traveled widely in the United States and Europe, and worked in many areas, including Palm Beach, as seen in his *Street in Palm Beach* [Pl. 9.5], 1942. In addition to his extensive career as an artist, he published two books on watercolor techniques. **Wallace Herndon Smith,** another artist who came to Florida, left us a painting titled *Parking on Boca Grande,* circa 1940.

Anthony Thieme gave us *Negro Town,* 1938. His extensive biography includes as many prizes as places of residence. Born in Rotterdam, he emigrated to the United States in 1917. He had studied art in Europe, but he wholeheartedly embraced the American art scene and became a member of numerous art groups. His sun-filled painting titled *Old Aviles Street, St. Augustine* [Pl. 9.3], circa 1938, offers a different view of the town than those seen earlier in this book. The street is as narrow, but the house portrayed is more substantial. Although based in New England, Thieme produced a number of paintings in St. Augustine before 1940. For example, his undated *Still Water, St. Augustine,* reveals a rural view in which the fisherman is the least important element. He continued to paint Florida scenes until his death in 1954.

Hailed in London as the "Landseer of chickens" (after English painter Sir Edwin Henry Landseer, who was noted for his animal painting), **Ben Austrian** may be the only American artist whose reputation was built on paintings of chickens. He was born in Pennsylvania and achieved his first successes there. In 1902 he opened a studio in Paris, but he did not achieve fame until his pictures were exhibited in London. He became a Florida resident later in life and went on to paint a series of local landscapes, among them the undated *Little Glimpses of Florida* and *Jungle, Clark Estate, Palm Beach, Fla.* [Pl. 9.4], 1916.[2]

John Singer Sargent came to Miami in 1917 at the invitation of wealthy businessman James Deering, who wanted the artist to paint his portrait. Born in Florence, Italy, to expatriate American parents, Sargent was twenty before he even visited the States. He became America's premier portraitist of international society and, along with Winslow Homer, its leading exponent of watercolor. Sargent, whose reputation had been made in oil, was a compulsive sketcher who turned to watercolor for pleasure. A number of local watercolor scenes remain to document his visit, including

9.6 John Singer Sargent. *Basin with Sailor, Villa Vizcaya, Miami, Florida,* 1917. Watercolor on paper, 13 3/4 × 20 1/2. Collection of the Orlando Museum of Art, Acquisition Trust Purchase 1988, 88.5.

Sargent's use of watercolor is modern and unconventional and conveys the dynamism of light and color.

Basin with Sailor, Villa Vizcaya, Miami, Florida [Pl. 9.6], 1917; *Palm Thicket, Vizcaya; Derelicts; The Bathers; Palmettos;* and *Muddy Alligators,* all painted in 1917. Unlike most of Sargent's previous essays, these works demonstrate a modern, unconventional use of watercolor and paper and a dynamic use of light and color.

James Deering, vice president of International Harvester Company, came to Florida in 1912. Although not as wealthy as Flagler, he arrived at a crucial time in the state's development. The completion of Flagler's railroad to Key West in 1912, along with Flagler's death in 1913, left a big hole in the local economy. Ten percent of Miami's population of 12,000 was left without work. During the nearly three-year construction of Deering's palatial home, Villa Vizcaya, begun in 1914, money poured into the local economy. In addition to hundreds of technicians imported from abroad, more than one thousand Miami men were employed.

Architect Paul Chalfin was the inspiration for Vizcaya. He persuaded Deering, who had originally wanted a Spanish-style home, that an Italian villa was better suited to the climate. The cost of building Vizcaya is estimated to have been between $7 million and $15 million. Chalfin had purchased much of the art and furnishings for this home in Europe in 1914, before the onset of World War I, at a cost of more than $1 million. The estate includes

a palace, gardens, elaborate outbuildings and surrounding walls, a gatehouse, a boathouse, homes for the chauffeur and superintendent, and greenhouses. Deering moved into Vizcaya in 1916, a few days before Christmas. He spent nine winters at Vizcaya before his death in 1925 at the age of sixty-six. Altogether, he had spent about twenty-seven months in his palace.

After Deering's death, no one in his family wanted to live in Vizcaya, and much of it stood deserted for several years. The Deerings sold off parts of the estate until 1952, when only thirty acres remained. This property contained the palace, formal gardens, gatehouse, and several other elaborate attendant buildings. Dade County purchased those holdings for $1,050,000, and furnishings and art worth $1.5 million were donated. Vizcaya has been preserved and is now operated as a museum under the Dade County Parks and Recreation Department. The original European art and artifacts are still on view.[3]

Artists often create works that do not follow a customary pattern. One such artist was **Abbott Fuller Graves**, who was acclaimed throughout his life for his garden paintings and scenes of North and South America and Europe. These scenes are usually filled with bright sunlight and bold colors. However, his *St. Augustine*, 1910, (private collection) rather than showing the old town, depicts a rural scene in a somber mood with sketchy brushwork. A more typical Florida work by Graves is his undated *Garden Scene with Fountain*, a painting suffused with light and color. In contrast, the pastel of a young girl looking at the sea in *Child in the San Augustin Bastion, Ft. Marion, St. Augustine* [Pl. 9.7], circa 1910, beguiles with its simplicity.

Another artist whose claim to fame rested on realistic still-life paintings was **George Cope**. He studied at the Pennsylvania Academy of the Fine Arts and met Hermann Herzog (see chapter eight) at the 1876 Centennial in Philadelphia. Herzog's loose Barbizon manner influenced Cope somewhat, but he preferred meticulous detail. In 1891 Cope received a commission to paint a Florida landscape for a land development company that planned to exhibit at the Chicago World's Columbian Exposition in 1893. He spent two months in Florida, returning with sketches of the landscape. Perhaps one of these sketches was the foundation for *Central Florida Lake Scene*, 1915 (now in a private collection).

Artists came to Florida from everywhere. **Harold Harington Betts**, who came from a family of Chicago artists, made his reputation as an artist of the Southwest but visited Florida many times. *Miami Palms, Florida* [Pl. 9.8] is an example of his work. The figures in the landscape tend to be diminished while bright colors are emphasized.[4]

One of the towns whose growth was stimulated by Henry Flagler's railroad was Ft. Lauderdale. The town was named for Major William Lauderdale, commander of a unit of Tennessee volunteers in the Second Seminole War. An outpost established by the major in 1838, it was rarely occupied for most of the nineteenth century. In 1905, after the railroad connection was established, Governor Broward

9.7 Abbott Fuller Graves. *Child in the San Augustin Bastion, Ft. Marion, St. Augustine*, ca. 1910. Pastel on paper, 14 x 10. Private collection.
The pastel of a young girl beguiles with its simplicity.

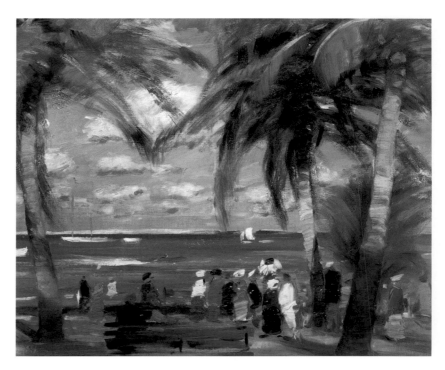

9.8 Harold Betts. *Miami Palms, Florida,* 1917. Oil on canvas, 23 x 27. Courtesy Eckert Fine Art, Naples, Florida.
 Though Betts was known as an artist of the Southwest, he visited Florida frequently.

ordered the draining of the Everglades. The resulting prosperity brought incorporation of the town in 1911, and by 1920 it had become a major tourist attraction.

A painting by **Arrah Lee Gaul** titled *Garden in Fort Lauderdale,* 1920, in the Vickers Collection, demonstrates the level of sophistication the town already possessed. It shows a garden court with pool and statuary, the architecture reminiscent of a southern European villa. Impressionistic style and strong color predominate on the canvas. Gaul attended the Philadelphia School of Design for Women (later known as the Moore College of Art), where she became chairman of the art education department. She was an inveterate traveler who spent years abroad painting in Asia and Europe. The artist visited Florida often between 1920 and 1964. Obviously she was not permanently put off by the killer hurricanes of 1926 and 1928 or by the Depression that followed.

The first of the two hurricanes inspired a strong picture by **Franz Josef Bolinger**, *Hurricane in Miami 1926,* painted in 1927, now in the Vickers Collection. Bolinger was born in Illinois and moved to Ft. Lauderdale when he was two years old. In 1919 the family moved to Miami, where Bolinger attended college, receiving degrees in science and art. His work reflects the European sensitivity engendered by his teachers, Jamuli Al Hadji-birra and a Swedish landscape master, Dr. Eric Carlberg. Late in his career, Bolinger was selected by the U.S. government as the official artist for Cape Kennedy, where he completed paintings of the early spacecraft launches.

The 1920s brought tremendous expansion to Florida. Growth was of boom proportions, but a real estate market collapse in 1926, coupled with the devastating effects of two hurricanes, shut it down, and Florida entered the Great Depression three years ahead

of the rest of the country. The population grew from less than a million in 1920 to almost 1.5 million in 1930. Miami increased from fewer than 30,000 residents in 1920 to more than 110,000 in 1930. Thirteen new counties were created in the 1920s, most of the growth taking place in the southern part of the peninsula.[5]

Artists continued to arrive, and as their numbers increased, they began to organize into groups. As early as 1918, before the big boom, the Woman's Club of Palm Beach organized artists to hold an exhibition. **Jane Peterson** and **Isabel Vernon Cook**, Northern artists who were visiting at that time, encouraged the local group. Since men were not eligible for membership in the Woman's Club, the Palm Beach County Art Club was formed to accommodate them. **Laura Woodward**, who had arrived in Palm Beach County before the turn of the century, was a pioneer of the art club. In time this group became the foundation for the Norton Gallery of Art, established in 1940, the earliest Florida art museum of note.[6]

Laura Woodward told columnist Frances Gillmor in the *Palm Beach Times*, (February 17, 1924) how she began to paint in Palm Beach County:

> I was disappointed in St. Augustine. . . . It was not the South as I had imagined it. But in St. Augustine I was told of the beauty of Palm Beach. In those days it was a hard trip of several days from St. Augustine, but when I finally arrived I found the semi-tropical foliage of which I had dreamed. It was the most beautiful place I had ever seen—long before the great hotels had gone up, long before the jungles had been "improved" . . . I did not paint much at first. I was seeing all the little details, all the differences from the north. I decided then, however, that if a hotel was ever put up here, which would warrant my opening a studio, I would be the first to come . . . Then the Royal Poinciana (1894) was built. I came down. It was in March. I told Mr. Flagler that I wanted to open a studio then and there in the Royal Poinciana. . . . Then I painted . . . There were footpaths through the jungle. My sister and I explored every one, I knew every foot of it. I even knew the times when it would make pictures; the times when the shadows and the sun would be just right. In the north I could paint outdoors only in the summer . . . Here, however, I could paint all the year around . . .[7]

The same columnist reported that many of Laura Woodward's paintings hung in the writing room of the Royal Poinciana Hotel. We do not know if her untitled painting [Pl. 9.9], 1898, was among this group. See also chapter six for more on Laura Woodward [Pls. 6.7 and 6.8].

Augustus Goodyear Heaton became president of the Palm Beach County Art Club in 1924. An artist with an international reputation, he had arrived in Florida just a few years before. His obituary claimed he was the first American to study at the École des Beaux Arts under Alexandre Cabanel. Until 1890 he exhibited widely at

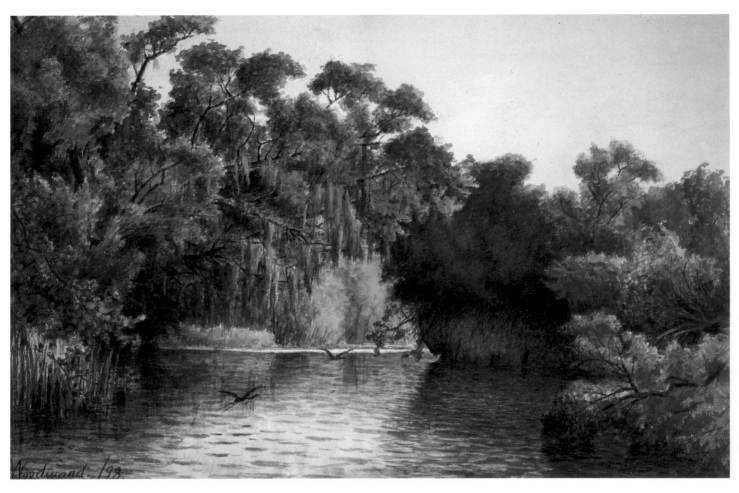

9.9 Laura Woodward. Untitled (scene along St. Johns River) 1898. Oil on canvas, 13 1/2 x 21. Private collection.
A north Florida scene—not the semitropical foliage she dreamed of.

the National Academy of Design, specializing mostly in figure and genre scenes. Robert W. Torchia, in his catalog *A Florida Legacy: Ponce de León in Florida*, describes Heaton's painting entitled *Ponce de Leon, Dreaming He Has Found the Fountain of Youth*, n.d.: ". . . a semi-comical Rip van Winkle–like Ponce de León was clearly the least heroic of all the early conquistadors."

The art club's exhibition in March 1924 received extensive coverage from the local papers, which recorded the attendance of numerous enthusiastic visitors. Among the exhibitors listed were **Frank Gervasi, James Mallory Willson, Anne Fletcher, C. Barrett Strait,** and **Daisy Erb**. Local amateurs swelled their numbers. In addition to the art club's annual exhibitions, the papers were filled with reports of other art events that occurred during the year.

The Association for Artists began showing work in 1927 at a gallery on Australian Avenue in Palm Beach. Many wealthy patrons were in attendance, which was undoubtedly the reason for the roster of artists represented at the first showing. The exhibit demonstrated the cultural advances being made as well as the existence of a market for fine art. The paintings, not locally inspired, were the creations of already well-known artists. Included were works by **Emil Carlsen, Charles Shepard Chapman, Ernest Lawson, Charles Woodbury,** and **Henry Bayley Snell**, all

academicians of the National Academy of Design. Some were associates of the academy, including **Rae Sloan Bredin, John Fenton Folinsbee, Paul King,** and **Harry Aiken Vincent.** Female artists, mentioned separately, included **Hilda Belcher, Jane Peterson,** and **Estelle Manon Armstrong.**[8] Jane Peterson exhibited in St. Petersburg as well. It is not known how many Florida scenes were included at the gallery's first showing. Although local landscapes were always popular as curiosities, European scenes remained the most desirable purchases. Bronzes were also featured, notably those of **Harriet Whitney Frishmuth.**

Another exhibition the following year included many of the same artists, as well as **Arthur Bowen Davies, Richard Emil Miller, Maurice Brazil Prendergast,** and **Theodore Robinson. Randall Davey** was another artist who exhibited, showing his specialty pictures of horse races.[9] Yet another exhibition, held in February 1928, was reviewed in the *Palm Beach Post* of February 19. It listed Hilda Belcher, holder of many awards and many other memberships, as a portrait painter.

Jane Peterson showed thirty-two paintings at the 1928 exhibit, some of which are mentioned in the same review: "Her scenes of Venice and Constantinople and her interesting flower studies are alive with color. . . . She paints with a sure hand and a full palette."[10] These descriptions point out the continuing interest of the well-to-do in scenes from abroad. Peterson was one of New York City's most important artists during this period. Her paintings provide a vital link between Impressionism and Expressionism. She traveled abroad for further study with money earned as an art instructor. In 1938 Peterson was named the "most outstanding individual of the year" by the American Historical Society for her artistic achievement. She was only the second woman in the history of the society to be so honored. Many of her paintings of Florida scenes as well as flower paintings are extant. In *Florida Waterway* [Pl. 9.10], circa 1920, her ability in color and composition shines.

Although native Floridians who became artists were rare, one such was **Andrew Janson,** who was born in Marianna. He studied in New York but returned to Florida in the 1940s, working for the Florida State Museum and the state park service. Janson, whose contributions were mainly in the field of natural history, provided paintings of bird groups for the Museum of Natural History in New York. He received a medal for this work in 1936. His *Spanish Gateway, Florida* is very different in appearance from his scientific works because it concentrates on light and color.

Hermann Dudley Murphy was an artist who visited Florida in the early twentieth century. Though known for his Whistler-inspired figures, in *Coconuts* [Pl. 9.11], circa 1919, he chose to portray only the landscape. Note how he concentrated on the tonalities of the scene.

In the aforementioned *Post* review (February 19, 1928), the reviewer said of **George Snow Hill** that he "portrayed Paris as an artist sees it, both literally and figuratively. Two of his canvases . . .

9.10 Jane Peterson. *Florida Waterway*, ca. 1920. Gouache on paper, 18 x 24. Courtesy D. Wigmore Fine Arts, New York.

Peterson's paintings provide a vital link between the Impressionist and Expressionist movements.

are views of Paris from his high-perched studio window." Later, Hill achieved fame for his paintings and murals of Florida in public buildings. In the same review it was noted that **Anne Goldthwaite** (or Goldwaite—her name is seen spelled both ways) depicted work-a-day life in the "quarters" in the old South. Washerwomen at work are contrasted as "irregular splotches of color take shape at the proper distance into daring flower arrangements. . . ."[11]

Wallace Herndon Smith received a degree in art from Princeton and continued his education in Paris at the École des Beaux Arts. He lived a life of privilege, wintering in Boca Grande and Palm Beach and spending summers in the North. Two of his well-known paintings are *Parking on Boca Grande,* done in the 1940s, and *Terrace at the Gasparilla Inn,* circa 1945–1950.[12]

No story of art in Palm Beach can ignore the contributions of **Addison Mizner**. He arrived in Palm Beach in 1918 on a stretcher (as did his future patron, Paris Singer). An assortment of ailments, undoubtedly aggravated by a weight of three hundred pounds, had brought him to that state of affairs. However, instead of an end, it proved to be a beginning. Mizner was an architect, and Singer, one of the heirs to the Singer sewing machine fortune, loved art and artists.[13]

Before coming to Florida, Mizner had studied architecture in Spain and worked with Willis Polk, a proponent of the Spanish mission style in California. He had also visited Guatemala several times and become enamored of Spanish colonial artifacts. Mizner's background paved the way for his innovative dwellings in Palm Beach, and he set a standard for style where none had existed before. When Mizner came to Florida, social life centered on the hotels. Practically no one owned a home until Mizner showed Palm Beach the possibilities of recreating exotic architectural beauty in Florida.

Facing page: 9.11 Herman Dudley Murphy. *Coconuts,* ca. 1919. Oil on board, 16 x 20. Courtesy Eckert Fine Art, Naples, Florida.

Murphy concentrated on tonalities in this scene.

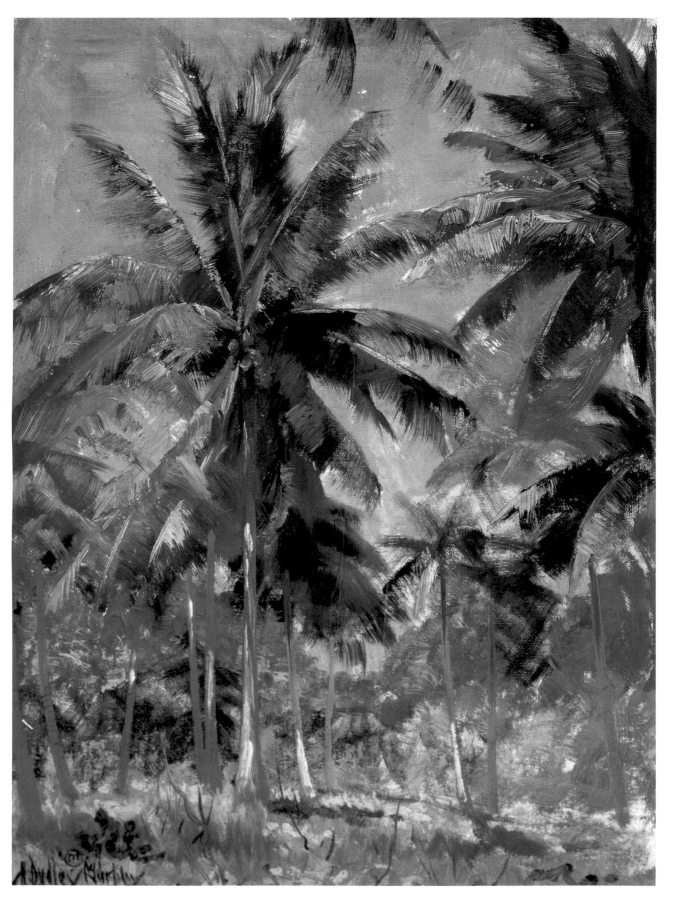

a collection of over seventy works of art destined for a future museum. She also collected chests—ranging from tiny rosewood boxes with inlaid designs to large German chests made of iron—and developed a passion for gardening. Arthur Cummer died in 1943, but Ninah continued her interest in gardening and art. When she died in 1958, she left her paintings and three distinct gardens to a foundation funded to research and present the collection. The Cummer Museum of Art & Gardens opened to the public on November 11, 1961. Perhaps because of Ninah Cummer's example, art associations began to form in Jacksonville beginning in the 1950s.

The Art Club of St. Petersburg was established before the Palm Beach groups. In 1914, J. Liberty Tadd, an artist who was born in England and came to Florida from Philadelphia, founded the Florida Art School in St. Petersburg. After he died, his wife helped found the Art Club of St. Petersburg. From its inception, the club held ten exhibitions each winter season. **George Inness Jr.** was one of its first exhibitors. A collection of etchings by **Joseph Pennell**, exhibited circa 1916, was perhaps the only one of its kind that had been shown in the South up to that time. **Susan Ricker Knox** showed her famous immigration paintings in 1923, and **Frank Weston Benson** exhibited twice. In Florida and later in his career, Benson concentrated on sporting pictures of birds and the sea rather than on the figural compositions for which he was previously well known.[17]

Benson's visits to Florida began in March 1914 when he was invited to spend a week on the houseboat of a friend, Gus Hemenway. Bela Pratt, a close friend, also went along.[18] That he made other trips to Florida is documented in many paintings. Faith Andrews Bedford, in her 1989 exhibition catalog about the life and work of her grandfather, wrote: "A stunning etching of egrets most certainly evolved from a sketch made in Florida . . . but the finished work was done in his Riverway studio or in North Haven (Maine)." A mixed media study of the Florida Keys was done by Benson around 1915. Another watercolor, *Souvenir of Florida* [Pl. 9.14], 1934, was seen in a 1989 retrospective at the Berry-Hill Galleries in New York. According to Bedford, Benson began to work seriously in watercolor in 1921, with the human figure no longer the focus of his work. Here is Bedford's description of *Souvenir*: it ". . . captures the shimmering heat of noon-day off the Florida Keys. The boat seems to scarcely interrupt a delicate unity of sea and sky; the horizon is all but dissolved."[19]

Some other artists who became well known in the St. Petersburg area were **George Snow Hill**, who favored oils, and his wife, **Polly Knipp Hill**, who was an outstanding printmaker and painter. Her etching titled *Green Benches, St. Petersburg* [Pl. 9.15], circa 1940, demonstrates her skill. George Hill was one of the muralists employed by the Treasury Department Section under the Works Progress Administration (WPA).[20] Also working in St. Petersburg, **Wilmot Emerton Heitland** specialized in watercolors but was also

9.14 Frank Weston Benson. *Souvenir of Florida*, 1934.
Watercolor on paper, 19 x 24. Private collection.
 ". . . captures the shimmering heat of noon-day off the
Florida Keys."

9.15 Polly Knipp Hill. *Green Benches, St. Petersburg,* ca. 1940. Etching on paper, 8 1/4 x 9 3/4. Courtesy Museum of Fine Arts, St. Petersburg, Florida. Gift of Costas Lemonpoulos.

Facing page: 9.16 Charles Bullett. *Sunset,* n.d. Oil on board, 14 x 9. Courtesy Eckert Fine Art, Naples, Florida. Sunsets, produced with glowing Luminist colors, were Bullett's forte.

an illustrator and teacher. **Mark Dixon Dodd** from St. Louis went to New York City in 1917 to study at the Art Students League. There he met and married Vivien Moran, grandniece of the artists **Thomas, Edward,** and **Peter Moran.** In 1924 the Dodds moved to St. Petersburg for the health of one of their children. Dodd soon established an art school, and both artists became involved in the cultural life of the area. In 1933 Mark Dodd was commissioned by the State of Florida to paint a mural for the Florida exhibit at the World's Fair in Chicago.

Charles George Blake, a retired monument and mausoleum manufacturer, devoted the years from 1929 to 1936 to producing ninety scenes of St. Petersburg. Copied from photographs in painstaking detail and done in watercolor, they depict nearly every edifice and notable object in the town. Blake's early art training had been in Boston and Chicago, and the project fulfilled a youthful dream.

The region around Ft. Myers on Florida's west coast was not heavily populated in the early twentieth century. **Charles Bullett** from Bellevue, Kentucky, was an early winter resident who painted on nearby Sanibel and Captiva Islands. Beach scenes and sunsets, produced with glowing, Luminist colors, were his forte. His painting *Sunset* [Pl. 9.16], n.d., captures the fading light on water wreathed by palms.[21]

The story of the growth of Sarasota and its connection with art is the story of the Ringlings, particularly John. Although the art he collected was not American art, his cultural contribution to Florida cannot be ignored. Circus king John Ringling first came to Sarasota in 1911. He liked the town so much that he bought a waterfront home. The Ringlings were prosperous, with many investments, including his famous circus.[22] He and his wife, Mable, shared the Venetian fantasies popular at the time, and when they decided to

build a new home, they hired architect Dwight James Baum and requested that he build them a house along the lines of the Doge's Palace in Venice, topping it with the tower from Madison Square Garden. When completed in 1926, it was christened *Cà d'Zan*, which in Venetian dialect means "House of John."[23]

The real estate collapse in 1926 removed much of the luster from Florida development, but John Ringling's investments were sufficiently diversified to weather the storm for a while. Sarasota became the winter headquarters for the circus. By this time Ringling had become an avid art collector and announced plans to build the finest art museum in the South next to his palatial home.[24] John H. Phillips, one of the architects from New York's Metropolitan Museum of Art, was brought in to design an appropriate setting for the Old Masters already purchased. The museum opened in 1930.

In the course of his travels, Ringling had met the Munich art dealer Julius Böhler. In 1925 they traveled together and began to purchase decorative columns, urns, and sculpture for a hotel Ringling was planning in Sarasota. These objects now adorn the museum. In a period of only six years, Ringling purchased 625 paintings. While he bought the masterpieces of other schools, he also assembled one of the great repositories of Baroque paintings, the latter enabled by the public's momentary disinterest in baroque art. The collection is perhaps most famous for the magnificent *Triumph of the Eucharist* series of the Flemish painter, Peter Paul Rubens. Art for Ringling was concentrated in the period from about 1550 to 1775, but the museum now also exhibits nineteenth-century art and actively collects twentieth-century art.

Anthony F. Janson in his *Great Paintings from the John and Mable Ringling Museum of Art* states:

> There can be little question that he had an innate sympathy for an era whose character was much like his own. The baroque was marked by epic theatricality and illusionism; they formed a splendid, if artificial, facade that reflected the rich complexity of the era while masking its inner contradictions. The largest part of Ringling's holding is in Italian art. Nevertheless, if any single acquisition can be said to epitomize his taste, it is the Rubens tapestry cartoons, which brilliantly embody these very qualities.[25]

The crash of 1929 also saw the death of Mable Ringling. After that, nothing went right for John. He died of pneumonia in 1936, leaving a mountain of debts. He also left frozen assets conservatively appraised at more than $23 million. It took more than a decade to untangle the details of his estate, but the State of Florida was the beneficiary of a grandiose art museum and a mansion that reflect the life and tastes of John Ringling. Although the art he collected was not American art, his cultural contribution to Florida cannot be ignored.[26]

When building the museum, Ringling had announced: ". . . I

intend to put in a college, too, to teach art and things like that." He did found a school not far from the museum in 1931. A number of the teachers of the Ringling School of Art have left their artistic impressions of the area, as well as, of course, their influence on young new artists. **Stanley Wingate Woodward**, an instructor there from 1937 to 1938, had a long career that brought him many prizes. In 1937 he entered his painting *After the Hurricane* in an exhibition at the National Academy of Design. **Lois Bartlett Tracy** took instruction from Woodward, as well as from **Ernest Lawson** and **Hans Hofmann**. She was born in Michigan, but her painting shows that most of her time was spent in Florida, where she won many prizes. She received a degree from Rollins College in 1929, and in 1936 her painting *The Florida Jungle* [Pl. 9.17] won first prize for best Florida landscape at the Florida Federation of Art. She later became most interested in Abstract Expressionism, and her paintings are part of the permanent collections of The Smithsonian Institution and The Metropolitan Museum of Art.[27]

9.17 Lois Bartlett Tracy. *The Florida Jungle,* 1936. Oil on canvas, 30 x 25. Courtesy Cornell Fine Arts Museum, Rollins College, Winter Park, Florida.
 In 1941, after a fire destroyed all of Lois Bartlett Tracy's possessions (including much of her art), she switched from painting landscapes to painting in the abstract: "I decided that from then on I would only paint the basic substance of things rather than their outward appearance."

In this era, very few artists were tempted to paint a scene like *Florida Roadgang: Gulf of Mexico* [Pl. 9.18], 1938. Georges Schreiber, born in Belgium, was grateful for the opportunities offered in this country. He traveled to each of the forty-eight states and recorded in the same number of paintings his impressions of each state. Another of his watercolors is entitled *Cotton Pickers, Louisiana*, n.d. Schreiber became one of the artists with the Associated American Artists of New York City, and his work was held in major collections.

So many impressive paintings indicate the growing popularity of Florida as a place to visit and depict in the first half of the twentieth century. The colorful, undated *Florida Spanish Style Building*, by **Howard Russell Butler** (in a private collection), is one example. The artist began drawing as a boy but went on to take a science degree from Princeton University in 1876 and a law degree from Columbia University in 1882. Despite successes in these fields, he decided in 1884 to pursue a career in fine art, studying at the Art Students League before spending two years abroad. His work is held by museums across the country. **George A. Hays**, a self-taught Providence, Rhode Island, artist, left a striking undated oil titled *Morning in the Florida Everglades* (collection: Vincennes Art Gallery, Chicago). **Theodore Coe** studied at the National Academy of Design and in Paris, as well as with John Henry Twachtman. He later settled in Tampa, where he painted *Florida Hills*, 1920, and *Palms*, circa 1926.

Reynolds Beal painted the *Matanzas River, St. Augustine, Florida* [Pl. 9.19] in 1919. Beal attended Cornell University, graduating with a degree in naval architecture, but turned to the fine arts after graduation and went abroad to study, primarily in Madrid. Upon his return he began more formal study with William Merritt Chase.

9.18 Georges Schreiber. *Florida Roadgang, Gulf of Mexico,* 1938. Watercolor on board, 19 1/2 x 23 1/2. From the permanent collection of the Cornell Fine Arts Museum, Rollins College, Winter Park, Florida.
 Roadgangs were a familiar sight in those days.

9.19 Reynolds Beal. *Matanzas River, St. Augustine,
Florida,* 1919. Oil on canvas, 23 7/8 x 30. On extended
loan at the Cummer Museum of Art & Gardens, Jacksonville,
Florida. From the collection of Robert B. and Thelma M.
Nied.
 Beal developed his own style using colors that are fresh
and light.

He developed his own style using colors that are fresh and light; a
good example of these elements is the *Matanzas* painting. National
Academy of Design records show a number of Beal paintings of
Tampa dating from 1920 to 1944.

Above: 9.20 Frederick C. Frieseke. Untitled, ca. 1920.
Oil on canvas, 26 x 32. Courtesy the Kilmer Family Trust.
 The style of Frieseke's Florida paintings is quite different
from that of his more famous paintings.

Left: 9.21 Clarence Holbrook Carter. *New Construction in
Lakeland, Fl.,* 1926. Watercolor on paper, 18 x 12. Courtesy
Harmon-Meek Gallery, Naples, Florida.
 This painting demonstrates the power of the building boom
of the '20s.

Clarence Holbrook Carter, who became a Florida resident after an active career in the Midwest, painted *New Construction in Lakeland, Fl.* [Pl. 9.21], 1926, when he was just 22. By 1945 the artist had turned to the resort aspects of Florida in such paintings as *Riding the Surf.*

Frederick Carl Frieseke was one of the outstanding American Impressionists of his day. His official biography states that he moved to France in 1898 and never returned to the United States. In 1932 he dictated a memoir to his daughter, Frances, of a trip to Florida taken when he was only seven. Later he stated that he was not an expatriate since he returned to the states often. Nevertheless, he lived abroad for the rest of his life. In the 1920s he produced a series of paintings—including a number of landscapes in watercolor and oil—from memories of Florida, concentrating on local life in the Jacksonville area. Among these pervasive recollections is an untitled landscape [Pl. 9.20], circa 1920. These works vary widely in style from those paintings that brought Frieseke fame. Two of the others are *Night, Orange Grove* and *Plantation House* (both in the Kilmer Family Trust). They seem to emphasize the nostalgia with which they were produced.

St. Augustine continued as an art colony well into the twentieth century and still attracts artists today. **Louis Charles Vogt** was a resident of the town by the 1930s. Three bright and colorful works document his residence. Two of the paintings, titled *Garden Scene, St. Augustine* and *Ladies of Aviles Street*, both dated 1932, depict town scenes. The former shows couples around a table in a garden setting; the latter depicts a picturesque neighborhood with people in a bright Impressionistic style. Quite a different approach is taken in a painting of two people on horseback against a lowering sky, identified by Vogt as *Horseback Riders, Anastasia Island* [Pl. 9.22], circa 1930s.

Guy Wiggins was not only a winter visitor in the 1930s but was also conducting art classes. Carleton Wiggins, his father, had an acclaimed career as a landscape painter. He was also the first tutor of his son, who went on to study architecture and drawing at the Brooklyn Polytechnical Institute and painting at the National Academy of Design. Guy Wiggins won many important prizes from 1916 until his death in Florida in 1962. Although Wiggins taught in Florida, no Florida paintings have surfaced.

In the 1920s the Miami suburb of Coral Gables was developed by George Merrick, who had been buying up land for some time. Merrick designed the buildings in the popular Mediterranean style. He avoided the anathema of newness by bringing in antique tiles from the ruins of Spain, Morocco, and Cuba. Stucco walls were stained to give a weathered appearance. A rock quarry became known as "The World's Most Beautiful Swimming Pool," as shown in the painting by Martha Walter. As part of the unsurpassed ballyhoo of the marketing of Coral Gables, Merrick engaged William Jennings Bryan to speak twice daily at the pool.[28]

9.22 Louis Charles Vogt. *Horseback Riders, Anastasia Island,* ca. 1930s. Oil on canvas, 30 x 36. Private collection.

One of three paintings Vogt did of St. Augustine in the 1930s.

9.23 Martha Walter. *The Venetian Pool, Coral Gables*, ca. 1926. Watercolor on paper, 19 1/2 x 15 1/2. Private collection. Photo courtesy D. Wigmore Fine Arts, New York.
 Philadelphian Martha Walter was a prolific painter of Impressionist beach scenes and landscapes.

Martha Walter was a well-known, prolific painter of Impressionist beach scenes and landscapes. She first studied under William Merritt Chase before winning the prestigious Cresson Traveling Scholarship in 1908, which enabled her to study abroad, mainly in Paris. Disenchanted with the academicism of the Parisian schools, she set up her own studio and began producing *plein air* paintings in the manner of the French Impressionists. At the beginning of World War I, she returned home and took up painting at various East Coast beach resorts such as Coney Island and Gloucester. Her resort scenes emphasize the colorful aspects of their subjects. When the war ended, Walter traveled between Europe and the United States, continuing to concentrate on coastal views. According to Carl David, who handled Walter's estate, when she came to Florida, she divided her time between Palm Beach and Miami. *The Venetian Pool, Coral Gables* [Pl. 9.23], circa 1926, is evidence of her light, vivid style and her artistic presence in the area.

In 1926 Merrick paid novelist Rex Beach $18,000 to write a slim, syrupy, hardcover volume titled *The Miracle of Coral Gables*. The book featured beautiful color illustrations by **Edward Arthur Wilson**, a prize-winning illustrator. Although not of great literary value, the book was a gem of the bookmaker's art, and free copies were distributed to everyone who answered a newspaper ad. The illustrations in the book, for example, *Where Tropic Trade Winds Blow* [Pl. 9.24], demonstrate Wilson's talent. Although attempts were made to make Ft. Lauderdale an art colony, the Gables became more attractive to artists.

In 1920 and 1921, artist **Frederic Clay Bartlett** built a home called Bonnet House in Ft. Lauderdale. His father-in-law, Hugh Taylor Birch, had bought three miles of beachfront property in 1893 for less than one dollar an acre. When Bartlett and Helen Louise Birch were married, her father gave the couple a house lot, the dimensions of which are described in the Bonnet House history as "... about as far as you can swing a cat." It was a good swing, consisting of seven hundred feet of beachfront property that extended back more than thirty-five acres. Although not an architect, Bartlett designed the home to fit his own conception of a Southern plantation house. The couple collected post-Impressionist paintings; when Helen died, her husband donated the collection to the Art Institute of Chicago. Bartlett painted at the site and also developed the house in many imaginative ways. His paintings, along with many of the artifacts, can still be seen in his studio there. In 1930 he married Evelyn Fortune, who was divorced from Eli Lilly. With Frederic's blessing, Evelyn took up painting. **Evelyn Fortune Bartlett's** work focused on flowers, still life, and portraits, and her preference was for brilliant color. Within a few years she held a one-woman exhibition at New York's Wildenstein Gallery, where several rooms were filled with her work. She usually wintered at Bonnet House but gave up this practice in her last years. She died in 1997 at age 109. Today the property is in the Florida Trust for Historic Preservation, and the house is open year-round to visitors.[29]

Many other artists visited or became residents of south Florida. In 1933 **Louis Comfort Tiffany** was in Florida again, visiting the Miami and Coral Gables areas with his companion, **Sarah E. Hanley**. Both left evidence of their many visits. Tiffany's sojourns are documented in paintings titled *The Children Wading*, 1917; *Study of a Tree on the Shore*, 1924; *On the Beach, Miami, Florida*, 1931; *Sarah Painting, Florida Shore*, circa 1933; and *Sarah Reading in the Grotto*, circa 1933. These complement paintings done in St. Augustine in 1883 and 1885 (see chapter six).

Ernest Lawson, who first gained notice in 1908 as one of the "Eight" in the Ashcan School, also resided in Coral Gables. Lawson, however, depicted river and landscape scenes rather than the street scenes that had inspired the epithet "Ashcan." He was drawn to Florida during the boom of the 1920s, and his painting *Florida River Scene with Seminoles*, 1920, in the Vickers Collection,

Facing page: 9.24 Edward A. Wilson. *Where Tropic Trade Winds Blow*, 1926. Lithograph on paper, 5 5/8 x 3 5/8. Illustration for *The Miracle of Coral Gables* by Rex Beach. Designed and printed by Currier & Hartford Ltd., New York, 1926.
A gem of the bookmaker's art.

9.25 Ernest Lawson. *Tropical Moss*, 1934. Oil on canvas, 40 x 50. Courtesy Eckert Fine Art, Naples, Florida.
 Lawson's vegetation is highlighted with bright color and heavy impasto.

illustrates his early interest in Florida. In *Tropical Moss* [Pl. 9.25], 1934, a very large picture, he highlighted the native vegetation. Lawson,[30] who originally studied Impressionism with Twachtman, developed his own brand of that style in vigorous work emphasizing bright color and heavy impasto brushwork. His Florida work was done in an expressionistic style. By 1931 he had begun to visit annually, and he continued to work and paint in the area until his death in the surf in 1939.

 Mathias Joseph Alten, born in Germany in 1871, studied in Paris with various artists including Whistler. He won many prizes, as exemplified in his *Tarpon Springs, Florida* [Pl. 9.26], 1935, painted three years before his death.

 Ralston Crawford was an early Modernist painter who most

9.26 Mathias Joseph Alten. *Tarpon Springs, Florida*, 1935. Oil on canvas, 24 x 30. Courtesy Detroit Institute of Arts, Founders Society. Gift of Mrs. Mathias J. Alten in memory of her husband.
 By a notable prize winner, as were many artists who came to Florida.

144

9.27 Ralston Crawford. *Overseas Highway,* 1939. Oil on canvas, 28 x 45. Courtesy of Curtis Galleries, Minneapolis, Minnesota.

A Precisionist, Crawford shows his individual approach with an extreme form of linear perspective combined with flat, two-dimensional color areas.

effectively brought the Precisionist tradition forward to the present day. Like the others in this school, he typically used austere shapes, sharp outlines, and flat color in his paintings. His association with Precisionism spanned the 1930s and beyond. His *Overseas Highway* [Pl. 9.27], 1939, demonstrates his approach, an extreme form of linear perspective combined with areas of flat, two-dimensional color. He used this treatment in scenes of industrial sites, grain elevators, ships, and machines, creating unique perspectives and a sense of movement.

Artist **Henry Salem Hubbell** was born in Kansas in 1870. He began his career as a scene painter, later attending the Art Institute of Chicago. He studied briefly with Whistler in Paris, as well as others, but soon moved on. Before settling in Miami Beach in 1924, he was invited by the federal government to paint the official likenesses of fifteen secretaries of the U.S. Department of Interior as well as one of Franklin Delano Roosevelt. By this time, Hubbell had developed his spontaneous one-day portraits. His years in Miami were filled with commissions to paint the portraits of many civic leaders.

An undated watercolor titled *The Canaveral Club* (private collection) by an artist identified only as **A. W. Rice** is of interest for its site, a gathering place for a small group of men. The

Kennedy Space Center now occupies the site of the painting obliterating for all time this vision of the past.

The difficulties often faced by women artists are exemplified in the life of **Martha Dewing Woodward**. She was born in Williamsport, Pennsylvania, and attended the Harriet Hall Seminary for Young Ladies. Evidence of her artistic ability appeared early. She taught art at the Female Institute at Lewisburg, which, with the Male Academy, was to become Bucknell University. She studied in Paris and at the Pennsylvania Academy of the Fine Arts before becoming a teacher at Goucher College in Baltimore. In 1892 she returned to Paris, studying and serving as assistant art critic at the Académie Julian for eleven years. Faced with the chauvinist attitudes of males in her field, Woodward dropped her first name. Her painting titled *Wooden Shoemakers* was accepted with acclamation by the jury for one of the Paris salons. Such praise usually guaranteed first prize. However, the jury was informed by Jule Le Febre that the artist was a woman: ". . . the painter, whom you think a man is a woman, a student of my own: she painted the picture in Holland and who knows who might have helped her!" She was forced to withdraw the picture. Despite this setback, she won the Grand Prix de Concours de Portrait and the International Grand Prix de Portrait Gold Medal, among other prizes.

After her return to the United States in 1905, Woodward lived in Woodstock, New York, where she established the Blue Dome Fellowship. In 1916 she moved to Florida, focusing on paintings of the swamps. Native Americans fascinated her as well, as we can see in *Clearing the Dugout, Boy-Seminole Chief, Billy Bowlegs and Family* [Pl. 9.28], n.d. When the University of Miami opened in 1925, she was appalled to find no art courses in its advertised curriculum. She offered her services free of charge but must have received some compensation. The department closed in 1928 because there was no money to pay the staff; for years afterward, Woodward wrote to the president of the university begging for some reimbursement.

9.28 Martha Dewing Woodward. *Clearing the Dugout, Boy—Seminole Chief, Billy Bowlegs, and Family,* n.d. Oil on board, 20 x 29 3/4. Courtesy the McKenna Collection.
 The tradition of the Seminoles carried on by Billy Bowlegs.

In the early 1930s, the arts division of the Works Progress Administration (WPA) hired Martha Woodward to paint murals in a number of public buildings, as well as miniatures of historic antiques. The WPA provided work only to artists who were already on welfare, as Woodward undoubtedly was. When her painting titled *Flamingos* was exhibited at the Corcoran Gallery in Washington, D.C., Eleanor Roosevelt singled it out for acquisition. The work was hung in the Sub-Treasury Building along with Woodward's painting *Great Blue Herons*.[31]

South Florida was not the state's only area of growth during the 1930s. Winter Park, just east of Orlando, was also experiencing a modest boom. Here, as in other parts of Florida, art was flourishing. In 1931 a young artist named **Hugh Ferguson McKean** graduated from Rollins College, winning a prize offered by Louis Comfort Tiffany for his painting originally titled *Sugar Mill,*

9.29 Hugh Ferguson McKean. *Ruins of Old Florida Mission, New Smyrna,* 1931. Oil on canvas, 20 1/4 x 25. Courtesy the Charles Hosmer Morse Museum of American Art, Winter Park, Florida. Copyright The Charles Hosmer Morse Foundation, Inc.

McKean concentrated on the dappling of sunlight on the leaves and the wall.

9.30 James Calvert Smith. *Plains Indians Confined at the Fort, St. Marks*, 1943. Watercolor, 14 x 18. Courtesy of the St. Augustine Historical Society.

The scene dates from 1886, when some 500 Apache prisoners were confined at the fort for a year.

New Smyrna, now retitled *Ruins of Old Florida Mission, New Smyrna* [Pl. 9.29], 1931. The painting, which concentrated on the dappling of sunlight on the leaves and the wall, entitled McKean to two months on Long Island working under Tiffany's tutelage. More than just a little work, the prize offered McKean the possibility of a career in art. After his time in New York, McKean continued to paint, later returning to Rollins College as a teacher and administrator. He was the college's president from 1952 to 1969 and subsequently director of the Charles Hosmer Morse Gallery of Art in Winter Park.

In the 1930s and '40s many talented artists were being drawn to Florida. One of them was **James Calvert Smith**, an illustrator who was brought to St. Augustine as a small boy. In the 1940s he put down his reminiscences in watercolor. A work titled *Capo's Bath House*, circa 1940, documents a local custom of the time: women used the enclosed bath house while the tide was out; when the

tide came in, the men and boys took their turns. When weather allowed, the people of St. Augustine enjoyed other outdoor activities, as shown in *An Outdoor Dance*, circa 1940. Smith pictured himself as the small boy in the work titled *Plains Indians Confined at the Fort, St. Marks* [Pl. 9.30], 1943. The fort in the illustration was actually Fort Marion. Smith must have been at the fort in 1886, when some five hundred Apache prisoners were confined for one year.[32]

Andrew Newell Wyeth can hardly be defined as a Florida artist, yet he may have visited Florida in 1939 seeking authenticity for three paintings of pirates. A watercolor titled *Pirates* [Pl. 9.31], 1939, depicts a spirited if imaginary confrontation between two persons of that ilk. Born in 1917, Wyeth was very young when the painting was completed, with a successful career still ahead. Two years before his supposed visit to Florida, he held his first one-man

9.32 Elsa Martin Anshutz. *Summer,* n.d. Oil on board,
15 1/4 x 5. Private collection.
 Conveys the heat and somnolence of a typical hot
summer day in St. Augustine.

9.33 Ralph Fletcher Seymour. *Keewayden Beach, West
Coast,* ca. 1935. Etching on paper, 7 3/8 x 10.
Private collection.
 Expressive of a wind-driven, lonely shore.

exhibition at New York City's Macbeth Gallery. The event was completely sold out.

A small undated picture by **Elsa Martin Anshutz** titled *Summer* [Pl. 9.32] of a horse-drawn cart under palm trees conveys the sense of heat and somnolence on a hot summer day in St. Augustine. Anshutz held several one-person shows in Florida and was a member of many art groups. She was also director of the School of Creative Arts in East Gloucester, Massachusetts. Anshutz exhibited only once at the National Academy of Design, with the painting *Tranquillity,* 1933.

Ralph Fletcher Seymour from Chicago was an author and illustrator who was drawn to the west coast of Florida in the 1930s. His etching titled *Keewayden Beach, West Coast* [Pl. 9.33], circa 1935, is expressive of wind-driven waves on a lonely shore.

Adolf Arthur Dehn was particularly known for his watercolor landscapes. Before World War I, he studied art in Minnesota and New York. After the war and until 1929, he taught art, mainly in Paris, London, and Vienna. On his return to the United States, he relied on the production of lithographs and black-and-white drawings to see him through the Depression. By 1936 he had begun painting again. *Sand Dunes at Pensacola,* 1938; *Beach at Key West,* 1942; and *Key West* [Pl. 9.34], 1942—all indicate that he had not lost his way in paint but had certainly found his way to Florida.

During the Depression, times were as difficult in Florida as anywhere else, but these conditions are not generally represented in paintings. Hard times, however, gave new material to many photographers who came to Florida. Just a few of the many who came were **Arnold Newman, Walker Evans, Marion Post Wolcott,**

9.34 Adolph Dehn. *Key West*, 1942. Watercolor on paper, 21 x 29. Courtesy Harmon-Meek Gallery, Naples, Florida. Collection of Virginia Dehn.

After a hiatus, Dehn returned to painting with renewed strength.

9.35 Burgert Brothers. *Strawberry Workers in the Factory at Plant City, Fl.*, 1935. Gelatin silver print, 7 1/2 x 9 1/2. Courtesy Collection of the Norton Museum of Art, West Palm Beach, Florida.
 The tables and workers form a pattern.

Jules André Smith, and brothers **Al** and **Jean Burgert**. One of the photographs by the Burgerts titled *Strawberry Workers in the Factory at Plant City, Fl.* [Pl. 9.35], 1935, presents a realistic view, with the tables and the bodies of the workers forming a pattern. *Sideshow at Carnival Strawberry Festival, Plant City, Fl.* [Pl. 9.36], 1937, by **Marion Post Wolcott**, is reminiscent of a form of entertainment no longer popular.

An **Arnold Newman** retrospective was held at the Norton Gallery of Art in 1987. Newman lived in Miami Beach from 1934 to 1938 and attended the local high school. He went on to the University of Miami, but financial difficulties forced him to drop out of school. One of his father's friends offered him a job in his photography studio with an opportunity to learn the business. *Billboards, West Palm Beach* [Pl. 9.37], 1940, was one of a number of photographs he took in a working-class neighborhood of West Palm Beach. The strength of the image predicts Newman's later successes. His West Palm Beach portfolio led to a joint exhibition with another photographer, Ben Rose, at the Museum of Modern Art in September 1941. His symbolic portraits are held in many of the world's outstanding museum collections, and he continues to have one-person exhibitions, the latest at Cultural Village, Madrid, Spain, in 1998.

In 1983 the Norton Gallery of Art presented an exhibition called *The Sun and the Shade: Florida Photography, 1885–1983.* Included were photographs by **Walker Evans**, such as Resort *Photographer at Work* [Pl. 9.38], 1941, and *Auto Graveyard* [Pl. 9.39], 1941, which offer a contrast for the period, as he concentrates on irony. The catalog and selection of photographs for the Norton exhibition gave important views of changing Florida, highlighting not only the pleasant but also the grimmer sides of the state.[33]

Some of the artists who were in Florida before World War II

Above: 9.36 Marion Post Wolcott. *Sideshow at Carnival Strawberry Festival, Plant City, Fl.*, 1937. Silver gelatin print, 6 x 9. Courtesy Museum of Fine Arts, St. Petersburg, Florida. National Endowment for the Arts Purchase Award, 1977.

Below: 9.37 Arnold Newman. *Billboards, West Palm Beach*, 1940. Silver gelatin print, 11 x 14. Courtesy Boca Raton Museum of Art, Boca Raton, Florida.

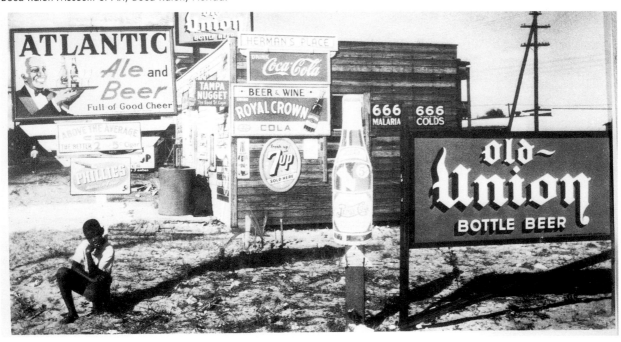

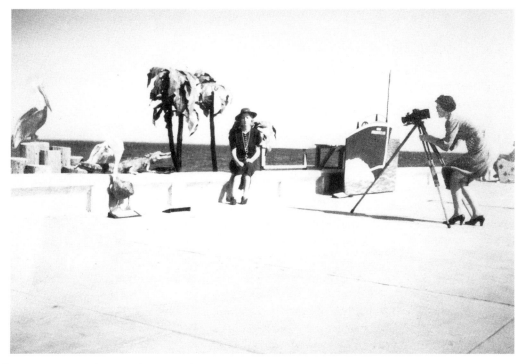

Above: 9.38 Walker Evans. *Resort Photographer at Work,*
1941. Silver gelatin print, 6 x 7 3/4. Courtesy Lowe Art
Museum, University of Miami. Gift of anonymous donor.

Below: 9.39 Walker Evans. *Auto Graveyard,* 1941. Silver
gelatin print, 6 x 7 1/4. Courtesy Lowe Art Museum,
University of Miami. Gift of anonymous donor.
 Resort Photographer and *Auto Graveyard* are an ironic
contrast in Palm Beach.

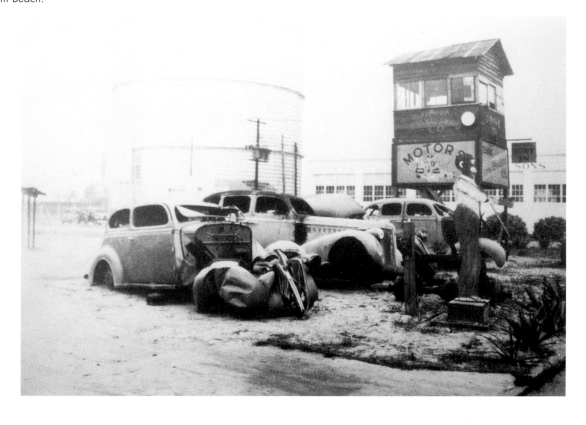

continued working here after the war. For the most part, the widely diverse styles of their art showed little change. They included **Milton Avery, Warren Baumgartner, Lucille Blanch, David Burliuk, Eliot Candee Clark, Edward Cucuel, Adolf Dehn, Emil Gruppe, Jack Levine, Eliot O'Hara, Jane Peterson, Wallace Herndon Smith, Syd Solomon, Anthony Thieme, Martha Walter,** and **William Zorach**.

These artists and others were especially active in Florida following the war. Among them was **Doris Lee**, who first arrived from Woodstock, New York, with her husband, **Arnold Blanch**, in the 1930s. Having developed her own style, which was never trite or easy to pin down, she received much recognition for her painting titled *Thanksgiving*, 1935, now in the collection of the Whitney Museum of Art. Around 1938 Arnold and Doris spent their first winter in Florida and liked it so much that visits to the state became a pattern in their lives. *Under the Royal Poinciana Tree* [Pl. 9.40], 1942, illustrates very well Lee's unique ability as well as her familiarity with the scene. In her undated *Florida Vacation*, Sally and Milton Avery were painted by Lee as they played cards together on the beach. Avery's influence can be seen in a number of Lee's paintings.

Milton Avery also left records of his stay in Florida. Avery, a self-taught painter, was strongly influenced by Matisse. He subordinated line to color in his images, using delicately modulated color shapes to define form. As his career progressed, he simplified his shapes, helping to forge a unique, modern style of art in the United States that served as a bridge to Abstract Expressionism, as seen in *Florida Lake* [Pl. 9.41], 1951. The works *Palms at Sunset*, circa 1950,

9.40 Doris Lee. *Under the Royal Poinciana Tree*, 1942. Gouache and tempera on board, 20 x 15. Courtesy D. Wigmore Fine Arts, New York.
 Lee developed her own style, never trite or easy to pin down.

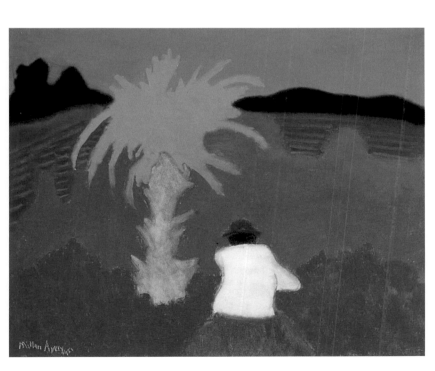

9.41 Milton Avery. *Florida Lake*, 1951. Oil on canvas, 28 x 36. Courtesy The Harn Museum of Art, University of Florida. Museum purchase by exchange. Gift of William H. and Eloise Chandler.
 Avery's work is related to Abstract Expressionism.

9.42 Emile Gruppe. *Boat Dock, Naples, Florida,* n.d.
Oil on canvas/board, 16 x 20. Private collection.
Photo courtesy D. Wigmore Fine Arts, New York.
 This exhibits Gruppe's penchant for bright color.

and *Tropical Palms*, 1950, both in the collection of Sally Avery, also clearly indicate his approach.

In 1937 Lee and Avery, along with Ralston Crawford and **Jules André Smith,** founded the Maitland Art Center (which is still active). Other artists active in the center were David Burliuk, **Ernest Roth**, Arnold Blanch, and **Harold McIntosh**. The St. Augustine Art Center was also active in the 1940s, but it no longer exists today. It was founded by **Tod Lindenmuth** along with **Elizabeth Boardman Warren, Carl Austen**, and **Norman MacLeish**, among others.

Abstract art was gaining a foothold in 1945 when **Virginia Berresford** produced her watercolor titled *Tropic Garden*. She studied at Wellesley College and with Charles Martin, among other artists. Her work is held in the Detroit Museum of Art.

Although Emil Gruppe was born in the United States, his father had been a landscape artist in Europe for twenty-five years before settling in Rochester, New York. Gruppe was educated both in the United States and abroad. He established a studio in Naples, Florida, and is best known for his Impressionist landscapes. His

9.43 Charles Prendergast. *Florida Grocery*, 1947.
Watercolor and appliquéd tinsel on paper, 8 9/16 x 11.
Private collection.
 A folk art style begun in the late 1930s.

undated painting *Boat Dock, Naples, Florida* [Pl. 9.42] exhibits his manner and penchant for bright color.

Another artist who continued to work after World War II was **Albert Ernest Backus**, better known as "Beanie" Backus. He was unique in that he was a native Floridian working as a painter. His focus was on landscapes in which color was used in a gentle fashion. We value these works because they show us a Florida that is fast disappearing, both stylistically and in actuality. An untitled landscape [Pl. 9.45], circa 1940, is an example of his work.

Charles Prendergast came to Florida for the first time in 1946 and visited again the following winter. He had been ill but recovered sufficiently to produce eighteen watercolor sketches and four panels (tempura on gessoed masonite) of Florida in his studio in Westport, Connecticut, and on his next trip to Florida. One of these gessoed panels, *Florida Grocery* [Pl. 9.43], 1947, depicts everyday rural, Southern life. Prendergast continued a folk-art style begun in the late 1930s but was also strongly influenced by Haitian folk art.

157

9.44 Charles Prendergast. *Florida Grove,* 1946–1947.
Tempera laid down on gessoed masonite, 11 x 13 1/2.
Courtesy Williams College Museum of Art, Williamstown,
Massachusetts. Bequest of Mrs. Charles Prendergast.
 One of the Florida pieces converted to gesso.

From the Haitians came strong coloring and active gestures. His outdoor subjects used trees to form a stylized background. Figures, birds, animals, and oranges symbolized his theme of fruitfulness. Prendergast's methods were unique. When Prendergast transformed his watercolor sketches into tempera and incised on gessoed panels, he used the originals to suggest but didn't copy directly from them, as in *Florida Grove* [Pl. 9.44], 1946–1947 (in the collection of Williams College Museum of Art in Williamstown, Massachusetts).

Prendergast had two careers, the first as a fine art framemaker and the second as an artist, a career begun when he might have been considered a senior citizen by many. In 1911, sparked by a trip to Italy, he was inspired to begin work on his first gilded pictorial panel. He used gesso, a ground made of gypsum or chalk

mixed with water or glue to provide a dense, brilliantly white, absorbent surface for tempera (based on egg yolk) and some types of oil painting. In his work he also used gold leaf. He finished slightly more than one hundred pictorial works. In her exhibition catalog, *The Art of Charles Prendergast from the Collections of the Williams College Museum of Art & Mrs. Charles Prendergast*, Nancy Mowll Mathews writes:

> Based as they were on ancient motifs and contemporary folk art subjects, these painted and carved objects have so few parallels in the art of Prendergast's time that they stand outside the established history of American art and have earned their creator only a small—but very passionate following among connoisseurs and art historians. His works will probably always be the province of the very few because, by their very nature, they are fragile and precious, beautiful to look at and elusive in meaning. But . . . they reveal a rich world of wit and symbol that is unexpectedly universal in its appeal.[34]

Though there are other artists who began to produce Florida paintings during the 1940s, they are beyond the scope of this book as they continued on to create their major work here after 1945. The end of the war is where we must end this volume. After that the art scene in Florida flourished in new ways. Both the number of artists and of Florida paintings exploded in new forms and styles, which will have to be left for another volume. ❧

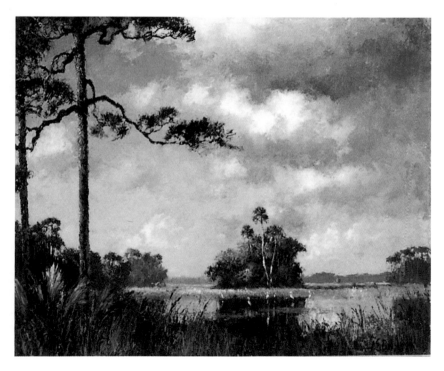

9.45 Albert Ernest Backus. Untitled landscape, ca. 1940. Oil on canvas, 25 x 30. Courtesy the McKenna Collection.
Backus recorded a Florida that is fast disappearing both stylistically as well as in actuality.

10.1 Christopher Clark. *The Crap Shooters,* 1936. Oil on canvas, 30 x 36. Courtesy The Ogden Museum of Southern Art, University of New Orleans, New Orleans, Louisiana. The headline of the newspaper adds an ironic note.

Government-Sponsored Art in the 1930s

ACCORDING TO MARLENE PARK and Gerald E. Markowitz in
Democratic Vistas: Post Offices and Public Art in the New Deal:

> During the New Deal the government of the United States
> altered its relationship to the people for the first time. For the
> first time, Washington built housing for its citizens, regulated
> the stock market, established the right of labor unions to exist,
> and provided relief—or money—directly to the people who
> were destitute. It also became a patron of the arts. Where once
> it had commissioned a work or a building, now it initiated
> comprehensive and extensive programs. Its theory was
> that though the country was in the worst depression in its
> history, although millions were out of work, hungry and
> living in shacks, Americans needed cultural as well as
> material assistance. Culture was not to be just for the rich,
> the educated, the elite; it was also to be for the poor, the
> uneducated and the remote. To accomplish this end,
> the government put thousands of artists, themselves often
> destitute, to work.[1]

Detail of Plate 10.4

Franklin Delano Roosevelt's New Deal initiated the largest art
program ever undertaken by the federal government. A series of
projects was designed to provide work for artists and to bring
art to people of every age and circumstance. The results were stag-
gering. Between 1933 and 1943 the government employed and
commissioned more than ten thousand artists nationwide, many
young or virtually unknown. They produced one hundred thou-
sand easel paintings, eighteen thousand sculptures, over thirteen
thousand prints, and more than four thousand murals. A more
ephemeral result was the shift away from individualism toward
collectivism. Roosevelt summed it up in a campaign speech:

10.2 *Coral Reef Yellow Tail,* n.d. A. P. J. Burns. Watercolor on paper, 15 x 24. Courtesy Collection of the St. Petersburg Museum of History.

The tropical beauty of the Florida sea.

"Always the heart and soul of our country will be the heart and soul of the common man."[2]

The initial program, called the Public Works of Art Projects (PWAP), was created between 1933 and 1934. However, as it became evident that more long-term solutions to unemployment were necessary, this controversial program came to be regarded as a stopgap measure. Consequently, new programs were established. The largest and most famous of these, the Works Progress Administration's Federal Art Project (WPA/FAP, 1935–1943), sought to aid artists by employing those already on public assistance. Although some twenty-five thousand people were on relief in Florida in the 1930s, only twenty-five claimed to be artists. The paintings these artists produced while they were on the program have been very difficult to find and identify.

One example that has been located is *The Crap Shooters* [Pl. 10.1], 1936, by **Christopher Clark**. The artist was born in Quincy, Florida, and lived in Tampa in the 1930s. During his extensive career, he worked on murals at Radio City Music Hall in New York City, was an illustrator for *Forbes* magazine, and taught art at the Ringling School of Art in Sarasota. In the painting, a dynamic group of five men throwing dice on a newspaper is dominated by a central figure, while an ironic note is provided by the newspaper's headline: "Jury Probes Vice."

Another Federal Art Project painter, **A. P. J. Burns**, executed a number of watercolors of local fish in the waters of the gulf. One is called *Coral Reef Yellow Tail* [Pl. 10.2]. In the upper right, a sea plume appears; in the lower right, brain coral with a sea urchin; in the lower left, closed and half-open anemones on dome coral; and in the upper left, moose antlers. In his painting of the *Florida Puffer*, which is also at the St. Petersburg Museum of History, the artist demonstrates how the fish fills itself with air when approached. Burns created many pleasing compositions while sacrificing nothing to accuracy.

To provide decorations for public buildings, the U.S. Treasury Department, which during that period constructed and administered the buildings, also directed two art projects. One, under the WPA/FAP, was directed largely toward artists on relief. The other was managed by the more long-lasting of these agencies, the Section of Painting and Sculpture, later called the Section of Fine Arts. Unlike assignments in the WPA/FAP project, the Section's assignments were made on a competitive basis.

In Florida, twenty-two murals, including two frescoes, were commissioned and completed between 1938 and 1942. None of the artists involved had been born or educated in the state, and only two, **Denman Fink** and **George Snow Hill**, were residents at the time. This was not unusual in a state where for a portion of the year transients were the rule, not the exception.

Through commissions granted by the Section of Painting and Sculpture, awards were given in open competition to embellish new federal buildings. In 1935 the Section allocated one million

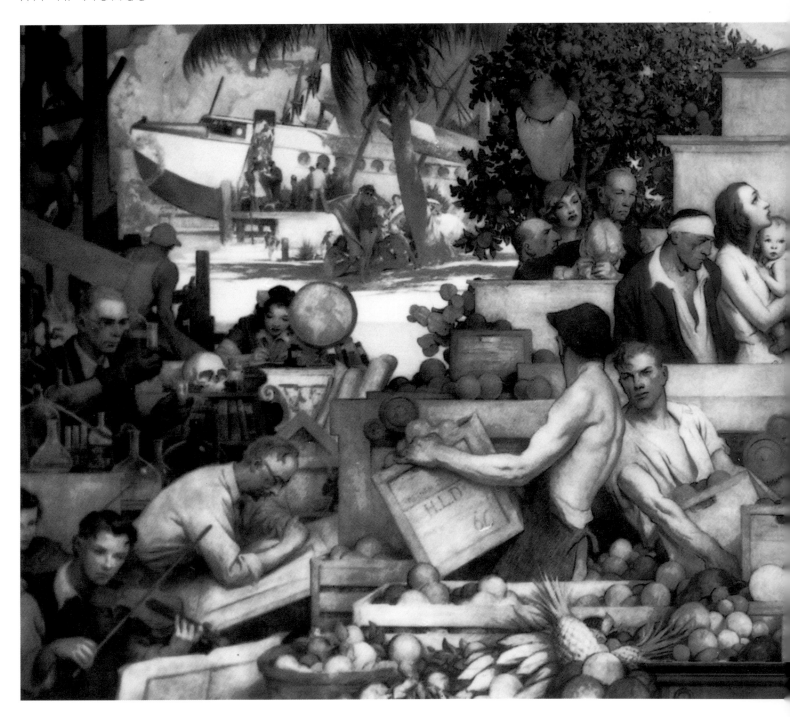

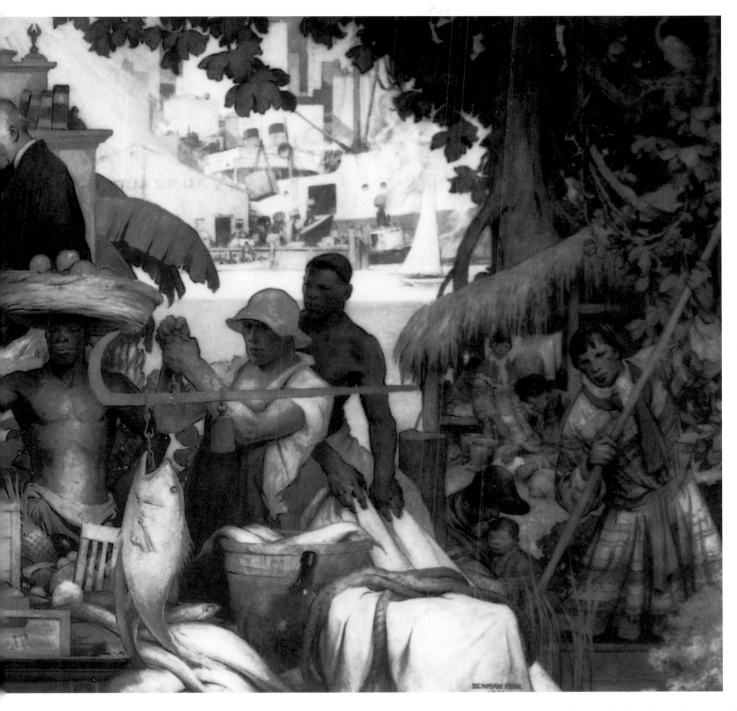

10.3 Denman Fink. *Law Guides Florida Progress*, 1941.
Oil on canvas, 6 3/4 feet x 25 feet. Mural in the Miami Post
Office and Courthouse. Courtesy of the Federal Works
Agency, Section of Fine Arts, Public Buildings Administration,
Washington, D. C.
 A panoramic view of the bounty of Florida.

dollars—a hefty sum in those days—to be spent in Florida on music, art, and drama.

The artists involved in Florida mural commissions traveled to the cities where the murals were to be installed to collect data, develop ideas, make on-the-spot sketches, and view the areas to be decorated. Being largely unfamiliar with local subject matter, customs, and history, some artists found it necessary to request iconographic suggestions from local officials.[3]

Although the Section's regulations stipulated that artists have historical ties to the areas in which they competed, only Fink and Hill met these requirements. Compared to major metropolitan areas throughout the country at the time, there was a general paucity of arts in Florida. The design for the Miami Courthouse was awarded to Denman Fink, an artist with an impressive background who was teaching at the University of Miami, but only after both senators from Florida intervened. Charles Shepard Chapman, a New York artist, had been requested to submit designs for the mural. Local protest, combined with the senators' objections, resulted in a new competition, at which Fink's composition was chosen.

Fink's original sketches for the mural were subjected to some alterations by the competition's judges. The artist accepted most of the changes but balked at eliminating the fruit as depicted because he wanted the picture to convey the impression of a packing house. His mural *Law Guides Florida Progress* [Pl. 10.3] was installed on February 28, 1941, in the post office and courthouse in Miami. Whereas Fink's proposed piece was to measure eleven feet and two inches in height by twenty-five feet and three inches in width, the installed mural measured six feet and nine inches by twenty-five feet. Fink was also awarded a project for Lake Wales titled *Citrus Harvest, Lake Wales*.[4]

As a result of the impressive drawings submitted in the previous competition, artist **Charles Hardman**, a resident of Atlanta, Georgia, was invited to submit sketches for the Miami Beach Post Office, though not in the context of a competition. In September 1938, Hardman was paid three thousand dollars to execute a three-part mural. In a letter to Edward Rowan, an artist and Section leader, Hardman disclosed his lack of formal art education. At the age of twenty-six, he was a relative amateur, with only six months of training at the Art Students League in New York City. After a good deal of discussion, the sketches titled *Themes from Florida History* [Pl. 10.4] were selected for installation in the Miami Beach Post Office. The first section depicts the discovery of Florida by Ponce de León, the center portion portrays an Indian attack on de Soto and his scouts, and the final section shows a conference between Indian chiefs and American soldiers regarding the removal of the Indians to reservations. One of the comments made about Hardman's sketches was that ". . . the lower extremities of the two rearing horses be turned to avoid the necessity of portraying their sexual organs in so prominent a way."[5] The

final work shows that this comment was ignored. It is easy to see why the judges were so impressed with Hardman's work. The strong forms were very different from other entries submitted for the "Law Guides" competition. No further artistic record of Hardman has been found.

Eight impressive panels were installed in the post office in Tallahassee in 1939, the culmination of a project begun in 1937 by **Edward "Buk" Ulreich**. Born in Austria-Hungary, he was only six months old when his family emigrated to the United States. After studying for four years at the Kansas City Art Institute, he went to Arizona to become a cowboy on a ranch on the Apache Indian reservation. Ulreich's art featuring his favorite subjects, Indians, won him a four-year scholarship to the Pennsylvania Academy of the Fine Arts. The murals in Tallahassee were originally displayed in the old post office above the general-delivery and lock boxes. Ulreich's eight panels, done in fresco, depict various scenes in the history of Florida. Their titles are *Osceola in Conference with Hernandez; Andrew Jackson; Ponce de León; Saturiba Receiving the French; Sir Francis Drake Attacking St. Augustine; Modern Florida; Five Flags: English, Confederate, United States, French and Spanish;* and *Bimini Island.* Each panel measures 51 inches by 110 inches.

In 1997 in Tallahassee, construction began to remodel and expand a 1936 building that sat on the same block where Leon County's first courthouse was located in 1838 and where the Leon Hotel was located at the turn of the century. The refurbished neoclassical-revival building is now home to the U.S. Bankruptcy Court, where the Ulreich panels, now cleaned and restored, are installed. Other of Ulreich's murals were exhibited at the Century of Progress Exposition at the 1933 Chicago World's Fair and at Radio City Music Hall in New York City, among other places.[6]

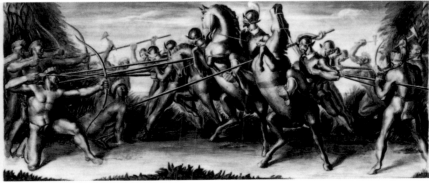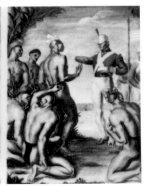

10.4 Charles Hardman. *Themes from Florida History,* 1941. Oil on canvas, 7 1/2 feet x 32 11/12 feet. Mural in the Miami Beach Post Office. Courtesy of the Federal Works Agency, Section of Fine Arts, Public Buildings Administration, Washington, D. C.
 From Ponce de León to the removal of the Indians to reservations.

In 1977 inquiries from Fran Rowin of *Update* magazine were addressed to the postmasters of fourteen cities that had received Section murals. At the time, Rowin was aware of only fourteen murals. All of the murals were reported still to be hanging, but most had been neglected. Today, some are in better condition than others. Condition reports are given here when available.[7]

George Snow Hill, educated at Syracuse University, was based on Florida's west coast near St. Petersburg. Among Hill's works are four Florida murals: *Loading Pulp Wood* in Milton, *Cypress Logging* in Perry, *Long Staple Cotton Gin* in Madison, and *Scenes Depicting Coast Guard Air Service* at the St. Petersburg Coast Guard Air Station. The last one was lost for a time in 1972 but was eventually recovered, restored, and rehung temporarily at Tampa International Airport. The mural depicts the history of aviation from the Greek myth of Icarus to the 1914 flight of Tony Jannus from St. Petersburg to Tampa, the first commercial plane trip. At last accounting, the aviation mural was in storage with the Aviation Authority in Tampa with the hope that it will be rehung at Tampa International Airport. Hill used bright colors and large figures to illustrate the story. In the panel depicting the French launching of the first balloon by the Montgolfier brothers, the first passengers are shown as a sheep, a rooster, and a duck. The saga continues with a sweeping look at Otto Lillienthal's hang glider. It ends with Tony Jannus, who died in 1916 in an air crash in Russia while demonstrating his company's product there.

Two other murals by George Hill are lost for all time. In 1935 fifty feet of controversial murals were installed in the Clearwater Municipal Auditorium. Not only are they missing from the federal records, but only vague memories of them remain in Clearwater. The controversy arose when Judge John U. Bird refused to allow the scantily clad Florida bathing beauties depicted in the murals to undermine the dignity of his court. It is assumed that the murals were destroyed when the auditorium was remodeled in 1955. Also lost is a mural Hill painted for the Florida building at the Century of Progress Exposition at the 1933 Chicago World's Fair. Despite newspaper accounts claiming it had been permanently installed in the Capitol Building in Tallahassee, it is not there.

Hollis Howard Holbrook and **Ferris Stephen** covered the walls of the Golden-Collum Federal Building/Courthouse in Ocala with eighteen murals titled *A History of Industry in Marion County*. Each oil measured 6 feet 10 inches by 14 feet 9 inches. Because the murals were so large and numerous, it was 1964 before they were all in place. Holbrook was born and educated in Massachusetts, where he began his initial work in art. By 1938 he was teaching at the University of Florida School of Architecture and Allied Art in Gainesville. He undoubtedly required help to complete the massive project. During this period (1937–1942), local artists on welfare were recruited to assist with such projects. No information about Stephen has been found.

Another Section work, *Arcadia*, is a stone bas-relief finished in 1939 by **Constance Ortmayer** for the town of Arcadia. Ortmayer was born in New York City and studied at the Royal Academy in Vienna. In 1935 she exhibited and won a prize at New York's National Academy of Design. In 1937 she taught art at Rollins College in Winter Park.

Thomas Laughlin, a New York City painter, installed a Section mural of a town scene in a federal building at DeFuniak Springs in 1942. In another federal building, the Fort Pierce Post Office, **Lucille Blanch** completed *Osceola Holding Informal Council with His Chiefs* [Pl. 10.5] in 1938. Blanch was born in Minnesota and in the 1930s was a resident of Woodstock, New York. Her art career was full and varied, and some of her art reveals a delightful sense of whimsy. However, the Section's conservative policies did not allow that quality to emerge. Blanch worked on the mural while employed at the Ringling School of Art in Sarasota. From her experience working at the school came *Bach's Zirkus*, 1935, a colorful painting filled with details of one of the small circuses drawn to Florida by the Ringling example. Her *Florida Wildflowers* was purchased by the Metropolitan Museum of Art in 1938.[8]

In Jasper, Florida, **Pietro Lazzari** painted two panel murals in tempera, *News From Afar: Harvest at Home*, which were installed in a federal building in 1942. He had studied art in Rome, where he was born, but by the early 1930s he was a resident of Washington, D.C. Another Section mural, *Settler Fighting Alligator from Rowboat*, circa 1940, by **Joseph D. Myers** was installed in the Lake Worth Post Office. Regrettably, years of grime have obscured the scene. **Charles Rosen**, who came from Pennsylvania, settled in the art colony of Woodstock, New York. After a long history of success in the art field, he won a Section competition for the Palm Beach Post

10.5 Lucille Blanch. *Osceola Holding Informal Council with His Chiefs,* 1938. Oil on canvas, 4 feet x 11 feet. Courtesy of the Federal Works Agency, Section of Fine Arts, Public Buildings Administration, Washington, D. C.
 An accurate and colorful portrait of Seminole life.

10.6 Stevan Dohanos. *The Legend of James Edward Hamilton, Mail Carrier,* 1940. Tempera on canvas, 4 feet x 8 feet. Courtesy of the Federal Works Agency, Section of Fine Arts, Public Buildings Administration, Washington, D. C. Striding barefoot across the sand.

Office murals. His *Seminole Indians* and two landscapes formed a triptych.

In Sebring, at what is now City Hall, **Charles Robert Knight**, who was born in Brooklyn and worked in New York City, installed *Prehistoric Life in Florida*, 1942. The scene depicts a pair of saber-toothed tigers with their cubs and mammoths in the background. Knight later became an author and illustrator dealing mostly with animal, bird, and fossil subjects; as such, he was eminently well suited for the subject of this mural.

Toledo, Ohio, artist **Elizabeth Terrell** was another who settled in Woodstock, New York, before coming to Florida. She painted the mural *Reforestation*, which was installed in a post office in Starke, Florida, in 1942. Several of her earlier landscapes of Daytona and New Smyrna dwelt on patterns of light and color cast by the sun through palms and moss-laden trees.

Six panels in the West Palm Beach Post Office titled *The Legend of James Edward Hamilton, Mail Carrier* [Pl. 10.6] were done by **Stevan Dohanos**. The artist was born in Westport, Connecticut, and eventually settled in West Palm Beach. The designs, each measuring eight by four feet, relate the tragedy of this U.S. Postal Service mail carrier, who lost his life in the line of duty in 1887. The dramatic story took place along an eighty-mile strip of lonely beach between the Lake Worth area and Miami, Florida. The panels depict incidents during his journey from the lighthouse to the bayou, where he died attempting to retrieve a skiff in water infested with sharks and alligators. One illustration shows him striding barefoot across the sand past the ruins of a sailing ship.

New to the landscape were coconut palms, whose nuts had been swept onto Florida shores from a schooner wrecked at sea. In 1972 the panels were relocated to a new post office building on Summit Avenue in West Palm Beach.

How does one sum up such a public program? The authors of the 1984 book, *Democratic Vistas: Post Offices and Public Art in the New Deal*, who surveyed the federal program that commissioned four hundred works of art, came to some conclusions. According to these authors, the Section, which awarded the contracts, was the most conservative of art programs. The WPA/FAP of 1935–1943 employed as many artists and artisans as did the Section but served as much of the public as possible in its various divisions. The Section dealt only with public buildings while the WPA/FAP concentrated on individual paintings and sculpture.

The Section had certain goals, which, for the most part, were realized. It may seem to have promoted a middle-class view of the world, but in the 1930s, when labor unions and other supporters of the political left saw the New Deal as an ally in transforming society, the positive vision of regionalism reflected in the art commissioned by the Section indicated its confidence in the possibility of change.[9] As the authors of *Democratic Vistas* state: "That regionalism was an ideal but not an ideology is clear from the results of their commissions. That ideal informed a number of the murals and is sufficiently vivid to distinguish Section work from government commissions before and after the New Deal."[10]

Another program, organized in 1935 as a nationwide activity under the aegis of the Federal Art Project, was the Index of American Design. The Index was limited to the practical, popular, and folk arts of peoples of European origin who had created this country's known material culture up to that time. It was operated under the direction of the Federal Art Project's Washington staff. The program was charged by the government with finding useful employment for thousands of artists referred to the WPA by local agencies throughout the country. The basic directive of the WPA program was to help maintain workers' skills. Index projects could not compete with private enterprise projects, but they benefited private enterprise by providing a reservoir of pictorial research material about American design and craftsmanship.

Thirty-five states, including Florida, participated in the program. Supervisory staffs were set up in key cities. In Florida the center was in Jacksonville, and fourteen artists were eventually involved. One of them was **Annie B. Johnston**, represented by three fine watercolor renderings of a corn shuck chair [Pl. 10.7], a stoneware jar [Pl. 10.8], and a dipper [Pl. 10.9]. A description and history of the jar, which appears on the picture, is a good example of how the Index of Design serves an important role in recording the history of American craftsmanship. It reads, "A vitrified stoneware jar 15 inches in diameter, 9 7/8 inches high, of light olive green spotted glazed stoneware. Made by M. M. Odem at the old Knox Hill Pottery, Knox Hill, Walton County, Florida, 1859. M. M. Odem and

Above: 10.7 Annie B. Johnston. *Hickory Cornshuck Chair,*
ca. 1840–80, 1939. Watercolor on paper, 10 x 9 1/2.
Courtesy Museum of Florida History, Tallahassee, Florida.

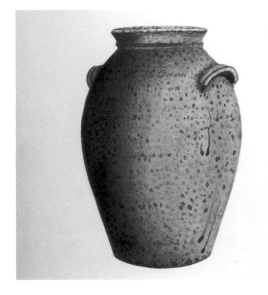

Left: 10.8 Annie B. Johnston. *Vitrified Stoneware Jar, 1859,*
1939. Watercolor on paper, 15 x 9 7/8. Courtesy Museum
of Florida History, Tallahassee, Florida.

Turnlee, Proprietors and Partner . . ." The renderings of these items in watercolor were not only characteristic of the period but also were executed with great skill in a form far less perishable and more interpretive than are color photographs. An artist can capture nuances in a watercolor that a photograph misses, and the latter will fade in time.

Some artists who participated in the Index of American Design complained about the lack of creativity involved in depicting the objects, and many difficulties were encountered later during the compilation of the renderings, but, nonetheless, the effort was worthwhile. The final collection contains more than seventeen thousand examples of American decorative art created from before 1700 to about 1900. In the introduction to the publication *Index of American Design*, J. Carter Brown, then-director of the National Gallery of Art in Washington, D.C., said, "Over 2900 illustrations, some 850 in color, present a previously unsurpassed panorama of American crafts and folk arts."[11] Of these national figures, Florida artists produced 309 renderings, 72 of these by Annie B. Johnston. The objects pictured vary widely from circus items to clothing and spinning wheels. All the artists produced multiple items, which are in the collection of the Museum of Florida History in Tallahassee. ❧

82434 Annie B. Johnston.

10.9 Annie B. Johnston. *Copper Dipper, ca. mid-19th century,* 1939. Watercolor on paper, 11 x 9 1/8. Courtesy Museum of Florida History, Tallahassee, Florida.

173

Artists

This list of artists includes not only artists mentioned in the text (in bold) but also artists who left records in exhibition catalogs, newspapers, and other periodicals during the period under discussion and about whom little or nothing else is known. Birth and/or death dates are given when available; dates that an artist was active in Florida are given when birth and death dates are not known. Additionally, a question mark indicates either that an artist's date of death is not known or that it's not known if that artist is still alive. Any readers who have more information or records of Florida paintings are requested to correspond with the author via the publisher.

á Becket, Marie Cecilia (?–1904; active 1890s)
Abbey, Edward Austin (1852–1911)
Adams, Cassily (1843–1921)
Adams, John Ottis (1851–1927)
Adams, Wayman (1883–1959)
Albrecht, F. A. (active 1937)
Alden, James Madison (1834–1922)
Alten, Mathias Joseph (1871-1938)
Anderson, Karl (1874–1956)
Anshutz, Elsa Martin (active 1933)
Atkinson, J. G. (active 1892)
Audubon, John James (1785–1851)
Austen, Carl Frederick (1917–?)
Austrian, Ben (1870–1921)
Avery, Milton (1885–1965)

Bacher, Otto Henry (1856–1909)
Backus, Albert Ernest (1906–1987)
Bagg, H. C.
Baker, Elizabeth Gowdy (1860–1927)
Barber, Joseph B. (1915–?)
Barchus, Eliza Rosanna (1857–1959)
Barnett, Bion, Jr. (1887–?)
Bartlett, Evelyn Fortune (1887–1997)
Bartlett, Frederic Clay (1873–1953)
Bartram, William (1739–1823)
Baumgartner, Warren W. (1894–1963)
Beal, Reynolds (1867–1951)
Bean, Caroline Van Hook (active 1920s and 1930s)
Behrend, Mary B.
Belcher, Hilda Ana (1881–1963)
Benson, Frank Weston (1862–1951)
Bernard (ca. 1900–?)
Berninghaus, Oscar Edward (1874–1952)

Berresford, Virginia (1904–?)
Betts, Harold Harington (1881–1915)
Bierstadt, Albert (1830–1902)
Birley, Oswald (1880–?)
Blake, Charles George (1866–1941)
Blanch, Arnold (1868–1968)
Blanch, Lucille (1895–?)
Blodgett, Walton (1908–?)
Bolinger, Franz Josef (active 1926)
Bredin, R. Sloan (1881–1933)
Brewster, Ada Agusta (active 1889)
Brigham, Stella M.
Bristol, John Bunyan (1826–1909)
Brouwer, Anthony Theophilus, Jr. (active 1910)
Brush, George de Forest (1855–1941)
Bullett, Charles (active 1918)
Burd, Clara Miller (active 1920)
Burgert, Al (1887–1956)
Burgert, Jean (1882–1968)
Burliuk, David (1882–1967)
Burns, A. P. J. (active 1930s)
Burnside, John Thrift Meldrum (1834–1900)
Butler, Howard Russell (1856–1934)

Carlsen, Emil (1853–1932)
Carter, Clara Mitchell (active 1887)
Carter, Clarence Holbrook (1904–?)
Cary, William de la Montagne (1840–1922)
Catesby, Mark C. (1796–1849)
Catlin, George (1796–1872)
Champney, James Wells (1843–1903)
Chanler, Robert W. (1872–1930)
Christy, Howard Chandler (1872–1952)
Claghorn, Joseph Conover (1869–1947)

Clark, C. H. (active early 1900s)
Clark, Christopher (1903–?)
Clark, Eliot Candee (1883–1980)
Clarke, Thomas Shields (1860–1920)
Coe, Theodore (1866–1958)
Collins, John (1814–1902)
Coman, Charlotte Buell (1833–1924)
Cook, Isabel Vernon (active 1918)
Cooper, Astley David M. (1856–1924)
Cope, George C. (1855–1929)
Cozzens, Frederic Schiller (1846–1928)
Crawford, Ralston (1906–1978)
Cucuel, Edward (1879–1951)
Curran, Charles Courtney (1861–1942)
Curtis, Robert J. (1816–1867)

Dana, Charles Grafton (1843–1924)
Darrow, Dr. Anna
Davey, Randall (1887–1964)
Davies, Arthur B. (1862–1928)
de Bry, Theodore (active late 1500s and early 1600s)
de Crano, Felix (1842–1908)
Dehn, Adolf (1895–1968)
Dietsch, C. Percival (1881–1961)
Dodd, Mark Dixon (1888–?)
Dohanos, Stevan (1907–?)
Dreher, H. (active 1860s)
Drew, Clement (1806–1889)
Drown, William Staples (1856–1915)
Dutton, Charles N. (active 1924–1926)

Eastman, Seth (1808–1875)
Ehninger, John W. (1827–1889)
Eisele, Christian (active 1880)
Ekblad, K. Felix (active 1885–1900)
Erb, Daisy (active 1920s and 1930s)
Evans, Walker (1903–1975)

Farnsworth, Jerry (1895–1980)
Fassett, Cornelia Adele (1831–1898)
Fenn, Harry (1845–1911)
Fink, Denman (1880–?)
Finlay, E. J. (1874–1940)
Fister, Jean Jacques (1878–1949)
Fletcher, Anne (1876–?)
Fluhart, Harry Davis (1861–1938)
Fournier, Alexis Jean (1865–1948)
Fraser, Malcolm (1869–1949)
Frenzeny, Paul (1840–1902)
Frieseke, Frederick Carl (1874–1939)

Gabriele, Gabrielle (1906–?)
Gaul, Arrah Lee (1888–?)
German, Robert S. (active 1890s)
Gervasi, Frank (1895–?)
Gifford, Robert Swain (1840–1905)
Glackens, William J. (1870–1938)
Goldthwaite, Anne (1875–1944)
Golinkin, Joseph W. (1896–?)

Graves, Abbott Fuller (1859–1936)
Grozelier, Leopold (1830–1865)
Gruppe, Emile Albert (1896–1978)

Haggin, Ben Ali (1882–1951)
Hallowell, W. R. (1886–1939)
Hamilton, Hildegarde Hume (1898–1970)
Hanley, Sarah E. (?–1958)
Hardman, Charles (active 1930s)
Hare, John C.
Harlow, Louis Kinney (1850–1930)
Hartman, Shirley P. Glaser
Harvey, George (1800–1878)
Hastings, Thomas (1860–1929)
Hayman, E. B. (active 1889)
Hays, George A. (1854–?)
Heade, Martin Johnson (1819–1904)
Heaton, Augustus Goodyear (1844–1930)
Hedges, W. S.
Heitland, W. Emerton (1893–?)
Helstrom, Bessie
Henry, Edward Lamson (1841–1919)
Herter, Albert (1871–1950)
Herzog, Hermann (1832–1932)
Hess, Mabel Jane (active 1932)
Higgins, George Frank (active 1850–1884)
Hilder, Howard (1866–1935)
Hill, George Snow (1898–1969)
Hill, Polly (Pauline) Knipp (1900–1990)
Hilliard, William Henry (1863–1905)
Hodges, George Schuyler (1864–?)
Holbrook, Hollis Howard (1909–?)
Homer, Winslow (1836–1910)
Howard, Edith Lucile (1885–?)
Hubbell, Henry Salem (1869–1949)
Hull, Marie Atkinson (1890–1980)
Humphreys, Malcolm (1894–?)
Hunt, William Morris (1824–1879)
Huntley, Victoria Ebbels Hutson (1900–?)

Inness, George (1825–1894)
Inness, George, Jr. (1853–1926)
Irving, John Beaufain (1826–1877)
Jambor, Louis (1884–1954)
Janson, Andrew (1900–?)
Jefferson, Joseph (1829–1905)
Jeffery, Frank Moore (active 1920s)
Johnston, Annie B. (active 1930s)

Kellog, L. L. (active 1885–1895)
King, Charles Bird (1785–1862)
King, Eleanor (1909–?)
Knight, Charles Robert (1874–1953)
Koehler, Henry (active 1881)
Korner, Jules Gilmer, Sr. (1851–1921)
Krondorf, William F. (1877–1968)

Lathrop, William Langson (1859–1938)
Laughlin, Thomas (active 1930s and 1940s)

Lawson, Ernest (1873–1939)

Lazzari, Pietro (1898–?)

Leake, Gerald (1885–1975)

Lee, Doris (1905–1983)

Lehman, George (?–1870)

Le Moyne, Jacques de Morgues (?–1588; active 1560s)

Levine, Jack (1915–)

Lindenmuth, Tod (1885–1976)

Link, Carl (1887–?)

Lloyd, Frank Edward (?–1945)

Locke, Walter Ronald (1883–?)

Lundgren, Eric (1906–?)

MacLeish, Norman (1890–?)

Maynard, George (1843–1923)

McClure, Mary (active 1880s)

McCord, George Herbert (1849–1909)

McIntosh, Harold

McKean, Hugh Ferguson (1908–1997)

Meeker, Joseph Rusling (1827–1889)

Merkel, Otto (active 1895–1917)

Merrick, Richard L. (1903–?)

Mignot, Louis Remy (1831–1871)

Miller, Richard (1875–1943)

Mitchell, Guernsey S. (1854–1921)

Mizner, Addison (1872–1933)

Monks, John Austin Sands (1850–1917)

Montanus, Arnold

Mooney, John (1843–1918)

Moore, Benson Bond (1882–1974)

Moran, Edward (1829–1901)

Moran, Mary Nimmo (1842–1899)

Moran, Thomas (1837–1926)

Morse, George Frederic

Muranyi, G. (1881–1961)

Murphy, Henry Dudley (1867–1945)

Myers, Joseph (active 1930s and 1940s)

Nelson, William Henry de Beauvior (1861–1920)

Newman, Arnold (1918–)

Nichols, Edward W. (1819–1871)

Nicoll, J. W.

Nicoll, James Craig (1846–1918)

O'Hara, Eliot (1890–1969)

Ogilby, John (active 1671)

Ortmayer, Constance (1902–?)

Osborne, Charles H. (active 1885–1903)

Osborne, Norman (1875–1965)

Owen, Clara Belle (1854–1955)

Owen, Robert Emmett (1878–1957)

Paris, Walter (1842–1906)

Parrish, Stephen J. (1846–1938)

Parshall, Douglas Ewell (1899–?)

Parsons, Philip Brown

Pascin, Jules (1885–1930)

Pataky, Tibor (1901–)

Peale, Titian Ramsey (1799–1885)

Perkins, Granville (1830–1895)

Peterson, Jane (1876–1965)

Picknell, William Lamb (1854–1897)

Porter, William Arnold (1844–1909)

Post, Charles Johnson (1873–1956)

Potter, George W. (active 1920s)

Powell, Lucien Whiting (1846–1920)

Prendergast, Charles E. (1863–1948)

Prendergast, Maurice Brazil (1859–1924)

Remington, Frederic (1861–1909)

Rice, Arthur Wallace (active 1930s)

Ripley, Aiden Lassell (1896–1969)

Robbins, Ellen (1828–1905)

Rosen, Charles (1878–1950)

Roth, Ernest David (1884–1964)

Ruggles, Carl (1876–1971)

Russell, Walter (1871–1963)

Sambugnac, Alexander (1888–?)

Sargent, John Singer (1856–1925)

Savage, Eugene Francis (1883–1966)

Scheibner, Vira McIllrath (1889–1956)

Schlamp, Philip Martin (active 1920s)

Schlemmer, Ferdinand Louis "Fritz" (1893–?)

Schreiber, Georges (1904–1977)

Schulz, Adolph Robert (1869–1963)

Scott, W. V. (active 1860s)

Seavey, George (active 1880s and 1890s)

Serres, Dominic

Seymour, Ralph Fletcher (1876–?)

Seymour, M.

Shapleigh, Frank Henry (1842–1906)

Shinn, Everett (1876–1953)

Siems, Alice Lettig (1897–?)

Silsbee, Martha (1858–1929)

Smillie, George Henry (1840–1921)

Smith, Jules André (1880–1959)

Smith, James Calvert (1878–1962)

Smith, Wallace Herndon (1901–1989)

Smith, Xanthus Russell (1839–1929)

Solomon, Syd (1917–)

Stephen, Ferris (active 1930–1960)

Stites, John Randolph (1836–?)

Stowe, Harriet Beecher (1811–1896)

Strait, C. Barrett

Strater, Henry (1896–?)

Straub, William L. (active 1904)

Stuart, James Everett (1852–1941)

Sully, George Washington (1816–1890)

Sword, James Brade (1838–1915)

Sylvester, Harry Elliot (1860–1921)

Taylor, Frank Hamilton (1846–1926)

Terrell, Elizabeth (1908–?)

Thieme, Anthony (1888–1954)

Thompson, Bruce (active 1930s)

Tiffany, Louis Comfort (1848–1933)

Tilghman, Mattie H. (1837–1927)

Tittle, Walter Ernest (1883–1943?)
Tojetti, Virgilio (1851–1901)
Tracy, Lois Bartlett (1901–)

Ulreich, Edward Buk (1889–1962)
Underwood, Leon George Claude (1890–?)

van Benschoten, Clare (active 1930s)
Van Boskerck, Robert Ward (1855–1932)
Van Dresser, William (1871–1950)
Vinton, John Rogers (1801–1847)
Vogt, Louis Charles (1864–1939)

Walker, William Aiken (1838–1921)
Waltensperger, Charles (1871–1931)
Walter, Martha (1875–1976)
Warren, Elizabeth Boardman (1886–1979)
Watson, Amelia Montague (1856–1934)
Weber, Theodore Alexander (1838–1907)
Weeks, Edwin Lord (1849–1903)
Weir, Robert Walter (1803–1889)
White, Edwin D. (1817–1877)
White, John (active 1585–1593)
Whitehead, W. A. (active 1820s)

Whitehurst, Camelia (1871–1936)
Wiggins, Guy (1905–1962)
Wikstrom, Broz Anders (ca. 1840–1909)
Wilcox, James Ralph (1866–1915)
Williams, Helen L. (active 1886)
Willson, James Mallory (1890–?)
Wilson, Claggett (1887–?)
Wilson, Edward A. (1886–1970)
Wilson, Rose Cecil O'Neill (1875–1944)
Wolcott, Marion Post (1910–1990)
Wolkin, J.
Wood, Charles Erskine Scott (1852–1944)
Wood, Ethelwyn A. (1902–?)
Woodbury, Charles Herbert (1864–1940)
Woodward, John Douglas (1846–1924)
Woodward, Laura (1836–1929)
Woodward, Mabel May (1877–1945)
Woodward, Martha Dewing (1856–1950)
Woodward, Stanley Wingate (1890–1970)
Wyant, Alexander Helwig (1836–1892)
Wyeth, Andrew (1917–)
Wykes, Frederic Kirtland (1905–?)

Zorach, William (1887–1966)

Notes

Introduction

1 Elliot James Mackle Jr., "The Eden of the South: Florida's Image in American Travel Literature and Painting, 1865–1900," (Ph.D. dissertation, Emory University, 1977), p. 2.

Chapter One

1 E. P. Richardson, *Painting in America* (New York: Thomas Y. Crowell Co., 1965).

2 Christian F. Feest, "Jacques le Moyne Minus Four," in *European Review of Native American Studies* (1988), pp. 33–38.

3 Arthos Lotsee Patterson and Mary Ellen Snodgrass, *Indian Terms of the Americas* (Englewood, California: Libraries Unlimited, 1994).

4 Gloria Deák, *Discovering America's Southeast* (Birmingham Library Press, 1992), p. 43.

5 Ibid, p. 42.

6 Michael Gannon Ed. *The New History of Florida* (Gainesville, Florida: University of Florida Press, 1996), p.73.

7 *American Architect*, "Fort Marion" (March 1935) p. 34. The fort will continue to be referred to as Fort Marion because of the art featuring the name.

8 Dorothy Keane-White, *Florida Painters: Past and Present* (St. Petersburg, Florida: St. Petersburg Historical Society, Nov. 30, 1984–Feb. 2, 1985), unpaginated.

9 Gene M. Burnett, *Florida's Past: People and Events That Shaped the State* (Englewood, Florida: Pineapple Press, Inc., 1986), p 183.

Chapter Two

1 Charles Vignoles, *Observations upon the Floridas* (New York: E. Bliss and E. White, 1823). A facsimile reproduction of the 1823 edition with an introduction and index by John Hebron Moore (Gainesville, Florida: University Presses of Florida, 1977).

2 Ibid, p. xii.

3 Keane-White, unpaginated.

4 Charles Lucien Bonaparte, *American Ornithology or the Natural History of Birds Inhabiting the United States* (Philadelphia: Cary & Lea, 1825–1833), vol. 4, p. 96.

5 John James Audubon, *The Birds of America, Viviparous Quadrupeds of North America* (New York: Sotheby's, June 23–24, 1989).

6 Joy Williams, *The Florida Keys from Key Largo to Key West: A History and Guide* (New York: Random House, 1987), pp. 116–147.

7 Linda V. Ellsworth, *The Magazine Antiques*, vol. CXXIII, no. 3 (1983), p. 602.

Chapter Three

1 Andrew F. Cosentino, *The Paintings of Charles Bird King (1785–1862)* (Washington, D.C.: Smithsonian Institution Press, 1977), p. 39.

2 Dorothy Downs, *Art of the Florida Seminole and Miccosukee Indians* (Gainesville, Florida: University Press of Florida, 1995), p. 2.

3 *W. P.A. Guide to Florida: The Federal Writers Project Guide to 1930s Florida* (New York: Pantheon Books, 1939), p. 43.

4 Downs, pp. 48–49.

5 Charlton W. Tebeau, *A History of Florida* (Miami, Florida: University of Miami Press, 1971), p. 164.

6 Oliver W. Larkin, *Art and Life in America* (New York: Holt, Rinehart & Winston, 1966), p. 27.

7 As quoted by Keane-White, unpaginated.

8 Gary R. Libby, ed., *Celebrating Florida: Works of Art from the Vickers Collection* (Daytona Beach, Florida: The Museum of Arts and Sciences, 1995), pp. 123–127.

9 Letter to Erik Robinson from the David Ramus Gallery (January 10, 1985).

10 Libby, p. 28.

11 Downs, pp. 2–3.

12 Ibid, p. 23.

13 Ibid, p. 42.

14 Ibid, p. 66.

15 Ibid. p. 69.

16 Ibid, p. 136.

17 Ibid, p. 210.

18 Ibid, p. 211.

Chapter Four

1 Perry T. Rathbone, ed., *M. & M. Karolik Collection of American Watercolors and Drawings, 1800–1875* (Museum of Fine Arts: Boston, Massachusetts, 1962), vol. 1, p. 177.

2 William Cullen Bryant II and Thomas G. Voss, eds., *The Letters of William Cullen Bryant*, vol.2 (New York: Fordham University Press, 1975–1992).

3 Richard A. Martin, *Eternal Spring* (St. Petersburg, Florida: Great Outdoors Publishing Co., 1966), p. 105.

4 Ibid, pp.106–107.

5 Ibid, pp. 109–113.

6 Ibid, p. 146.

7 *Ballou's Pictorial Drawing Room Companion*, vol. VIII, no. 7 (April 7, 1855), p. 97.

8 Libby, p. 30.

9 Ibid, p. 36.

10 Ibid, p. 32.

11 Ibid, p. 35.

12 Tebeau, p. 215.

Chapter Five

1 Hart's hotel identified as Brown Hotel by Steve Hess, owner of painting.

2 Edward King, *The Great South* (Baton Rouge, Louisiana: Louisiana State University Press, 1972, reprint), p. 378.

3 Ruth Beesch (Introduction), *Florida Visionaries 1870–1930,* University of Florida, University Gallery, College of Fine Arts (February 19–March 26, 1989). Refer to Carol Jentsch's essay, "James Wells Champney (1843–1903)," p. 56.

4 King, p. 393.

5 Ibid, p. 415.

6 Tebeau, p. 271.

7 A more detailed view of both approaches can be seen in the following: Sue Rainey, "Images of the South in *Picturesque America* and *The Great South.*" Edited by Judy L. Larson (Fayetteville, Arkansas: University of Arkansas Press, 1993).

8 Sue Rainey and Roger B. Stein, *Shaping the Landscape Image, 1865–1910.* University of Virginia, Bayley Art Museum (April–May 1996), p. 23.

9 Sue Rainey, guest curator of Woodward Exhibition at the Bayley Art Museum, University of Virginia, Charlottesville, Virginia, 1996–1997.

10 Rainey, "Images of the South," p. 206.

11 Thurman Wilkins, *Thomas Moran: Artist of the Mountain* (Norman, Oklahoma: University of Oklahoma Press, 1966), p. 108.

12 Julia E. Dodge, "An Island of the Sea," *Scribner's Monthly,* vol. XIV, no. 5 (September 1877), p. 653.

13 Ibid, p. 111. See footnote no. 6.

14 *Prints of Nature: Poetic Etching of Mary Nimmo Moran.* Thomas Gilcrease Institute of American Art (September 7–December 2, 1984).

15 Phyllis Peet, *American Women of the Etching Revival.* High Museum of Art (February 9–May 9, 1988), p. 32.

16 Sylvester R. Koehler, "The Work of the American Etchers: Mrs. M. Nimmo Moran," *American Art Review,* vol. XX, fig. 2, pt. 1881, p. 31.

17 Henry T. Tuckerman, *Book of the Artists: American Artist Life* (New York: James F. Carr, 1967 (second printing of reprint edition)), p. 438.

Chapter Six

1 Theodore E. Stebbins Jr., *The Life and Work of Martin Johnson Heade* (New Haven, Connecticut: Yale University Press, 1975), p. 158.

2 Thomas Graham, *The Awakening of St. Augustine: The Anderson Family and the Oldest City, 1821-1924* (St. Augustine, Florida: St. Augustine Historical Society, 1978), pp. 173–174, 193.

3 Thomas Graham, "Flagler's Magnificent Hotel Ponce de Leon," *Florida Historical Quarterly,* vol. LIV (July 1975), pp. 8–9.

4 Frederic A. Sharf, "St. Augustine: City of Artists, 1883–1895." *The Magazine Antiques,* vol. XCIV, no. 7 (August 1966), p. 220.

5 *Lightner Museum* (pamphlet). (St Augustine, Florida: St. Augustine Publishing Co., 1976), p. 2.

6 Scharf, p. 220.

7 *News Herald,* St. Augustine, Florida, n.d., p. 91.

8 Stebbins, pp.163–164.

9 Ibid, p. 116.

10 Sandra Barghini, *A Society of Painters. Flagler Museum* (January 15–May 3, 1998), unpaginated.

11 Ibid, unpaginated.

12 Mildred Parker Seese, *Old Orange Houses* (Middletown, New York: The Whitlock Press, ca. 1941), vol. 2, p. 96.

13 *The Tatler,* St. Augustine, Florida, vol. 1, no. 6 (1892), p. 4.

14 Sharf, p. 221.

15 Barghini, unpaginated.

16 Charles Vogel, letter to author, September 7, 1982.

17 *The Tatler,* St. Augustine, Florida (February 3, 1894), p. 10.

18 *News Herald,* St. Augustine, Florida, n.d., p. 90.

19 *The Tatler,* St. Augustine, Florida, vol. 3, no. 6 (February 17, 1894), p. 7.

20 Ibid (February 17, 1894), p. 7.

21 Timothy A. Eaton, *Florida Artist Series #14: Images of Old Florida (1890–1950).* Refer to article, "William Aiken Walker (1838–1921)." Boca Raton Museum of Art (December 21, 1990–February 3, 1991), p. 14.

22 Jentsch, pp. 45–47.

23 Barghini, unpaginated.

24 Ibid, unpaginated.

25 *The Studio,* vol. VII, no. 19 (April 9, 1982).

26 Jentsch, p. 60.

27 Ibid, p. 65.

28 Richard N. Campen, *Winter Park Portrait* (Beachwood, Ohio: West Summit Press, 1987), pp. 25–26.

29 Brian E. Michaels and the Putnam County Action '76 Heritage Task Force Historical Manuscript Subcommittee, *The River Flows North* (Palatka, Florida: The Putnam County Archives and History Commission, 1976), p. 208.

30 J. Russell Harper, *Early Painters and Engravers in Canada* (Toronto: University of Toronto Press, 1970), p. 52.

31 Tebeau, p. 285.

32 David Nolan, *Fifty Feet in Paradise* (New York: Harcourt Brace Jovanovich, 1984), pp. 112–114.

33 Stuart McIver, "Remington's Last Roundup," *News/Sun Sentinel and Sunshine Magazine,* January 5, 1986, pp. 20–21.

34 Michael Edward Shapiro and Peter H. Hassrick, *Frederic Remington, the Masterworks.* With essays by David G. McCullough, Doreen Bolger Burke, and John Seelye. St. Louis Art Museum (March 11–May 22, 1988). Refer to Burke's article, " In the Context of His Artistic Generation," pp. 48–49.

35 The latter drawing is in the Special Collections at the University of South Florida Library, Tampa, Florida.

36 Courtesy Peter A. Juley & Son Collection, National Museum of American Art, Smithsonian Institution, Washington, D.C.

Chapter Seven

No notes

Chapter Eight

1 Mackle, p. 177.

2 Ibid.

3 Donald Sykes Lewis Jr., "Hermann Herzog." Unpublished Master's thesis (University of Virginia, 1975), p. 3.

4 Nancy L. Gustke, *A Stately Picturesque Dream: Scenes of Florida, Cuba, and Mexico in 1887*. University of Florida, University Gallery, College of Fine Arts, Gainesville, Florida (February 17–March 25, 1984), pp. 1, 2.

5 Oliver W. Larkin, *Art and Life in America* (New York: Holt, Rinehart & Winston, 1966), pp. 273–274.

6 Ibid, p. 275.

7 Mackle, p. 191–192.

8 Ibid, p. 197.

Chapter Nine

1 Martin, pp. 151–164.

2 *Palm Beach Post* (March 30, 1916).

3 Nixon Smiley, *Florida: Land of Images* (Miami, Florida: E A. Seemann Publishing, Inc., 1972), pp. 109–119.

4 William H. Gerdts, *The Flowering of Florida Art: Tropical Landscapes from the 19th and 20th Centuries*. Eckert Fine Art/Naples, Inc., Naples, Florida (February 7–20, 1997), p. 11.

5 Tebeau, p. 378.

6 *Palm Beach Times* (February 17, 1924).

7 Ibid.

8 *Palm Beach News* (December 15 1927), p. 12.

9 *Palm Beach Post* (January 9, 1928).

10 *Palm Beach Post* (February 19, 1928).

11 *Palm Beach News* (February 19, 1928).

12 Eaton, pp. 25, 26.

13 Nolan, pp. 165–166.

14 Christina Orr, *Addison Mizner, Architect of Dreams and Realities (1872–1933)*. Norton Gallery of Art, West Palm Beach, Florida (March 5–April 17, 1977).

15 *Palm Beach Post* (March 26, 1928).

16 *Palm Beach Post* (January 10, 1932).

17 Karl H. Grimmer, *History of St. Petersburg* (St. Petersburg, Florida: Tourist News Publishing Co., 1924), p. 192.

18 Faith Andrews Bedford, *Frank W. Benson: A Biography*. Berry-Hill Galleries, New York, New York (May 17–June 24, 1989), p. 71.

19 Ibid, p. 110.

20 *St. Petersburg Times* (December 7, 1950).

21 Gerdts, p. 9.

22 Nolan, pp. 155–156.

23 Ibid, p. 185.

24 Ibid, p. 239.

25 Anthony F. Janson, *Great Paintings from the John and Mable Ringling Museum of Art* (New York: John and Mable Ringling Museum of Art in association with Harry N. Abrams, Inc., 1986). Refer to Foreword by Dr. Laurence J. Ruggiero, Director, p. 7.

26 Nolan, pp. 240–241.

27 Ibid, p. 239.

28 Ibid, p. 176–177, 200.

29 Jayne Thomas Rice, *Bonnet House*. Bonnet House, Inc. (1990).

30 Gerdts, p. 10.

31 Ralph Rees, mss. for *Bucknell Review* (November 1991), pp. 1–10.

32 Karen Daniels Petersen, *Plains Indian Art from Fort Marion* (Norman, Oklahoma: University of Oklahoma Press, 1971), p. 75.

33 Bruce Weber, *The Sun and the Shade: Florida Photography 1885–1983*. Norton Gallery of Art, West Palm Beach, Florida (December 3, 1983–January 15, 1984).

34 Nancy Mowll Mathews. *The Art of Charles Prendergast from the Collections of the Williams College Museum of Art and Mrs. Charles Prendergast*. Williams College Museum of Art (1993), p. 9.

Chapter Ten

1 Marlene Park and Gerald E. Markowitz, *Democratic Vistas: Post Offices and Public Art in the New Deal* (Philadelphia: Temple University Press, 1984), p. xvii.

2 Ibid, pp. 4–5.

3 Fran Rowin, "New Deal Murals in Florida Post Offices." *Update: Historical Association of Southern Florida*, vol. III (February 1977), p. 6.

4 Susan Hale Freeman, "Monument to Three Artists." *Update: Historical Association of Southern Florida*, vol. XIV, no. 3 (August 1987), pp. 4–5.

5 Rowin, p. 8.

6 Jan Pudlow, "Pictures from the Past." *Tallahassee Democrat* (January 12, 1997), pp. 1E, 10E.

7 Rowin, p. 8.

8 *Art Digest*, vol. 12, p. 10 (January 15, 1938).

9 Park and Markowitz, p. 179.

10 Ibid, p. 69.

11 J. Carter Brown. Foreword to *Treasury of American Design* by Clarence P. Hornung (New York: Harry N. Abrams, Inc., 1950), p. xvii.

Selected Bibliography

Books

Beach, Rex. *The Miracle of Coral Gables*. New York: Currier & Hartford Ltd., 1926.

Bonaparte, Charles Lucien. *American Ornithology or the Natural History of Birds Inhabiting the United States*. Philadelphia: Carey and Lea, 1825–1833, vol. 4, p. 96.

Brown, J. Carter. Foreword to *Treasury of American Design* by Clarence P. Hornung. New York: Harry N. Abrams, Inc., 1950.

Brown, Robin C. *Florida's First People*. Sarasota, Florida: Pineapple Press, Inc., 1994.

Bryant, William Cullen. *The Letters of William Cullen Bryant*, vol. 2. Edited by William Cullen Bryant II and Thomas G. Voss. New York: Fordham University Press, 1975–1992.

Burnett, Gene M. *Florida's Past: People and Events That Shaped the State*, vol. 1. Sarasota, Florida: Pineapple Press, Inc., 1986.

Campen, Richard N. *Winter Park Portrait*. Beachwood, Ohio: West Summit Press, 1987.

Cosentino, Andrew F. *The Paintings of Charles Bird King, 1785–1862*. Washington, D.C.: Smithsonian Institution Press, 1977.

Crespo, Rafael Agapito. *Florida's First Spanish Renaissance Revival*. Cambridge, Massachusetts: Harvard University Press, 1987, vols. 1–3.

Deák, Gloria. *Discovering America's Southeast*. Birmingham, Alabama: Birmingham Library Press, 1992.

Deland, Margaret. *Florida Days*. Illustrated by Louis K. Harlow. Boston: Little, Brown, and Company, 1889.

Downs, Dorothy. *Art of the Florida Seminole and Miccosukee Indians*. Gainesville, Florida: University Press of Florida, 1995.

Gannon, Michael, ed. *The New History of Florida*. Gainesville, Florida: University of Florida Press, 1996.

Graham, Thomas. *The Awakening of St. Augustine: The Anderson Family and the Oldest City, 1821–1924*. St. Augustine, Florida: St. Augustine Historical Society, 1978.

Grimmer, Karl H. *History of St. Petersburg*. St. Petersburg, Florida: Tourist News Publishing Co., 1924.

Gilliland, Marion Spjut. *The Material Culture of Key Marco, Florida*. Gainesville, Florida: University Presses of Florida, 1975.

Harper, J. Russell. *Early Painters and Engravers in Canada*. Toronto: University of Toronto Press, 1970.

Janson, Anthony F. *Great Paintings from the John and Mable Ringling Museum of Art*. New York: John and Mable Ringling Museum of Art in association with Harry N. Abrams, Inc., 1986.

King, Edward. *The Great South*. Published by *Scribner's Monthly*. Hartford, Connecticut: American Publishing Co., 1879. Reprinted, Baton Rouge, Louisiana: Louisiana State University Press, 1972.

Langley, Joan, and Wright Langley. *Key West: Images of the Past*. Key West, Florida: Christopher C. Belland & Edwin O. Swift III, 1982.

Larkin, Oliver W. *Art and Life in America*. New York: Holt, Rinehart & Winston, 1966.

Libby, Gary R., ed. *Celebrating Florida: Works of Art from the Vickers Collection*. Daytona Beach, Florida: The Museum of Arts and Sciences, 1995.

Martin, Richard A. *Eternal Spring*. St. Petersburg, Florida: Great Outdoors Publishing Co., 1966.

Michaels, Brian E., and The Putnam County Action '76 Heritage Task Force Historical Manuscript Subcommittee. *The River Flows North*. Palatka, Florida: The Putnam Archives and History Commission, 1976.

Nolan, David. *Fifty Feet in Paradise*. New York: Harcourt Brace Jovanovich, 1984.

Park, Marlene, and Gerald E. Markovitz. *Democratic Vistas: Post Offices and Public Art in the New Deal*. Philadelphia: Temple University Press, 1984.

Patterson, Arthos Lotsee, and Mary Ellen Snodgrass. *Indian Terms of the Americas*. Englewood, California: Libraries Unlimited, 1994.

Petersen, Karen Daniels. *Plains Indian Art from Fort Marion*. Norman, Oklahoma: University of Oklahoma Press, 1971.

Purdy, Barbara. *Indian Art of Ancient Florida*. Gainesville, Florida: University Press of Florida, 1996.

Rathbone, Perry T., ed. *M & M Karolik Collection of American Watercolors and Drawings, 1800–1875*, vol. 1. Boston, Massachusetts: Museum of Fine Arts, 1962.

Richardson, E. P. *Painting in America*. New York: Thomas Y. Crowell Co., 1965.

Seese, Mildred Parker. *Old Orange Houses*, vol. 2. Middletown, New York: The Whitlock Press, circa 1941.

Smiley, Nixon. *Florida: Land of Images*. Miami, Florida: E. A. Seemann Publishing, Inc., 1972.

Stebbins, Theodore E., Jr. *The Life and Work of Martin Johnson Heade*. New

Haven, Connecticut: Yale University Press, 1975.

Tebeau, Charlton W. *A History of Florida.* Miami: University of Miami Press, 1971.

Tuckerman, Henry. *Book of the Artists: American Artist Life.* New York: James F. Carr, 1867. Second printing of reprint edition, 1967.

Viola, Herman J. *Warrior Artist: Historic Cheyenne and Kiowa Indian Ledger Art.* Illustrated by Making Medicine and Zotom. Washington, D.C.: National Geographic Society, 1998.

Vignoles, Charles. *Observations upon the Floridas.* New York: E. Bliss and E. White, 1823. A facsimile reproduction supplied by Bicentennial Floridiana Facsimile Series, 1977.

Wilkins, Thurman. *Thomas Moran: Artist of the Mountain.* Norman, Oklahoma: University of Oklahoma Press, 1966.

Williams, Joy. *The Florida Keys from Key Largo to Key West: A History and Guide.* New York: Random House, 1978.

W. P. A. Guide to Florida: The Federal Writers Project Guide to 1930s Florida. New York: Pantheon Books, 1939. Introduction by John I. McCollum.

Zellman, Michael David, compiler. *300 Years of American Art,* vols. 1 and 2. Secaucus, New Jersey: Wellfleet Press, 1987.

Periodicals and Newspapers

Anonymous. "Fort Maine." *American Architect,* vol. 33 (March 1935): 9.

Art Digest, vol. XII (January 15 1938).

Ballou's Pictorial Drawing Room Companion, vol. VIII, no. 7 (April 7, 1855): 97.

Benbow, Charles. "A Rediscovered Art." *St. Petersburg Times* (August 11, 1972).

Benbow, Charles. "Hill's Works Are Intelligible Statements." *St. Petersburg Times* (January 4, 1980).

Dodge, Julia E. "An Island of the Sea." *Scribner's Monthly,* vol. XIV, no. 5 (September 1877).

Ellsworth, Linda V. *The Magazine Antiques,* Historic Pensacola Preservation Board, vol. CXXIII, no. 3 (1983): 602.

Feagin, Jackie, ed. *St. Augustine Record* (August 2, 1986): 7a.

Feest, Christian. "Jacques Le Moyne Minus Four." *European Review of Native American Studies* (1988): 33–38.

Florida Times Union, 1892.

Freeman, Susan Hale. "Monument to Three Artists." *Update: The Historical Association of Southern Florida,* vol. XIV, no. 3 (August 1987).

Graham, Thomas. "Flagler's Magnificent Hotel Ponce de Leon." *Florida Historical Quarterly,* vol. LIV, July 1975.

Harper's New Monthly Magazine, vol. 91, no. 543, pp. 339–345.

Koehler, Sylvester Rosa. "The Work of the American Etchers: Mrs. M. Nimmo Moran." *American Art Review,* vol. XX, fig. 2, pt. 1881, p. 31.

McIver, Stuart. "Remington's Last Roundup." *News/Sun Sentinel and Sunshine Magazine,* January 5, 1986.

News Herald (St. Augustine, Florida), n.d.

Palm Beach News, various issues.

Palm Beach Post, various issues.

Palm Beach Times, various issues.

Pudlow, Jan. "Pictures from the Past." *Tallahassee Democrat* (January 12, 1997).

Rowin, Fran. "New Deal Murals in Florida Post Offices." *Update: Historical Association of Southern Florida,* vol. III (February 1977).

Sharf, Frederic A. "St. Augustine: City of Artists, 1883–1895." *The Magazine Antiques,* vol. XCIV, no. 7 (August 1966): 220–223.

The Studio, vol. VII, no. 19 (April 9, 1892).

The Tatler (St. Augustine, Florida), various issues.

Exhibition Catalogs

Barghini, Sandra. *A Society of Painters.* Palm Beach, Florida: Flagler Museum, January 15–May 3, 1998.

Bedford, Faith Andrews. *Frank W. Benson, A Biography.* New York: Berry-Hill Galleries, Inc., May 17–June 24, 1989.

Beesch, Ruth (Introduction). Essays by Carol Jentsch, E. Michael Whittington, and Blair S. Sands. *Florida Visionaries: 1870–1930.* University of Florida, University Gallery, College of Fine Arts, February 19–March 26, 1989. Gainesville, Florida: University Presses of Florida, 1989.

Eaton, Timothy. *Florida Artist Series #14: Images of Old Florida (1890–1950).* Boca Raton, Florida: Boca Raton Museum of Art, December 21, 1990–February 3, 1991.

Gerdts, William H. *The Flowering of Florida Art: Tropical Landscapes from the 19th and 20th Centuries.* Naples, Florida: Eckert Fine Art/Naples, Inc., February 7–20, 1997.

Gustke, Nancy L. *A Stately Picturesque Dream: Scenes of Florida, Cuba, and Mexico in 1887.* Gainesville, Florida: University of Florida, University Gallery, College of Fine Arts, February 17–March 25, 1984.

John James Audubon, The Birds of America, Viviparous Quadrupeds of North America. New York: Sotheby's, June 23–24, 1989.

Keane-White, Dorothy. *Florida Painters: Past and Present.* St. Petersburg, Florida: St. Petersburg Historical Society, November 30, 1984–February 2, 1985.

Matthews, Nancy Mowll. *The Art of Charles Prendergast from the Collections of the Williams College Museum of Art and Mrs. Charles Prendergast.* Williamstown, Massachusetts: Williams College Museum of Art, August 14, 1993–January 4, 1994.

Orr, Christina. *Addison Mizner: Architect of Dreams and Realities (1872–1933).* West Palm Beach, Florida: Norton Gallery of Art, March 5–April 17, 1977.

Peet, Phyllis. *American Women of the Etching Revival.* Atlanta, Georgia: High Museum of Art, February 9–May 9, 1988.

Prints of Nature: Poetic Etching of Mary Nimmo Moran. Tulsa, Oklahoma:

Thomas Gilcrease Institute of American Art, September 7–December 2, 1984.

Rainey, Sue, and Roger B. Stein. *Shaping the Landscape Image, 1865–1910.* Charlottesville, Virginia: University of Virginia, Bayly Art Museum, April–May 1996.

Rice, Jayne Thomas. *Bonnet House.* Ft. Lauderdale, Florida: Bonnet House, Inc., 1990.

Shapiro, Michael Edward, and Peter H. Hassrick, with essays by David G. McCollough, Doreen Bolger Burke, and John Seelye. *Frederic Remington, the Masterworks.* St. Louis, Missouri: St. Louis Art Museum, March 11–May 22, 1988.

Weber, Bruce. *The Sun and the Shade: Florida Photography 1885–1983.* West Palm Beach, Florida: Norton Gallery of Art, December 3, 1983–January 15, 1984.

Travel Tracts

Corse, Carita Doggett. *Shrine of the Water Gods.* Silver Springs, Florida, 1935.

Into Florida, A Round Trip Upon the St. Johns. De Bary-Baya Merchants Line. New York: The South Publishing Company, circa 1883.

Into Tropical Florida; or, A Round Trip Upon the St. Johns River. De Bary-Baya Merchants Line. New York: Leve & Alden's Publication Department, circa 1884.

Ocala and Silver Springs Company. New York: John G. Franklin, 1892.

Reynolds, Charles B. *The Standard Guide to St. Augustine.* St. Augustine, Florida: E. H. Reynolds, 1890.

Winter Cities in a Summer Land. Cincinnati, Ohio: Cincinnati, New Orleans and Texas-Pacific Rwy. Co., 1881.

Unpublished Documents

Lewis, Donald Sykes, Jr. "Hermann Herzog." Master's thesis, University of Virginia, 1975.

Mackle, Elliot James, Jr. "The Eden of the South: Florida's Image in American Travel Literature and Painting, 1865–1900." Ph.D. dissertation, Emory University, Atlanta, Georgia, 1977.

Rees, Ralph. Mss. for *Bucknell Review* (November 1991).

Miscellaneous Publications

Lightner Museum (pamphlet). St. Augustine, Florida: St. Augustine Publishing Co., 1976.

Rainey, Sue. "Images of the South in Picturesque America and The Great South." Edited by Judy L. Larson. Article presented at Graphic Arts of the South, proceedings of the 1990 North American Print Conference (Fayetteville, Arkansas: University of Arkansas Press, 1993).

Personal Communications

Barr, Jeffrey. Letter to author, April 12, 1999. Jeffrey Barr is a rare books librarian in the Department of Special Collections at the George A. Smathers Libraries, University of Florida, Gainesville.

Patton, Robert. Letter to author, January 20, 1992. Robert Patton is an art dealer in Troy, Ohio.

Robinson, Erik. Letter from David Ramus Gallery to Erik Robinson, January 10, 1985. Erik Robinson is historian at the Museum of Florida History in Tallahassee.

Vogel, Charles. Letter to author, September 7, 1982. Charles Vogel is an author and art collector specializing in artist Frank Henry Shapleigh.

Ward, David, Sr. Letter to the author, April 19, 1999. David Ward Sr. is associate editor of the Peale Family Papers at the National Portrait Gallery in Washington, D.C.

Index